Creative Quest

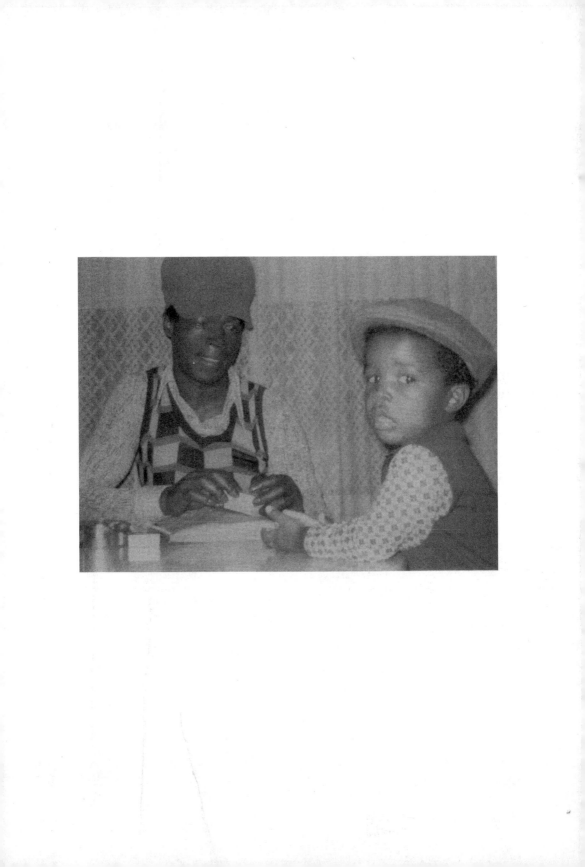

To my father, my first mentor.

Thank you for teaching me how to be creative,
how to be focused,
how to be resilient—how to be.

Table of Contents

I want to show people how I learned to move along two tracks at once—how I kept taking personal risks in my art while at the same time negotiating the ins and outs of commercial success. The result is this book, which is my story of understanding creativity and succeeding in creative endeavors. I want to use my experiences—not only my own successes and failures, but the challenges faced by (and overcome by) others—to help readers plot a course through the creative process. Everyone knows the broad shape of that process. Everyone knows that it starts with the idea and ends with the execution of that idea, but the quest of the artist is both more general and more specific. You have to know when to leap on an idea and when to leave it alone, when to keep it close to the vest and when to release it into the world, when to consolidate your gains and when to move into uncharted territory. Creativity isn't Candyland—it's more complicated than that—but there is a game board, with general principles to follow, and I want to sketch it out for readers.

In *The Wizard of Oz*, after Dorothy has been through the wringer, the Good Witch tells her that she has had the power to go home all along. All she had to do was click the heels of her ruby slippers. I'm not going to Good Witch you guys and make you wait until the end. I'll tell you this right at the beginning: you—and only you—have the power to make these creative exercises work. All I can do is drop hints, drop bread crumbs, and drop science. Pick up what you want when you want. The book is in your hands. How it gets used is also in your hands.

I won't make grand claims. But I will make this one: if you use this book properly, you'll learn something, even if what you learn is that you already believed your own versions of many of these insights. That's one of the secrets that maybe a savvier marketer would save for a bonus track but I'm sequencing first—lots of these things will harmonize with the instincts you already have. I'll give you supporting evidence. I'll show you how other people have similar practices, both to each other and to me. Most important, I'll encourage

you to recognize that your suspicions about creativity are probably correct. Getting to the point where you can credit your own intuition is an important part of moving forward creatively.

———

I often think of creativity as functioning in the middle of a stream. Ideas are happening all around me, all the time, and I have had to learn how to process them all. I have learned how to be a filter: informed, active, engaged, and motivated. Whether I'm working on an album, a song, a design, or a conversation, I've been lucky enough to cross paths with thought leaders in various fields: from Neil deGrasse Tyson to President Barack Obama, to Tom Sachs to Björk to Ferran Adrià, to David Lynch to Kehinde Wiley to Wangechi Mutu to Usher. These people have inspired me, often with stories about how others inspired them. Each creative person sits at the base of a tree whose branches stretch far and wide—to other fields, back through time—in ways that help to define and redefine their creative process.

What follows is a bit of a leap, but creativity always is. So let's interlock arms, metaphorically speaking, and jump.

—**Questlove**
New York City

The Record Collection

When I was a kid, my dad had the record collection. I guess it was technically a record collection, but to me it was THE collection. He had so many records of so many different kinds. He had soul music, of course, because he had been a doo-wop singer and the leader of a popular group in the mid-fifties, and soul—at least the smooth soul of the mid-seventies, before disco came along—was the most direct descendant of doo-wop. What we've come to call yacht rock—soft rock with vocal harmonies, like Kenny Loggins or Christopher Cross—was his favorite genre, because it had sort of the same vibe as doo-wop. But he also had arena rock and jazz and classic soul and funk and reggae, a little of everything.

The thing about records was that they didn't feel like closed ideas. They were ideas you could open and ideas you could use. And that's what my dad did. He played records in the house. The memories are so vivid for me. I was at home in Philly: I was three. Usually after dinner and before bedtime, we had a two-hour window where my mom and dad would relax and listen to music; they would stack up six records over the turntable, on the changer, and then let them play through. That meant that I got all the side ones of all the LPs. One night, the first record in the stack was *Stevie Wonder Presents Syreeta*, the second album by Syreeta Wright, the talented songwriter and vocalist who was Stevie's ex-wife. The second song on that particular record was "Spinnin' and Spinnin'," which puts forward the theory that a love affair can be like a merry-go-round: exciting but also dizzying. The middle of the song has a circus feel, almost music hall, and then it accelerates and accelerates. Right as it ended, I heard a large clap in the kitchen. I looked over and saw a mouse in a trap, neck caught, still alive and squealing. To this day, rodents remain a major trauma.

That memory anchors the song emotionally. But I also remember thinking about it analytically, obsessing over all the other ele-

ments of the record. In particular, I became preoccupied with the final synthesizer wash that was playing right when the mouse's neck went into the trap. In retrospect, I can see clearly that Stevie and Syreeta had overdosed on the Beatles, and particularly on *Sgt. Pepper's Lonely Hearts Club Band*. (Syreeta had covered "She's Leaving Home" on her first record, two years before.) Using the Beatles and white British pop as a touchstone gave Stevie freedom: as a black artist he wasn't confined to funk workouts or four-on-the-floor. It led him to some of his greatest music, which happens to be some of the greatest music that anyone's ever made. At the time, though, I was three. I hadn't separated my reactions into emotion on the one hand and analysis on the other. I got all of it in one waterfall. That final synthesizer sound is a death knell for the mouse, and it's frightening. The feeling has never left me.

I started to think that way about every record in the house. It didn't matter if it was Al Green singing "Call Me" or Pilot singing "Magic." They all meant more than they were. They captured a time (in the sense that they were a record or a recording session), and then they captured another time (in the sense that I remembered vividly where I was when I heard them). That has lasted through my whole life: my first car accident was to the tune of Alanis Morissette's "Ironic." I skidded on ice while I was on a date with a Rutgers girl. I was driving carefully by a pileup of five cars, rubbernecking a bit, and we spun right into it. That song is forever a car-accident song. Spinnin' and spinnin'.

Those records were some of my most important introductions to idea-making and how it becomes creative product. I heard music from other sources. I heard it from the radio. I heard it from my parents' band when they went onstage to play. I heard it from myself when I was practicing drums. But records were a full package. They were music on the air, but they were also that black disc spinning around with the label in the middle, and they were the cover photo, and they were the liner notes. They were something in my hands,

physical weight, something that could block out sunlight. They did everything they could with the idea, and it was something. After a lifetime of making records, I now stand in the shade of the tree of the entire process and the entire product. But I think I had the seed of things even then.

We've come a long way since then, and in some sense we've gone backward. Records don't have big covers anymore. They don't have liner notes in the same way. They don't have labels at the center. And most of the music we consume is not in physical form. It's in a cloud, and then it gets sent to our pocket, without ever being a thing that we put our hands on. But you can put your head on it. Songs are still ideas. When I hear them, I still think back to those moments when I held a cover in my hands and thought about the brain that brought it out of nothingness into existence. I didn't understand that process back then, and I'm not sure that I understand it now.

Torr Up

Talking about creativity tends to take place in metaphors. For starters, it's hard to hit the thing head-on: I have read lots of books about the creative process over the years, and their first job usually is to figure out what makes for a creative person. If there is a person standing in front of you on the sidewalk, how do you know that he or she is a creative person? We don't expect that person to suddenly reach into a bag and produce a finished oil painting, so how do we know? Does it depend on what he says, or what she does? Are there indications in body language, or the ways the eyes move?

I would answer these questions by saying that they are the wrong questions. The issue isn't whether people can tell that you're creative. If that's what you're worried about, wear a beret. The issue is whether you can connect to your own creative impulses. Creativity is a fire. We've established that. But I'm going to start with the spark.

What is the spark? It's the beginning of any creative act. You can't start a fire without it. (I'll resist the #TeamSpringsteen or #TeamJoel debate this early in the book.) So that's where I would like to start—inside your own head. How do you have an idea? How do you notice it forming within your mind? And how can you make your mind the kind of mind that is friendly to ideas?

There are people who will tell you that studies have shown that everyone is creative, to some degree. For that matter, there are studies that show almost everything. But let's say it's true. Everyone is creative to some degree. But degrees matter, just like they do in weather or in crime. I remember talking about this once with someone in the business world. It was at one of my food salons: these are gatherings I host at New York by Gehry where I invite chef friends to create new dishes for me and a group of guests, usually musicians, or artists, or comedians, or writers. There are some businesspeople, too, though mostly not Wall Street types—cultural businesspeople, I guess you'd call them. (In fact, some of those businesspeople have been responsible for some of the most interesting insights, since they tend to come at creativity from a different angle.) This person worked for an Internet company. As a younger man, he had been very interested in music. He had played piano, but he hadn't really taken to lessons because he was always trying to write songs of his own. I told him that many of the musicians I knew were like that. They rejected narrow instruction because they wanted to go wide. He told me that many businessmen went the opposite way: they accepted narrow instruction because going wide was a risk.

"Is creativity in business important?" I said.

It was a question I had thought about but not one I had ever asked directly, at least not to someone who worked in business. This was in the first months of thinking about this book, and I considered it research.

"I have two words for you," he said. "Gordon Torr."

"What?" I thought he was speaking in code. Maybe it was Cock-

21

ney slang. Maybe "Gordon Torr" meant "To the core" or "Through the door."

It turned out that Gordon Torr was a name. Torr was a South African creative director in the eighties and nineties. He ran ad campaigns, ran companies, and also wrote motivational books and novels. He also took a position against the idea that all people were equally creative.

> Believing that everyone has the capacity to be just as creative as the next person is as ludicrous as believing that everyone has the capacity to be just as intelligent as the next person, yet it has become almost universally accepted as a truism. It's also relatively new, taking root in only the last 30 or 40 years, coinciding much too precisely to be accidental with the popularization of creativity as an essential ingredient of social and business success.

I wouldn't have said that if you had asked me a few days before. I would have stood up for the idea that everyone is creative, though not in the same way. But after this friend Gordon Torr-ed me, I started to see the world through his eyes, at least for a little while. That's one thing about being creative. Don't be too set in your own ways. Be suggestible from time to time. Allow unexpected influences (like Torr) to shift your ideas. You can always come back to your own convictions if they're real. But be a tourist in other perspectives. I started to look at examples of business creativity with a cynical eye. Online once, I saw a bullet-pointed list of "Ways to Be Creative," and while once I would have just skimmed it and moved on, it stopped me a little bit and left me more than a bit cold. Was the writer trying to codify something in a crass and reductive way that dissolved their very mission?

In the end, I come down somewhere in the middle of the question. I do think that everyone is born with some creative impulse, or at least most people. It's an authentic human energy. Children tell themselves stories about the world. They make drawings. They free-

That's one thing about being creative. Don't be too set in your own ways. Be suggestible from time to time.

play with their toys, making stuffed animals talk to each other. But this book isn't for children. It's for adults. And when it comes to adults, I feel that the creative impulse—even though it might be present in most humans—is unevenly distributed. And yet, I see that uneven distribution differently from Gordon Torr. I've never met him. He's probably a nice guy. But I don't see the point in arguing that some people are more creative than others in some essential way. What I would say definitively is that creativity is unevenly distributed within one individual. It operates differently in different disciplines. It operates differently in different times. We all have blind spots and creative areas where we wilt, but we also have bright spots and creative areas where we flourish.

As a result, all people—who are all creative people, at least in some respect, though maybe not in traditional ways—still have to learn how to locate their ideas, how to execute them, how to feel about them once they're released into the world, and how to cope with the reactions of others. A creative person can be unwilling to express ideas, at which point the creativity is just theoretical. And by the same token, so-called uncreative people can learn how to have ideas and how to make something from them, even if it doesn't come naturally—ideally, something that is a perfect fit for their personalities. When that happens, what's the point in drawing distinctions?

We're going to need a definition of a creative person to go forward. Here's a first stab at it: a creative person is a person who creates.

Let's start there. That's one of the fundamental lessons of creativity. Don't be worried if an idea or a scene or a song comes to you

in its most simplistic form first. That partial arrival is a form of gestation. The seed is expert at turning into something else. A creative person is a person who creates. Leave that in the soil for a minute. We'll be back to tend to it.

I want to address all people who create. I want to accommodate them all. That doesn't mean all of them will get the same things from this book. Some will find it all useful (hopefully). Others will be interested only in certain parts. I want this book to be a form of guidance more than a specific set of rules and exercises. Other books about creativity are very programmatic, partly because they want to convince you that they hold the secret. I don't think I have any secrets. I have the opposite. I have my stories, and the stories of others—people I know, or people I met through the process of writing this book—and I have the hope that people will learn from them. I don't want to tell people what to do. I want to tell them what they can do.

Einstein and Jiro

We've defined a creative person, unhelpfully, as a person who creates. But what is creativity? It's nearly impossible to get everyone to agree on a definition. Wikipedia is crowd-sourced. It says, "Creativity is a phenomenon by which something new and somehow valuable is formed."

I'm not sure that's entirely true. Does it have to be something new, or can it just be something new to the person who is making it, there in the moment? The same is true for the idea of value. Depending on who you are, when you are, and where you are, the value of something can vary wildly.

But there's a more fundamental problem. This definition focuses on the impersonal nature of creativity. It focuses on the things that are formed, rather than the creator. For this book, at least initially, I want to think about what creativity is—and isn't—inside the

mind. What are the habits and beliefs that form around it, that encourage it, that prevent it? By my definition—the Questopedia definition—creativity is the personality that makes it possible that something new and somehow valuable can be formed. Does that take some of the pressure off? It should.

For me, the personality is not always a positive one. Or rather, it's positive mostly only when it is allowed to operate creatively. Otherwise, it can be a drag. For me, creating things is about finding a place for feelings that would otherwise interfere with ordinary life. Those could be feelings of aggression. They could be feelings of depression. For me, those are two common ones, and they're not feelings that I want to dominate my ordinary life, which is why they work so well as an engine for making things.

When I was a kid, and people told me that Einstein spent the last decades of his life in New Jersey, I thought the idea was strange. It was hard to picture him walking around with other Jersey types—Tony Soprano came to mind, though he didn't exist yet. Did Einstein go with someone like Tony to construction sites? Or was he on the Atlantic City boardwalk, counting the change in his pocket, hoping he could scrape up enough cash to make it big at the casino? At some point my parents and I were driving up from Philadelphia so they could play a concert somewhere in the northeast. We took I-95, which went near Princeton, New Jersey, and when I saw the sign, I remembered reading that when Albert Einstein walked around Princeton, he would scan the ground for cigarette butts. When he saw one, he would pick it up and empty the remaining tobacco into his pipe. It wasn't that he was cheap. Maybe he was, but that wasn't why he did it. His doctor had forbidden him from smoking, and he was being defiant. He was being resourceful, but also he was telling the world that he didn't want them to put walls around him. If he wanted to do something, then he was going to do it. Try to stop him.

Einstein's cigarette butts remind me of another component of creativity, which is that you have to pay attention. You have to watch

Creativity is the personality that makes it possible that something new and somehow valuable can be formed.

the ground. I may be more guilty of this than other creatives, partly because I wonder whether I am really creative in the first place. Maybe I'm just a great student, scouring the sidewalk for pieces of things other people made so I can pick them up and stuff them in my pipe. I can't say for certain. But I have always paid especially close attention to the ins and outs of creative projects, especially musical ones. When I was a kid and I heard songs, I heard strange things inside them. I heard the obvious things, too, of course. Take a song like "Somebody's Watching Me," which was released by Rockwell in the early 1980s. Rockwell wasn't his real name. He took that name because he rocked well. His real name was Kennedy William Gordy, and he had an impressive pedigree. He was the son of Berry Gordy, the founder of Motown, and he was named for two of his father's inspirations—John F. Kennedy, who was assassinated six months before Rockwell was born, and William "Smokey" Robinson, who was designing hit after hit for his father's label throughout the 1960s. In the early eighties, Rockwell, thanks to the magic of nepotism, put together a sizable hit with "Somebody's Watching Me," which was a spooky song about paranoia and horror. The video was especially memorable. Rockwell saw terrors around every corner, then had to convince himself he was imagining them. At the end the mailman came. He seemed like a nice guy. But as he walked away the camera showed that he had a deformed hand, which suggested that maybe Rockwell hadn't been imagining anything. That was the hook in the video—the reveal. The hook in the song was the chorus, with soaring backup vocals by Michael Jackson. I heard that. How could you not?

But I heard something else more: a keyboard wobble that I was sure was the seed of the song.

Pay attention to seeds. We're back to botanical metaphors here. Big ideas grow from those little things. Writers tend to be people who are sensitive to words. Artists are sensitive to color and line. If you want to encourage your own creativity, try to pay attention to the creative acts of others. More than that: try to pay attention to the ways in which the things that you didn't think of as creative acts are actually perfect examples of creativity. This takes me back to Einstein, and the way that his smoking illustrates certain creative principles, but it also takes me to Tokyo. In 2016, I published a book called *something-tofoodabout*, where I spoke to ten chefs about their creative lives. The genesis for the book lay not in food, but in film, though it was a film about food. The film was *Jiro Dreams of Sushi*, the great documentary about the sushi chef Jiro Ono. At the time of the movie, in 2012, he was in his mid-eighties, and he was generally considered to be the world's greatest sushi chef. I was amazed by him. He had such focus and such dedication to what he was doing, which was . . . making sushi. I had seen that expression on people's faces before, but it was usually while they were making a record or a painting, or while they were onstage. Was it possible that the thing that he was doing with fish and rice was a related process, or maybe even the same thing? I watched the film over and over again. Then, for my birthday in 2013, I went to Japan. I had some DJ gigs, but the main point of the trip was to go see Jiro. I went into the Chuo ward, into the Ginza district, onto 4-chome street, and finally arrived at the Tsukamoto Sogyo Building. It's just an office building in downtown Tokyo. There's a neon sign. You wouldn't think twice about it. But then down through the subway system, off to the side, there's Jiro's place.

While I was eating, I was thinking about the meal as a creative act, and it's a good thing I was, because that's what allowed me to see what Jiro was doing. He wasn't only preparing pieces of sushi; he was planning the meal. Each course might have its own distinctive taste

and texture and color and smell, but he was also composing. It was like a classical concerto—or, maybe more accurately, like a DJ set. He knew that he had us, his diners, for a limited amount of time, and he wanted to lead us through an experience that activated a series of thoughts and emotions. There were a few pieces that brought you up, and then a few that flattened you out, and then a few that took you down, and then, before you knew it, you were lifted back up. I hadn't until that moment understood how a chef could be a creative artist. I mean, if we were talking at a party and you asked me if chefs were creative artists, I would have nodded and said that of course they were. Yeah, yeah: creative artist. But I wouldn't really have understood it the way I did when I was sitting at Sukiyabashi Jiro.

Weird Science

Near the beginning of the process of writing this book, I found an article online. It was called "Why Weird People Are Often More Creative." The article suggested that most people function by filtering out the majority of information in their field. But a certain group of them cannot or do not. They permit themselves a wider range of ideas, even ones that might not apply to the situation at hand. The Harvard psychologist Shelley Carson calls this weirdness "cognitive disinhibition," and thinks that it's at the heart of all creativity. If we're always discarding our thoughts to fit in with what's acceptable, or correct, or accurate, we're not going to have ideas that leap away from the ideas that are already there.

That's the first point. Encourage your own cognitive disinhibition. You don't have to wear a meat dress, but try to always be inspired by something surprising—or to surprise yourself by always being inspired. There are endless examples. Each of them is an act of creation. I remember being at a friend's house and sitting outside at night. Birds and crickets were chirping. I don't know very much about

birds and crickets. But I wanted in on the discussion. I imagined that they were talking to each other in the lyrics of songs that I knew. One of them was singing "Changes," the David Bowie song, because it had a little *ch-ch* to it. Another one was making z's, and I told myself that it was "Rump Shaker," because of the "zoom zoom zoom in the boom boom." After a while I started noticing something else, not the alphabetical aspect of the sounds, but the fact that they came in clusters. One of the animals (a bird?) was doing triads, and the other one (a cricket?) was doing pairs. That meant something more to me: 3-2-3-2. I got a little rhythm going from there. Da-da-da, da-da. It was "Louie Louie" by the Kingsmen, which meant also that it was another David Bowie song, "Blue Jean." I remembered being disappointed that it was Bowie's follow-up to "Let's Dance." Was that all there was? (Side note: toward the end of that song, as he keeps singing "Somebody send me," Bowie got more and more intense, to the point where I started to worry that he was going to throw up.) That made me think of the Jackson 5's version of "Mama I Gotta Brand New Thing (Don't Say No)," and how Dennis Coffey's guitar sounded like someone was saying "pick it up," and then I realized that I was thinking about that because I had dropped a paper cup. I picked it up. (That song is also an example, by the way, of Motown's consistent abuse of the abrupt creepy synthesizer ending.) None of this is especially consequential except to suggest that there are patterns and links everywhere, and if you are trying to remain in a creative frame of mind, you should let your brain find its way to them.

I'm going to attempt another definition of creativity. It's not about letting everything in, but it is about refusing to keep things out. There will be many definitions. Jot them down. There's a test at the end. (Don't worry, there's not really a test. I reserve that kind of thing for my students at NYU. You bought the book. You're reading the book. You're responsible for what you remember and what you don't.) You know those 3-D art posters that look like nothing but when you stare at them they become something? The hidden 3-D

Creativity is not about letting everything in—it's about refusing to keep things out.

image effect only works when you unfocus your eyes the right way. That's a metaphor for the process. Being creative is a mix of unfocusing your eyes in the right way, while still remaining focused on the picture.

And it's more than a metaphor. It's a physical state. Think of all the things you do in the course of a day. For most tasks, the best-case scenario is that your mind is bright, sharp, and alert. Figure out whether you're a morning person (like me) or a night person (sadly, also like me), and schedule your tasks for that time. If you need to get up at five in the morning so you can answer all your correspondence without a foggy brain, that's what you should do. If you need to stay late in the office so you can transcribe your notes from the meeting, that's what you should do.

But when you're creating, the equation is a little different. I remember reading a great article in *The Atlantic* a few years ago. It was great because it was so unexpected, and yet confirmed something I have long suspected, which is that creating requires a different kind of mind than most other tasks. The article quoted a study by a psychology professor named Mareike Wieth, who teaches at Albion College in Michigan. She designed an experiment for more than four hundred students, giving them examinations at both 8:30 A.M. and 4 P.M. She also gave them a survey so that she could determine if they were morning people or afternoon people. Then she set about figuring out whether the alertness of the students affected their performance on the exam. Some of the questions on the exam were analytical—word problems, like trying to figure out if a train leaves

Georgia at midnight, how many Pips are on it? In those cases, the time of day and the levels of wakefulness of the subjects didn't have any effect on their performance. Analysis was consistent whether the brains were tired or alert. That was a little surprising, in the sense that it suggested that the students didn't have to be super alert to do well at their math problems. So much for parents nagging their kids to get to bed on time. The more interesting results came from the other questions, which were a different kind: they asked the students to participate in innovative problem-solving. The article called them "insight-based." To figure them out, students needed to put themselves in someone else's place, or shift around inside some wordplay, or design and then untangle a puzzle. In those cases, the time of day and the level of alertness of the students affected their performance—but not in the way you might think. They didn't do better on the insight-based problems when they were more alert. They did better when they were less alert. That's right: creative problem-solving improved by around 20 percent as a result of fatigue. The professor who ran the study said that tiredness allows random thoughts in. (A similar study found that light levels of drinking achieve the same result.)

Wait a moment for that to sink in. People were more creative when they were less alert. People were less creative when they were more alert. The traditional sense of alertness is the enemy of what we think of as creativity. Remember—cognitive disinhibition. To truly get in touch with your creative side and the ideas it generates, you have to look through the organized and focused thoughts and find out what's behind them. There might be nothing back there, or there might be something brilliant.

It Is What It Isn't

In the fall of 2016, just as I started working on this book, I participated in a keynote conversation with Malcolm Gladwell at a confer-

ence in New York City. It wasn't a long conversation, and we didn't have much time to talk onstage, but before the event, in the greenroom, I asked him one of my favorite questions. "Do you ever run out of ideas?" I said. He looked stunned for a moment. "What do you mean?" he said. "You know," I said. "For books." His answer was thoughtful. He talked about how some of his ideas don't rise to the level of a book, and he has to rethink them later on, and how some of his ideas turn out to be parts of later, larger ideas. I heard it. But mostly I heard this:

No. No, I do not run out of ideas. There are secondary processes that matter much more, like refining an idea, perfecting execution, connecting an idea with the right audience, accepting critical assessment of it. But run out? No chance of that.

That conversation with Malcolm also reminded me of the stress points in any creative system. Again: creative people are always having ideas. That's not the trick. The trick is learning how to capture them without being captured by them, how to display them without exposing too much of yourself, how to move forward while remaining unafraid to also move sideways or backwards. Many books about creativity talk mainly about the journey. That's fine. I like the idea of a journey, and I don't even mind Journey that much—"Who's Crying Now" is pretty undeniable. But I also work and have worked in the commercial arts, and that means that the journey has an eventual destination in the market.

This book is, in that sense, different from other books about creativity. I am assuming that what you do will end up somewhere, in front of the eyes or ears of others. It doesn't have to be a traditional record store. But it has to end up somewhere. Other books I have looked at say that the creative artist should start with no expectations, that he or she should practice automatic writing or let the mind drift into any corner of any idea. That may work well for a little while, but I'm against the broader implications of that theory. It's not disciplined or directed enough. Everyone needs goals. This book, I hope,

Don't imagine what you will become—imagine what you won't become.

will help people to sketch out some of those goals in ways that are productive and affirming.

One of the most important strategies is negative affirmation. My late manager Rich used to talk about Maimonides's concept of "negative theology," where you know God only by what you can say that God is not. At the time it went over my head, but now that I'm older it makes a little more sense (plus, since he passed away I've gone back through all of his e-mails looking for moments of wisdom I might have missed). Give ideas that same respect. Carve out the negative space around your idea. If you know you are about to paint a portrait, make a list of all the things you don't want it to be: overly realistic, say, or brightly colored. It's sometimes hard to see the heart of an idea, so chip away at all the things that aren't the heart. This also helps to focus your overall artistic goals. Back in 2013, I did a joint interview with David Byrne at NYU's Skirball Center, and we talked about all different levels of creation. In our conversation, he echoed this idea: Don't imagine what you will become—imagine what you won't become. It helps to reinforce which parts of your creative identity you can't live without, and which might be there only because you've been told by someone else that they should be there. Imagining what you won't become is a necessary refining process.

It's also something I think about all the time these days. One of the things that concerns me is the way my own creative work has proliferated. Not only do I colead the Roots (along with Tariq Trotter) and work on *The Tonight Show*, but I'm producing records, teaching college classes, DJing, writing books, and designing objects, and I

have my own radio show and station on Pandora. I don't say this to brag or even to #humblebrag. Far from it: I say it because I'm a little worried that all these responsibilities are working against the refinement that David Byrne was recommending. There are times now when I think I don't really have a creative goal, other than the goal of continuing to do all these projects. Even though I have sixteen different jobs, it can sometimes feel like I don't have any job at all. When I remember David Byrne's advice, that puts me back in mind of defining myself, if only for a second. What's interesting about that process, when I engage in it, is how humbling it can be, because it separates work (jobs, responsibilities, obligations) from artistic identity (who I really am when I strip everything down to its essence). And the truth is that the things I do, the things I really am as an artist, are relatively specific things—things that, by the way, don't fit into the overall matrix of contemporary popular art. No one is ever going to give out an award for Breakbeat Drummer of the Year, or Best Feng Shui Melodic Rhythm DJ Who Bases Much of What He Does on Soul Music and Hip-Hop but Also Incorporates Any Other Genre That Springs to Mind. The reason I know I possess a pretty specific, arcane skill is because I so rarely feel that it's fully understood. The other day, I was at a party, first as a DJ, then as a guest, and toward the end of the night I ran into a music producer I know and respect. He came up to me and started talking about my DJ set, and how amazed he was at the way I let songs speak to each other and the way I built the whole thing as a work of architecture. I was amazed in return, because it reminded me of how rarely I hear a full account of what I do from someone who is both paying attention and who knows enough to reflect it back to me. That moment was very validating, and it helped me to get right back into that David Byrne question: What are you as an artist, and what aren't you? When I was talking to that music producer, when I was protected by a sympathetic audience of one, I could admit to myself that I wasn't exactly a pop songwriter, or an instrumental virtuoso, or a legendary TV star, or a brilliant professor. And once I cleared

all of that out, the essence of what I was doing—breakbeat drumming, feng shui melodic DJing—became something I could wear proudly, rather than something I felt apologetic about. Deciding what you're not before you decide what you are lets you stand strong in your own category.

Making Things In the World and Remaking the World

When you make things, no matter what they are, no matter how generally you feel the impulse or how specifically you understand it, it immediately moves you into a different part of the human experience. It's not necessarily better or worse—though I think it's better in some way, obviously—but it's different. Your brain and your soul are different after you've made something. So where does it leave you? What does it give you? At a fundamental level, what does it put into your bloodstream and your brainstream?

Laurie Anderson came to one of my food salons. It was a huge honor to have her there. At the time, she had just released *Heart of a Dog*, a mostly spoken-word album about death—the death of her dog Lolabelle, but also the deaths of her mother, Mary Louise, and of her longtime companion, Lou Reed. The album was strange and moving and sharp and all the things that people have come to expect from her. I was a little intimidated to talk to her, partly because of that, and partly because of "O Superman." There aren't many new wave or art-rock songs that are more influential in the hip-hop community. She got so much done with a spookily repetitive rhythm and a single voice. *The Heart of a Dog* album was the soundtrack to a film of the same name that had been commissioned by the French-German TV station Arte. She had worked with them before. The network had, since 2002, run a feature called *Why Are You Creative?*, in which the German director Hermann Vaske asked hundreds of artists, musicians, actors,

Being creative is the proof that we can leave an imprint on our surroundings, that we can make a mark on time.

and more about their creativity. It's a great resource, and one that I'll return to over the course of this book. I like Laurie's segment, which was broadcast in 2002 but probably filmed five years or so earlier. It starts with the usual Vaske question: Why are you creative?

Laurie takes a beat. "As opposed to, like, lying on the beach and just swimming and things? It can be creative. I like to pretend that I'm being creative when I'm lying on the beach.

"Why? It makes me laugh. It makes me feel like I can change things. It means something different almost every day because I'm what you'd call a multimedia artist. Some days I'm working on music. Some days I'm working on animatronics or just fixing computers. That's one of the big new jobs that I've gotten as an artist. In terms of what it actually means, I don't really know. The most exciting art I see is things that redefine it, and you kind of go, 'Is that art? I'm not sure.' I like it when it's just not so clear if it's art or politics or something else. I probably trust laughter more than anything that goes through my mind. If I really am laughing, I am thinking there's something here that is physical as well as mental."

And then she laughs, proving the point.

The thing that lingered, at least for me, was the other part of her answer. She makes things because it makes her feel like she can change things. It's a world where we grapple all the time with our insignificance, where things happen around us and to us. Being creative, in whatever form, is the proof that we can leave an imprint on our surroundings, that we can make a mark on time. Even her expansion of the definition of art into politics "or something else" stays

faithful to this idea of creativity. When we make something, we make something different.

Laurie's definition is one of the best and broadest that I've seen. Her answer sparked a series of thoughts in me, and one of the first was about the question of audience. It got me thinking about who I am talking to throughout this book. Who exactly do I mean when I say that I am addressing creatives? Is that the same as saying that I'm addressing artists? If so, what kind of artists are included? What kinds are excluded? If it's not the same, what are the differences between creatives and artists? Is it a question of talent? Is it a question of motive? Is it a question of which rewards are delivered, and how quickly, and how consistently?

Let's answer the question by starting with an indisputable. Some people have talent, no matter how you slice it. Take someone like Tariq Trotter, my partner in the Roots. Tariq is an artist, through and through. When we met, he was a fellow student at the Philadelphia High School for the Creative and Performing Arts (CAPA). He came in as a visual artist, with a huge amount of talent at drawing, and his talent expanded into writing and then rapping. Someone like Tariq is a source of intimidation. I don't mean that he himself is intimidating. I mean that when people start down the road to their own creative satisfaction, people like Tariq distort the field. They generate unrealistic expectations. And even Tariq—an artist in every way—doesn't fit the most exclusive definition of what some people would call an artist.

I want to reverse this whole movement of separating artists from each other, of saying that one man or woman is more or less of an artist than another one. For that matter, I want to broaden the definition to include anyone who is making something out of nothing by virtue of their own ideas. I include the dad who likes doing craft projects in the garage. I include the mom who sings on weekends and has started after twenty years to write songs again. I include armchair poets and sideways thinkers. I include the world, not because

every creative project is equal in conception or in execution, but because every creative project matters to someone. Time will sort out the difference between whales whittled out of balsa wood and *Moby-Dick* and Wale. I'll just say that while there is a difference, it may not be as great as some people believe.

The other reason for this definition is that it is a kind of activism. The people who already exist as artists know something about their own creativity. This isn't to say that they don't struggle with it. There are chapters later where I address in detail how even the most experienced artists can hit the skids, get blocked up, become overwhelmed by criticism, self-sabotage, give in to temptations of praise. Those things never go away. But I also want to reach people who are maybe not as sure about their own status as creative. Why? Because more creative work is one way to save the world. Is that a grand claim? I hope so. Studies have shown that creative people tend to be more sensitive to the feelings of others and to fluctuations in the social fabric around them. At the same time, they are often less equipped to deal with those things. The result can be withdrawal from the world. Defense mechanisms, depression. Creative production is not only a way to avoid those pitfalls, but a way to connect those people to the rest of the world. Creativity creates connectedness. Again, I'm defining it more broadly than most books about creative work do. If you're a teacher in an inner-city school who is working hard to get kids involved in an antiviolence program, and as part of that you're designing an ad campaign that needs slogans and a song, you're being every bit as creative as the guy who's writing a new jingle for a restaurant chain, who in turn is being every bit as creative as the commercial soul singer who is writing a new love song. The arrows are aimed differently, but they're coming from the same bow.

Don't get lost low down on the ladder trying to figure out who is creative and who is not, or why one kind of creativity is superior to another one. Start climbing. This is a guide to altitude adjustment. This is a guide to higher rungs.

Protesting Too Much

"But Quest," you might say. "I'm not creative. It's just not in me. When we would do free drawing in elementary school, I wouldn't know what to do. When we would be asked to tell a story, I would just blank out. I don't have ideas. I just see the world like it is. And part of seeing the world like it is is admitting to myself that I'm not the kind of person you're talking about. I wish I could be creative, but I'm not."

My answer would be simple. You protest too much. You know where that's from, right? It's from Shakespeare, from *Hamlet*. Hamlet's mom, Gertrude, is watching a play that Hamlet has staged that parallels something that happened in real life, where Hamlet's uncle Claudius murdered Hamlet's father so that he could marry Hamlet's mother. Not cool. Anyway, at one point Hamlet has some traveling actors put on a play in front of Claudius that has more or less the same plot. He's trying to get inside Claudius's head and see if he can make him confess, or at least feel guilty. That's the story behind one of Shakespeare's most famous lines: "The play's the thing / Wherein I'll catch the conscience of the King" (internal rhyme and alliteration—nice bars, Shakespeare). But the play affects Hamlet's mom first. While Gertrude is watching, she thinks the character in the play who is meant to represent her is making too big a deal of the fact that she's not involved in the murder plot at all. She "doth protest too much." When people talked about this part of the play, I always thought that Gertrude thought the lady in the play was protesting because she had repressed her guilt. But it's only partly that. She's actually putting the idea of her guilt into people's minds by protesting. Before she starts talking about it, they may not have even thought about her as a murderess.

That's how I feel when people deny their own creativity. The more they insist that they never have ideas, the more I think that maybe they do, even if up until that very minute I hadn't thought they were especially creative. That's why I want to help those people

39

tap into their ideas, even if they're not sure they really have any. I want them to get on their way, and to get out of their own way.

One of the things I have thought is that maybe the idea of creativity is greater than actual creativity. I didn't used to think this. My whole life, I created romantic theories about how things were created. For years, I was blown away by Pete Rock's remix of Public Enemy's "Shut 'Em Down." It was one of my North Stars. When I heard it, I had all these visions. It took me to a totally euphoric place. I had Pete Rock on my radio show, and I asked him about it. I wanted to know what his creative process was like, and more than that I wanted the deeper meaning. I wanted an epiphany. I didn't get that. "Oh, that," he said. "I forgot I had the session that day, overslept, grabbed the first five records on the top of the pile, threw something together, and crossed my fingers. They fell for it." It was nothing to him. Or rather, it was something, but something extremely mundane: he just didn't want them to go on to the next guy. That answer set me back a step, because it was so shockingly simple. But I think it actually proves what I was saying above. Creative things happen to creative people, especially when they let themselves go to the Zen of the moment, when they don't allow themselves to be paralyzed either by overthinking or by laziness. They have to be in the sweet spot between the two. If I was telling the story, it could never be that matter-of-fact. I would make a narrative, because creativity is narrative. But many stories I've heard from people on the show follow the same template as Pete Rock's "Shut 'Em Down" remix: they woke up, they became aware of a creative responsibility, they executed that responsibility, and they killed it.

Take a Pause

Hearing that D'Angelo was late may have saved my life. Strange to say, but true. Let me explain.

This book is a personal guide to the creative process, but it's also a practical guide, to the degree that creating things can never be practical. In that spirit, I sat down at the beginning of writing it and wrote myself a task. It said: "Figure out one unique strategy to recommend to people to protect and preserve their creativity."

I knew right away what it would be, roughly. It's a strategy that recognizes the world we're in. It's a busy world. There's lots of noise all around, and as a creative person, you're being asked to find the signal. But to truly find it, you need some sort of internal check or monitor. You need moments of silence where you can hear yourself. You need stretches where you can stretch.

If this sounds like I'm recommending meditation, I am. But it's more specific than that. There are many books that recommend meditations for mental health, and the recommended meditations come in all shapes and sizes. Some people say to go deep, to take an hour a day to really delve inside your own consciousness and feel the reticulations of the spirit. I didn't make that up myself. I copied it down from a flyer I found on the ground in Portland once: "the reticulations of the spirit." Other people say to take five minutes, but to take it at the moment just before you go to bed, because that allows you to steer your sleep into lucid dreams, and those dreams will turn into visions that will give you a route to realizing your ambitions. Some of these recommendations are focused on general mental health, others on physical health, others still on spirituality. These days, I am at the point in my normal life where I am older and calmer. I've gotten better control of my schedule, even as my schedule has gotten more hectic. As a result, I don't let a day go by when I don't meditate for thirty minutes.

Over the years, I have encountered many of these plans and tried more than a few. Some have worked wonderfully. Some have left me cold. I'm not here to comment on other people's practices. But over the last few years, I've been trying to look into types of meditation that work especially well for creativity. Creativity needs a

specific kind of energy. Internal peace can be its friend, but it can also be its enemy. So how do you dip down into yourself in a way that brings you closer to solutions while still keeping you engaged in the task at hand?

What I've arrived at, after years of trial and error, is the idea of the micro-meditation. These are brief and intense phases of departure from the self. They bring you out of the moment—whether it's a heated argument or a professional crisis or even just the morning doldrums before your mind is moving—into a different kind of moment, just for a moment, and then they return you to the exact same place you were before. Micro-meditations should last a minute at most, and sometimes they aren't even that long. Sometimes they are thirty seconds, sometimes fifteen. They're longer than a blink, but shorter than sleep. Maybe they're like a slow wink. They aren't long enough to relax you entirely. They don't require any special apparatus or condition. In some way, if they're done correctly, they won't seem like meditation at all, but rather a stepping back and a surveying. They work—at least for me—because they engage both parts of my brain, the part that's right in the moment, pushing against a task, and the part that's considering the moment from afar. They're a ground survey and an aerial view. When this split perspective is perfected, over time, it gives you the tools you need to bring your own best ideas to the surface, to assess them, to discard the ones that aren't working, to commit to the ones that might work.

This might seem a little abstract, but no example springs to mind. Hold on: I just did a micro-meditation, and an example sprung to mind. See: it works! Anyway, it happened at our first Roots Picnic in New York in 2016. We had a great lineup in Bryant Park that included John Mayer, D'Angelo, Rahzel, and lots of other artists. John Mayer was onstage with us, and he was heating up the place. He was on his very last solo, and in those last minutes Keith McPhee, the Roots' production manager, came running toward me. Keith, like many people I work with, thrives on panic (and not just panic—

Deciding what you're not before you decide what you are lets you stand strong in your own category.

PANIC!!!!!!). In fact, that's one of the conditions for certain positions in our operation: the panic guy. I am not natively like that. I leave stones unturned. I need a staff that can function like clockwork around me. That's another issue that I'll be talking about throughout this book. In the back of my mind, and sometimes in the front of it, there's an idea that certain kinds of anal-retentive behavior, while incredibly useful in the real world, are the enemy of creativity. They prevent the mind from reaching its best ideas in the best way. While I subscribe to that idea, I also know that it's probably time for my subscription to end. But now is not the time for that. I have a story to get through, and there's most of a book remaining.

At any rate, John Mayer was playing and singing and making guitar face, and all of a sudden I saw Keith rushing toward me. "Yo!" he said. "It's Mayer's last song, and D's not here!!!! Whatcha gonna do?!?" D'Angelo was scheduled to go on next. John Mayer was about to take the solo in his song, which meant that we had about three minutes to go. Keith's news landed on me so hard that I had a minor out-of-body experience. I felt something shift within me. At some level, I think it hit me in the heart, not emotionally but actually. I felt a palpitation. All Keith's panic transferred directly into me like a shock. (Here, I will talk in sitcom terms. It was like the *Scrubs*-style push-in-and-whoosh whenever Zach Braff was surprised by something. In this case, I was Zach Braff to Keith's John C. McGinley. The situation was exactly that.) All of a sudden I became aware that there were two fights now going on—the fight to figure out the crisis and the fight to live. I know this sounds a little melodramatic, but I'm just

You have to be both entirely consumed by the moment and also a million miles away.

reporting how I felt at that moment. A hammer was on me. What happened next was something that, now that I have had time to think about it, happens all the time, or rather has happened across the years, though I have never really codified it or given it a name. When Keith was there in front of me, his mouth open, his eyes open, the bad news hanging in the air between us, everything just stopped and I gave myself permission to close my eyes. They might have been closed for ten seconds. While I was in there I started deep-breathing the hardest I knew how. I imagined that I had a yogi in there with me, telling me to inhale until I felt the tip of my pinky toe. I knew that D'Angelo would be about twenty minutes late—this wasn't a mystical realization so much as remembering all the other times he had been twenty minutes late—and that we'd need a few more minutes to switch over, which meant that I was trying to fill a thirty-three-minute window. I saw a map in there of all the Roots songs that we hadn't played yet. Four of them illuminated, in a kind of miniset. That accounted for about twenty minutes. Next to those illuminated song titles were faces I recognized: Common's face, Dave Chappelle's face. Both of them were at the Picnic. Each of them could give me five minutes of material, or a stall. Even if they weren't thrilled, they'd do it. They'd have to do it.

I surfaced from my micro-meditation. Maybe ten seconds had passed, maybe fifteen. Kirk Douglas, our guitarist, was standing a few feet away from me. He must have walked up while I was thinking. "You okay?" I think he had seen me with my eyes closed, breathing hard, and worried (correctly) about my health. I snapped out of it.

I told him someone needed to do a miniset. Common, who agreed readily; Chappelle, who wasn't sure at first but came around quickly enough. After a bit, D'Angelo arrived, and the crowd cheered, and the problem was solved. Or rather: the problem had been solved inside the micro-meditation.

That was a deep moment for me. I was proud that I had solved the problem, but it was more of an epiphany than that. In the wake of the event, I felt like I was rising out of a rut that I had been in for months, maybe even years. I remembered a moment after *Things Fall Apart*, around the time of *The Tipping Point*, when the Roots encountered the first bad review of our career, when some parts of the job started to seem more like drudgery than excitement. At that point, there was a bit of darkness amassing, and it grew and spread over the years. There were many victories in that time, but also many failures. In lots of ways, it was a normal distribution of feelings about a creative career. But I also think that I slowly lost the ability to master my own mind. That's where these micro-meditations come in.

Again, it's hard to pinpoint an epiphany, and it always seems artificial from the outside. I knew that I was beginning work on a book about creativity. I knew that I would have to start thinking in an organized way about which habits contributed to creative production and which habits detracted from it. Even so, that moment at the Picnic was a major one, and the more I thought about it, the more it came into focus. It gave me a nearly perfect example of something that I knew I wanted to pass on to others, which is the importance of being both present and absent, of being both there and not-there. This is the mental strategy, the Jedi mind trick, the Zen exercise. You have to be both entirely consumed by the moment and also a million miles away.

Micro-meditations take many forms and pop up in many different situations. But they are a skeleton key for everything creative that you might need. If you're a writer, and you're in a coffee shop, typing away while you listen to Miles Davis's *Big Fun*, and you find that the

right words aren't there, just let yourself disappear for ten seconds inside "Ife." You won't know you're gone, but you'll also go around the world, and somewhere on that trip you'll find the words you need.

The final analogy for micro-meditations comes from the gym. When people say they're getting ripped, they're not using a slang term, but a technical one. The muscle fibers actually get torn and damaged, and when they repair themselves, that's when you get muscle. In a way, that's how I think of those micro-meditations. They're not necessarily peaceful things. Or rather: they put you in a place of inner-ness, but they can be intense, sometimes violent departures from the task at hand. The little tiny stress point repairs itself, and you have creative muscle.

↓

The Micro-Meditation
Spend a few seconds stepping back from what you're doing and let your mind settle.

Mentors
and
(Apprentices)

Voices of Authority

How does the human mind understand creativity? Let's back up a step: How do we come to first understand creativity? When we're getting started in a creative field, how do we evolve from an empty vessel to a mature creative producer filled both with ideas and with strategies for bringing those ideas to the world?

If you had asked me when I was young, I probably would have said that we learn these things from other people. I grew up in a household that was by any standard unconventional. My father, Lee Andrews, had been a doo-wop singer in the Philly area in the fifties. He and his group, the Hearts, had a series of hits, including "Teardrops" and "Long Lonely Nights." By the time I came around, my father's career had come and gone, the way that the entire doo-wop world did, and it came around again in the form of oldies tours and creative reinvention. He and my mother toured as a kind of nostalgic version of Lee Andrews and the Hearts, and my sister Donn and I toured with them. From a young age, I learned to navigate on the road (I wasn't driving, but I was the GPS: "Ahmir, is it faster if we turn left? Ahmir, it looks like this bridge is under construction. Ahmir, grab a pen and copy down what the gas station guy is saying." The gas station guy was an unsure source of directions, kind of like the Scarecrow in the *Wizard of Oz*). I learned to set up microphones and lights in the club (on a well-lit stage, green doesn't look great on black people). The whole time, I was also being trained as a drummer. I practiced endlessly at my parents' encouraging, and sometimes "encouraging" is a weak word to describe what went on. (I'm not complaining here, just saying that showbiz kids get a specific kind of education, and it's not about lots of fun free time.) When I was thirteen, my father's regular drummer got injured, and my parents were playing at Radio City Music Hall, and I sat in.

That was my training, and it was intense. Also, it wasn't necessarily about creativity. I was learning a trade: the family business.

Most of my education as an artist came a little later, and as a result of one specific mentor. Let's take a step back and look at the word "mentor." (I hope you're not actually backing up when I say to back up. That could be dangerous. If you are, please sign the thing at the front of this book that protects me from any litigation that results from injuries incurred during your backing up when I say so.) The word comes from a man named Mentor. He is a character in Homer's *Odyssey*; he was the older man entrusted with looking after Odysseus's son when Odysseus was away, fighting wars and one-eyed monsters. So from the very beginning of the word, a mentor was a man who helped a younger man, specifically when the younger man's father was away.

That's interesting to me, because while my father was one of the most important teachers in my life, the source of so much of my inspiration and motivation, I also had a mentor, Richard Nichols, who managed the Roots from the very beginning—from before the beginning, in fact, when we were just the Square Roots—until his death from leukemia in 2014. Rich was an important mentor early on: when we met him, I was in high school, as was Tariq, and we were starting to put together the band that would become the Square Roots and then the Roots. First we were Radio Activity. Then we were Black to the Future. Neither of those took. The Square Roots took for a while, until we learned that there was another group with that same name, and we had to shorten it up to the Roots, which turned out to be more of a statement in the long run. It got under the skin of our fans, which is what roots do. At that time, Rich was a guy who used to come around to see shows. He had been the host of a jazz radio show on the Temple University radio station, and he knew a guy named Joe "A. J. Shine" Simmons who was also on the scene. Joe saw us out somewhere and he told Rich that we had something. Rich came to see us at a place called the Chestnut Cabaret. I don't think he was that impressed with us that first night. We didn't have our regular bass player, and the material we performed was a little limited in its scope

for his taste. But we went backstage and talked to him, explained how that night fit into our overall idea of the band we wanted to be, and I guess he worked it out with Joe, and he decided to buy us some studio time. We went out to a studio in Bensalem, in the suburbs, and recorded "Anti-Circle" and "Pass the Popcorn." And something clicked. A mutual relationship of creative reinforcement sprang up. I have said it before and I will say it again. If I end up saying it in the exact same way, time after time, so be it, because some truths do not need variation: Rich was a creative lodestar for the band. We watched him to learn how to do it: how to have conviction and still experiment, how to use available materials and still introduce new ingredients, how to move with surprising speed from theoretical conception to actual execution.

Growing up as an artist in Rich's presence, learning to see things by the light that he produced, was a great education. One of the most important elements of his creativity was its relentlessness. He spoke about his creative process in strange ways. He talked about grifting, said that he was a kind of grifter, a con man of ideas. What he meant was that you had to always be on the make, creatively speaking. You had to take shortcuts where shortcuts presented themselves so that you could put in the hard work when that was necessary. It's possible, of course, that this is not exactly what he meant. He also liked sometimes to talk in riddles. He had that kind of Zen master ability, like he was training ninjas, and in a way he was—ninjas of the mind. He once said something to me about how you always have to be in the position of both knowing everything and knowing nothing. I know exactly what he meant, and I don't know what he meant at all.

The Ladder

Rich is always with me. Every important early mentor is. But opening a chapter in a book about creativity by talking about mentors is a bit

misleading—or at least relies on a bit of misdirection. What's import-
ant about that time with Rich, from the perspective of a creative edu-
cation, wasn't that lessons were taught. It was that lessons were
heard. Put another way: What's important in a mentorship relation-
ship is the other side, the apprenticeship. You could say that this is a
tautology, that anyone who has a mentor is by definition an appren-
tice. But what I mean is that the artist at the beginning of his or her
artistic career, in the first flowering of his or her creativity, can't worry
about the mentorship aspect. You have to think about the side you're
on. Much later, with hindsight and perspective, you can see around to
the other side and wonder about the approach of a mentor, the suc-
cesses and failures. That's how I think about Rich now, after more
than two decades of processing time. But art in progress is about
sticking stubbornly to your side of the equation, stubbornly and even
a little selfishly. Think about how you are treated as an apprentice.
Think about how you listen to others, what you're told and when
you're told it, and how you feel it strengthening your muscles and
broadening the bones of your face (creatively speaking): those are
the things that matter. Apprenticeship is what gets you from point
zero to point whatever. And even a creative person who wants to
move forward in a creative life without becoming a full-fledged cre-
ative professional has to reckon with these questions. Everyone has
to come up from something.

I discussed these questions at length in an earlier book of mine.
But it's not the book you'd think. The stories about Rich and my par-
ents are mostly in my first book, *Mo' Meta Blues*, because it is a mem-
oir. The whole Questlove life is in there, including many moments
where I reflect on how certain experiences fed my creative needs. But
the book I want to talk about is my most recent book, *somethingto-
foodabout*. In it, I dove into the world of food and chefs. I've devel-
oped relationships with many chefs over the course of the last few
years. I had a restaurant in Chelsea for a little while, and then after
that I started hosting food salons where I ask three chefs to design

dishes, sometimes around a broad theme (memory, community). From the seed of those salons, I grew this food book where I collected extended conversations with ten of the country's most innovative chefs, from Daniel Humm to Ludo Lefebvre to Dominique Crenn. I learned many things from making that book, but I only want to talk about one of them here: apprenticeship. The chefs I spoke to trained along a spectrum. Some of them went to culinary school, where they learned to cook in a classroom environment, surrounded by others who were undergoing the same training. Others were self-taught and came up either in traditional food metropolises like New York or Paris or unexpected places (Denver, Austin). Depending on their background, they had different ideas about apprenticeship. Some of them believed in a long apprenticeship. Young chefs, they warned, shouldn't be too eager to step out from behind their mentors, especially before they were able to develop their own voices and mature sets of ideas. Others believed in a short apprenticeship. What mattered to them was inspiration, and it could hit at twenty-five just as easily as forty-five.

In my life and in my art, I tend to side with the former camp. I had to practice drumming for years before I felt like I had any right to step forward as a drummer. But the answer isn't a simple one. As will become clear, my strong belief in a long apprenticeship took its toll on my ability to think of myself as an independent artist. People I know who jumped sooner off the apprenticeship track sometimes retained more confidence in their own ideas. They weren't always looking over their shoulder and weren't always aware that they were standing on the shoulders of giants.

In talking to the chefs specifically, I noticed a second major principle, which was that they are all very straightforward about the connections between apprenticeship and influence. I don't mean that they were influenced by the people who mentored them. That goes without saying, or maybe goes with saying once. What I mean is that after they identified and analyzed their relationships with men-

tors, they drifted quickly into discussing various forms of indirect apprenticeships: how they learned from people they observed without ever knowing, people they studied without ever studying *with*, people they encountered who may not have even known that they were making a creative impact. That's the second major section of this chapter, and for many creatives it will be the first section. Not everyone has a real live, flesh-and-blood mentor. I was lucky to have a series of them: first my father, then Rich, and there are many others. All are incredibly important and powerful, to the point where it's impossible to not think about them all the time. I constantly wonder what my early mentors would think about the creative choices I am making now, how they would guide me and apply course correction (gently or roughly) if they thought I was headed in the wrong direction. But I want to encourage people to think only partly about specific figures in their lives, and generally about the entire process of soaking up techniques and lessons from a group of like-minded creators. I want to talk about influence.

The Influence of Influence

Mentors are like big cats that keep the cubs close. When you stray, they come get you. When you're out of line, they bat you down. When you finally reach the point of self-awareness, there's that *Lion King* moment where they hold you up for the world to see. Influence, on the other hand, is an octopus. But it's a specific kind of octopus that I'm imagining, one that uses its tentacles to suck energy and nutrition from anything it touches. It's sort of a vampire octopus, except not scary—a plush vampire octopus.

There are many high-end theories about how much we should or should not remain in the shadow of (or illuminated by) the things that cast the brightest creative lights. When I went to high school at CAPA, many of my classmates were future success stories: ever heard

What's important in a mentorship relationship is the other side, the apprenticeship.

of a little group called Boyz II Men? Because the kids around me were so interested in developing themselves creatively, at least two schools of thought sprung up, and I want to look at those two through the narrow prism of jazz players. Among the young musicians, there were the traditionalists, led by people like the organist Joey DeFrancesco and the bassist Christian McBride. They took the Wynton Marsalis tack, arguing that the point of jazz was to preserve and extend the history of the genre. You needed to know where you came from to help you get where you were going. They respected, and even revered, their predecessors. There were also the rebels, led by people like the guitarist Kurt Rosenwinkel. He knew jazz history, but he didn't want to feel imprisoned by it. He wanted to follow the lead of artists like Frank Zappa, iconoclasts who learned about the past so they could dismantle it.

There are many interesting intellectual wrinkles in any argument about artistic influence. But the one thing no one can dispute is that artists are influenced by each other. We take our ideas where we find them, and largely we find them in the works of other artists. Just like when you're analyzing mentors, hindsight is the only thing that allows you to see exactly which artists influenced you. At the time you're coming up through the ranks, you're soaking it all up. The painter you think you're imitating may turn out to be a small influence. The songwriter you want to be exactly like may fade until she's a footnote. The writer you think you're rejecting entirely may turn out to be the closest thing you have to a direct inspiration. Creative growth resizes all these things over time. You'll have to track those

influences as you travel your own creative path. All I can do, all I will do, is tell some stories about how people influenced me at different times in my creative life and how that influence took root (all puns intended) and changed the shape of things to come.

Here's the first story. It takes place largely in a parking lot. When the Roots were first coming up, we had a strong interest in the Pharcyde, a Los Angeles-based hip-hop group that made some of the most interesting records of the early nineties. They just had sounds that weren't anywhere else. Their first album, *Bizarre Ride II the Pharcyde*, included a track called "4 Better or 4 Worse." It had the coolest sound that any of us could imagine. We listened to it over and over again, trying to decipher the samples. Was that Lou Donaldson? Someone else thought they heard the Emotions. And that was definitely Fred Wesley and the New J.B.'s. One of the sounds that kept hitting our ears was the Fender Rhodes. Right then and there, we decided we needed to have one of those on our record. Rich knew this kid who used to hang out at his house, which he had turned into a kind of clubhouse/recording studio. The kid's name was Scott Storch, and he had Human Jukebox Syndrome: he could sit down at any keyboard and play any song we called out. It was an amazing party trick, but it was more than that—it let us bring our influences right into the room. (Scott went on to be a major producer, first with Dr. Dre and then with everyone from Beyoncé to 50 Cent to Snoop Dogg.) At that time, Scott was a conduit to our artistic inspirations, along with being an illustration of the first secret of influence: the first step in creating is often re-creating. Most people make things because they love the things they hear or see or read and want to have more of those in the world—and the easiest and most sensible way to do that is to try to make your own version of one of the things that already exists.

The Pharcyde kept inspiring us in strange ways. When the Roots released our second album, *Do You Want More?!!!??!*, we played a show at Irving Plaza, in New York, and lots of other hip-hop acts showed up in the audience. Members of the Wu-Tang Clan were

there. Members of Brand Nubian were there. And members of the Pharcyde were there. Afterward, they came backstage and talked to us. By then, we were considered equals, or something close to it. They had their sound and we had ours, and the ways one group may have influenced the other had started to blur. This is a second fundamental point: once you are making things of your own, you're no longer completely in anyone's shadow. You can be derivative, or you can be trying too hard to distinguish yourself, or you can hope in your heart that the older artist recognizes the way you're paying homage, but the fact of the matter is that once you start making things, once you take that leap, you have the same status as any other artist. I'm not saying that you're as good. I'm not saying that you're as important. But all of a sudden it's a difference of degree rather than a difference of kind. The Roots and the Pharcyde, backstage at Irving Plaza, just two bands talking. There were some distinctions, still: there was a tour coming up, and we were opening for them. They were still slightly senior. But we were doing the same thing: again, degree, not kind.

During that conversation, I started asking them questions about the new album they were working on. I asked them if they were still working with J-Swift, who had produced *Bizarre Ride*. They said that they had broken off with him and were thinking of working with Q-Tip. This seemed like an amazing idea to me—A Tribe Called Quest and the Pharcyde collaborating? That was mentorship times ten. I said something honest about how excited I was to hear that. In the weeks after that, I heard that the project wasn't happening, at least not in that way. Q-Tip didn't have new music to share with the Pharcyde. Instead, he sent them to a young producer named Jay Dee. He was from Detroit, had a group there. I didn't know much more than that. He had been in the room that night at Irving Plaza, as it turned out, but he said nothing. He was the quietest person I had ever seen. (I've racked my brain to try to remember any conversation at all. I think I gave him a nod and he said, "What up, doe?" which is Detroitian for "Greetings and salutations.") And, to be honest, I wasn't

We take our ideas where we find them, and largely we find them in the works of other artists.

that interested in anything he had to say, even if he had said something. Jay Dee was a few years younger than me and didn't qualify as anyone I should keep on my radar. It wasn't personal. He just wasn't in line to be an influence. Not everyone can be.

A few weeks after that, we were on the road opening for the Pharcyde. At one show, we finished our set and packed up our gear and I went out to the parking lot. A kid from the college radio station was coming to get me for an interview, and I needed my jacket (which was Triple 5 Soul). While I waited for my ride, I listened to the Pharcyde's set, or whatever version of it I could hear as it leaked through the walls of the club into the parking lot. The main thing I heard was this strange sideways beat. It was the kick drum, and it was wobbling crazily. It was like nothing I had heard. I went back to the club to add eyes to ears, and when I got there, I saw the band going through "Bullshit," the opening track from their new album. This unprecedented kick pattern came courtesy of Jay Dee, the Detroit kid I had dismissed as too young to be an influence.

What I did then was what I did whenever I encountered something radically new. I froze. I've learned that over the years, my response to a creative innovation that comes flying in from left field isn't to worship its achievement or admire it or even recognize it in any sober, analytical way. More often, I am overcome by a kind of paralysis. That's what happened when I heard Dr. Dre's *The Chronic*, for example. It wasn't an album I necessarily liked or disliked. It was well beyond that. It was polishing P-Funk to a dangerous sheen, and it was advancing the gangster narrative, and . . . I didn't know more

than that. I needed to absorb, process, repeat process until satisfied. Alert—third fundamental point on the way: If something makes you very uneasy, especially if it's something that's being done in a creative field where you have experience, pay attention. Your mind is telling you that there's more to process than just your surface reaction. Jay Dee, who I would come to know as J Dilla, was delivering a drum sound that stopped me in my tracks. A year later or so, he would release the first album from his Detroit band, Slum Village, which both concentrated and extended the brilliant innovations he had used on "Bullshit." And after that, he would go on to be one of my closest friends and collaborators. He was younger, and because of that he wasn't exactly a mentor and I wasn't exactly an apprentice. But he was certainly an influence. I studied him. I watched the things he did. I was amazed by the way his mind worked, and by the way it made my mind work. There's nothing quite like someone else's brilliance, especially if it's left-field brilliance that you don't immediately understand, to keep you both challenged and bewitched. That's fundamental point number four (the hits just keep on coming): Influence isn't primarily about comfort food. It's about challenging your expectations of yourself.

There will be more on Dilla later, much more. But my first encounters with his musical mind, in the form of that parking lot epiphany and my absorption of (and in) Slum Village, started me thinking toward a greater understanding of my own drumming. Early on in the Roots, I went to great pains to show that I was worthy of being there, in the hip-hop world. That led to the approach I staked out for our first few albums, in which I drummed as precisely as possible. That was the frame around my mind. At that point, I had a very well-developed anxiety of influence with regard to the difference between hip-hop drumming and soul drumming. I wanted people to wonder whether they were listening to a person or a machine. I permitted myself no errors, no imperfections. When I heard J Dilla's work on "Bullshit," it touched off a profound change, and one that would reverberate

within me for years. It carried me into my musical relationship with D'Angelo (his "Me and Those Dreamin' Eyes of Mine," which I heard on an early copy of *Brown Sugar* in April 1995, had that same kick discrepancy, which taught me that it couldn't be an accident so much as an idea). That idea made me understand more about the drumming of musicians I love who aren't primarily considered drummers (most notably, Stevie Wonder and Prince). It opened my eyes to the musical equivalent of slouching on a couch with your hand on your belly. It's a hard thing to do, to be sloppy rather than flashy, and to do it just as well. But it's the way that you can let your art also show your humanity. This is a lesson I've never forgotten, and one that started in the parking lot behind a Pharcyde concert.

England Swings

J Dilla, as I said, became a close friend and collaborator before his death from a rare autoimmune disease in 2006. He's really woven into the fabric of my life as an artist. But I want to use another example that's less charged: a case when I took creative influence from someone who didn't go on to be a further part of my life.

When the Roots were just getting started, we spent a year in England. We were so poor that when we looked at dirt we were envious. We all lived crowded into a single flat, and we ate chips with cheese and tomato sauce. While we were there, I fell in love with a South African girl. She had to leave to go home and vote in the election—it was the historic one that would end apartheid. I can't say I blamed her. She made me promise to go see a DJ named Aba Shanti-I who performed at a place called House of Roots. I probably made a joke about the name. Rich went along with me. The place was a converted church. Aba Shanti-I was up at the pulpit with his back to the audience. He was facing the cross, flanked by absolutely huge speakers. Unlike any other DJ I had ever seen, he only used one turntable. That

meant that he had to pause between records, which created a great sense of theater. I was most taken by the way he used sound. Before he played records, he went to the control board and turned all the sliders down. He took off all the low frequencies, all the mids, all the highs. It was like an equalizer, but very muted. Then he picked up the microphone with his right hand and moved it to his mouth. The audience went nuts. Meanwhile, his left arm was dipping down into his box of 45s. He picked a record, put the B-side onto the turntable, and then put the needle on the vinyl. Because he had pulled all the sliders down, all you heard was the upper end of the spectrum, a little tinny noise. Midway through, he would turn up the middle of the range. The B-side (which was usually an instrumental version of the A-side) played out that way. Then he flipped to the A-side, the real song, and he went to the bass. He turned that way up and the room exploded. Everyone was physically moved by the bass sound. You felt that in your innards. I had never experienced anything like it. I was paralyzed, stuck in place, the same way that I would be a few years later when I heard J Dilla in the parking lot. I realized, all at once, that sound was a psychological force, and also that it could be broken down into basic components. Rich was transformed by the experience, too: an influenced mentor. He devoted himself to making the Roots the loudest live hip-hop band in the world. He said that he wanted people to have a colonic when we performed. Aba Shanti-I taught me that music could be reduced to a physical and almost sacred essence, and that you needed the bare minimum of equipment to communicate that essence.

It's not surprising that many of my stories about influence come from early in my career. That was the period where my artistic identity was still developing, when I was still unsure of what I wanted to be. To return to David Byrne's earlier insight, I probably had a sense of what I didn't want to be. I may have known, in some fuzzy way, that I didn't want to go on being a drummer who was indistinguishable from a drum machine, or that I didn't want to go on being in a

band that operates with a conventional sense of sound. But when you're a young soul rebel, where do you look? I looked where I could, and I was predisposed to be affected by the things I saw. I was receptive. If you're jotting down fundamental insights from this chapter—and I have lost count of how many have passed by—jot this one down, too. Be receptive. Be ready to hear your future in a parking lot behind a Pharcyde concert or at a church in England. But that's not all. Here comes the final fundamental point of this section: Be sure to summarize what you're learning. Isolate your insight and turn it into a short thesis statement. Dilla taught me to preserve humanity at any cost. Aba Shanti-I taught me how to isolate individual elements to obtain maximum power. For me, those were guide rails for future creation. You'll find guide rails of your own. Only you will know when you encounter the art that productively paralyzes you. But these moments start to supply principles. You are making commandments.

Haunted by the Ghost

Right at the beginning of this book, I said I wasn't creative. Part of me doesn't really believe that, and another part of me does. I'm of two minds about it, at least. One of the things that divides my opinion is the way I drum now. One of my primary techniques is to re-create the drumming of other artists from the past. I exactly replicate their specific technique and sound—and, through that, I try to inhabit their spirit. I do it well. I don't have to be modest about how well I do it because I'm not sure that it's anything to brag about. In fact, it may be a little worrisome. If you listen to *Wise Up Ghost*, the album that the Roots made with Elvis Costello back in 2013, I'm drumming on it, of course. But really I'm drumming on it as Steve Ferrone, the great veteran session drummer who has been on a million different projects, who's worked with everyone from Chaka Khan to the Bee Gees and has been with Tom Petty for more than twenty years. Steve gave me

the snare drum I used on that record, and with it he gave me (silently) a whole set of rules about how to play. He communicated it. He exists as an influence in my mind, because I'm a student of drummers, and when he gifted me that snare, he activated that influence.

My Questlove-as-Ferrone turn on *Wise Up Ghost* is only one example of a phenomenon that has happened hundreds and hundreds of times in my life and career, which is that when I drum, I'm me but not me. Or rather, I'm always me, but I question whether there is a "me" independent of context. In my mind, I'm always in the middle of a WW?D formula, but the question mark is interchangeable. In the case of *Wise Up Ghost*, it was Steve Ferrone. If I'm playing a James Brown–type song, it's the recently late, eternally great Clyde Stubblefield. If I'm playing something styled like early seventies soul, it's Bernard "Pretty" Purdie. The question mark gets filled in depending on the best answer. I know drumming and drummers well enough to guarantee that I'll never get the wrong answer. In these cases, when I answer the question mark, I show my real talent, which is playing it back for you—as a DJ, as a historian, as a teacher. Is that a form of creativity? If so, then I'm the most creative man for miles. I even go as far as replicating exact technical tricks. Say I'm spending a day making beats, and I decide to channel J Dilla. There are certain things that he did that won't ever leave me. I'll put damp Bounty paper towels on the floor tile to muffle the room noise. I'll play some songs with soft cotton mallets because of the texture they bring. When I was younger, my friends, my producers, my engineers would always tell me to stop hitting the snare so hard while we were recording. I didn't realize what they meant, and I certainly didn't listen, until I saw J Dilla play. I was in the studio in Detroit watching him track drums, and his engineer explained that the softer you hit, the better you hear it. It made sense all at once, in a way that it hadn't before, and it only made sense because I was watching it happen to him.

There is an element here of follow-the-leader behavior. But it's more than that. It's a literal, physical articulation of the distinction

between creation and creativity. On the floor of the band room at *The Tonight Show*, there are snare drums named after drummers I've idolized, and each of them is tuned to exactly re-create that drummer's sound. There's the one named after Jerome "Bigfoot" Brailey, which is tuned to sound like P-Funk. There's the one named after Gary Katz, which is tuned to sound sort of like the Steely Dan records he produced, or at least to that broad region of dry, sophisticated pop. There's the one named after Fish, from Fishbone, which is a sharp piccolo snare. There's the one named after John Bonham from Led Zeppelin, which produces an open, ringing sound like Bonzo did in the *Physical Graffiti* era. My Stevie Wonder snares are named after different records—there's *Music of My Mind* and then *Journey Through the Secret Life of Plants*, which sound different, because they represent different periods of Stevie's music. (This is probably the time to remind everyone that Stevie Wonder was a hell of a drummer, one of my favorites, if not always the most technically precise. He's the funked-up version of Tony Williams: all feel, lots of crash landings.) Once I engineer the drums to be Donald or Larry or Stevie 1 or Stevie 2, I just operate them to perfection. Does that mean that I'm creating? Enough people have said yes that I'm willing to accept that as the answer. More to the point, am I creating anything that's uniquely me? Or am I just a Frankenstein's monster cobbled together from all the perfect drummers I know and love?

It gets worse—or better, if you're looking for proof that all creative choices are modeled on past choices. Every single song I've ever played in the studio involves a period where my eyes are closed—that's so I can transport myself back to the year when the snare sounds the way I want it to sound. It's like a kind of method acting. Maybe I close my eyes and I'm Pretty Purdie, back at the Fillmore in 1971, backing Aretha. It can get even more specific than that. When I was tracking the Roots song "Radio Daze" for *How I Got Over*, something about the texture of the snare made me think of early-seventies Three Dog Night. To get there, I had to close my eyes and create a

mental picture of the ABC Dunhill logo, which looked like a little house. It was a type of influence, a type of mentorship, a type of synaesthesia, and a type of séance: the record logo entered my brain and put me in mind of a specific sound from the past.

Sometimes, it's not just mental machinations. I just did a record with Pharrell, and when we finished, he paid me the greatest compliment he could ever pay me. "Thank God," he said. "You finally are going to get me Stevie's attention." It's because we did a song that recalled Hitsville-era Motown, and he thought Stevie would become alert to it. But the fact that our song sounded like that wasn't an accident. The day we recorded, I wore a turtleneck, all black, and when I got to Daptone Studios, where we were working, I looked at the photos and possessions of Sharon Jones, who had just recently passed. I got into character. I was Questlove-playing-turtlenecked-Stevie, and that incarnation of Questlove knew exactly how to get the desired effect.

And sometimes, there are second-level and third-level variations, cases where the Frankenstein's monsters get together and build a monster of their own. One afternoon I was playing the Steve Ferrone snare and thinking about the night he backed Prince and Tom Petty and Dhani Harrison and Jeff Lynne when they played George Harrison's "While My Guitar Gently Weeps" at the Rock and Roll Hall of Fame induction ceremony. I wasn't there that night, but I have watched the clip over and over again, two of my idols playing together, one on guitar, one on drums. And each time I have watched it, I have thought about the creative choices that Steve made and the choices I would have made if I'd been in his place. I am guided as much by the song I'm playing as I am by the people around me—not to mention the people I'm modeling myself on internally—so if I were playing "While My Guitar Gently Weeps," my first instinct would be to play it like Ringo Starr, as dry as possible. That would work if I were playing with the Beatles. In fact, it might be the only way. But in the Prince cover of the song, that approach would only work up to a point.

The second Prince started soloing, a different kind of drummer was required, and I couldn't completely hear the argument for Steve's approach. For a moment, it seemed like I was on the brink of an original creative epiphany. I went through my memory banks again, went through the snares on the floor, went through the jukebox in my head, and I came up with Sheila E., who played drums on some of Prince's most adventurous and successful late-eighties records. I always thought that Sheila E. was Prince's best support when he was power soloing. So watching Steve play behind Prince, thinking about how I would play behind Prince, I figured that I would be Ringo up until the moment that Prince started soloing and then I would turn into Sheila E. That's often the case, and I always know the recipe for the alloy. Maybe on this song I'll be 40 percent Charlie Watts, 40 percent John Bonham, 10 percent Pretty Purdie, and 10 percent Gregory C. Coleman from the Winstons.

And yet, despite this all, people think I have a style as a drummer. Part of me thinks that it's because they don't know all the influences I'm drawing on at any given moment. But part of me, just as quickly, wonders if there's any difference. If you have pulled all your influences inside, and you output them appropriately at the right moments or in interesting new permutations, maybe you are engaging in a highly creative act. If a writer knows to really punch an image at the end of a paragraph, and he knows that another writer did that before him, is he just imitating the earlier writer, or is he bringing that writer's creative choice, studied until understood, across into a new context? Food for thought.

And food for funk. If I try to think of a purely original drummer, I usually end up with Clyde Stubblefield, who drummed with James Brown alongside another great drummer, Jabo Starks. Stubblefield is probably best known for "Funky Drummer," but he drove so many of the great songs from that late-sixties golden era of James Brown's music: "Cold Sweat," for starters, and do you need more? I have said before that Clyde was the Stones to Jabo's Beatles. Jabo was a cleaner

shuffle drummer, and Clyde had this free-jazz left hand that just went wild, moving the air around him, moving the crowd. To me, Clyde was a true original. But again, "original" can be a crutch word that people lean on when they don't know where things come from. In my mind, I drop back from the late-sixties Clyde-Jabo era of James Brown's catalog to the early sixties, and specifically go to "I've Got Money," a 1962 song that was the B-side of "Three Hearts in a Tangle." If you've never heard of it, shame on you—and also, I completely understand. R. J. Smith, who wrote the book on Brown, literally, described it as "one of the less-known great records of Brown's career." The drums in the song are one of the best things about it. They're done at breakneck speed. And they aren't Clyde or Jabo. This is long before either of them arrived. The drums in "I've Got Money" are by Clayton Fillyau, and from what I've heard from people in the James Brown circle, Clyde and Jabo really looked up to Clayton, to the point where he was in their head the way that Clyde and Jabo are in mine.

Where creativity is concerned, pure originality is at least partially a myth. People are heavily invested in that myth because they have egos, or because they are selling a brand. But it's not fully real. Young creatives shouldn't worry about it. Or rather: I think I can tell you with some confidence that you'll be worrying about it forever, so don't worry about the fact that you'll be worrying about it.

Time Passages

In the end, one of the most important things to remember about influence is that it's never the same. Time changes artists, and time changes the art they make, and time changes the way they look at the forces that shape that art. If you decide to hop aboard the life cycle of creativity, you're going to ride through a series of phases. In fact, this chapter is a consideration of all of them. That's the big reveal: I've been leading you all through a kind of timeline of the way creative in-

fluence works across the long life of an artist. I've already discussed my young-man phase, where I served under mentors like my father and Rich Nichols; my slightly-older-young-man phase, where epiphanies in the presence of others like the Pharcyde and Aba Shanti-I were possible; and my middle-aged-man phase, where I had matured into my own creative identity but still harbored suspicions that I was just imitating those artists who had come before me. To close this chapter, I want to talk about creativity in late middle age, or even old age. I'm not there yet, but I can feel it coming, and one of the things I feel coming is a certain brittleness with regard to the turning of the creative wheel. At some point, rather than worry about who's influencing you, you're going to worry about whether or not you're influencing others. You're going to get competitive about it and maybe even unpleasant. But you're going to have to work through it.

My example here, once again, begins with J Dilla. One February night recently, it was Dilla's birthday. I was remembering him, and in the course of remembering him, I called D'Angelo, who was also close to him. I called him because I was thinking about the more general phenomenon of how people feel a certain way. That's something black people say, that they "feel a certain way." It's a nuanced form of snark. It's not as bad as saying that you're totally jealous of a person or their achievement. It's admitting that they got to you in some way but also keeping your distance, playing it cool, slow-rolling whatever envy you admit by not admitting. It's about as good a neg as it gets. In fact, there are at least a few artists whose music I won't listen to at all, whether it's because I don't want to be influenced or because I don't want to learn too much about the people behind the creative work or because I feel a certain way. As I say, it gets worse with age. There are more of them each year. When I was ten I was curious with reckless abandon. There wasn't any fear about consuming things: if they interested me, I took them in. I ranged far and wide because I wanted to see what was out there. That was the vampire octopus. Now that I'm older, I'm more cautious. I've whittled my influences down to my

pantheon of drummers and singers and guitarists, and it's hard for new people to crack the shell.

When I called D'Angelo, I was thinking about this process of aging and hardening, and thinking about how J Dilla always somehow avoided being caught in its net. "Yo," I said to D'Angelo, "isn't it crazy how we weren't ever threatened by Dilla?" That stopped D'Angelo, or at least slowed him down. Normally, D'Angelo's like me in this regard. He can get envious of other artists in a millisecond. He can flinch away from someone because he's worried about being crowded. Dilla somehow skirted that issue, always. To some degree, it was because he was undeniable as a talent. But it was also because he took a certain stance as an artist.

Dilla reversed the circuit. He made everyone around him feel that he was genuinely in awe of who they were as a person and an artist. He was able not only to acknowledge that he was giving you creative energy, but to behave as if you were giving him energy. Whether it was sincere or strategic, this reversed the circuit. It made him young again in some way, made you older, but also made you question the entire hierarchy. It was, in its own way, extremely cool, and extremely motivational.

D'Angelo wanted an example. I had one. This was back when we were working on his album *Voodoo*, and one of the songs that we had really put our back into, "The Root," was finished. I wanted to play it for Dilla, who was visiting New York. He was about to catch a car to the airport to go back to Detroit, so he didn't have much time. But he listened to it, and he seemed to like it. "Yo, man," he said, "I cannot wait until I get home. I gotta practice this." About eight hours later, back in Detroit, he called me. "Check this out," he said. He put the phone up to the speaker and played back his own version of "The Root" to me exactly. He had somehow managed to listen to it once, to record it, and to re-create it perfectly. I had been part of the process of creating the song. I had heard it for hours and hours in the studio. Even I couldn't sit down and play it cold. I called the engineer

Time changes artists, the art they make, and the way they look at the forces that shape that art.

who was working on the record. "I'm coming over to the studio," I said. I wanted to see if I could play the same part again, the way he did. It was a challenge, like watching a magic show and then trying to cut the lady in half and put her back together yourself. I failed miserably. The lady was in pieces. I felt like a loser, man. I didn't understand how he had done it. I was re-creating a person who had re-created me, and I couldn't even be me as well as he had. But I didn't, even for a second, feel something about it. How could I? All Dilla was doing was taking something I had made and making something new from it, even as he was also making a copy. He was creating because I had created. With a different kind of person, a different kind of producer, a different kind of talent, I might have felt one-upped, or put down, but I didn't feel even a twinge of that. I was just amazed. (Dilla's one of two people I have ever met who have that talent of hearing something, absorbing it, and being able to put it right back out there. The other one is Tariq. He has an amazing brain for that. You can put him in a room, have him listen to a tape of the Gettysburg Address once, and then smash the tape, because you don't need it anymore. It's all in his head.)

Dilla was able to create in a way I didn't understand, which isn't typically the first thing I think about when I think about mentorship. I would have thought that it was more about teaching certain skills, refining them, identifying what's there and what's not there. And yet, Dilla's ability to make the street seem like it was a two-way street, like everyone was inspiring everyone—his talent for making sure that there was an absence of malice in any direction—probably helped to

bring the story to a happy conclusion. At that time, we were still working on reel-to-reel, not ProTools. When the tape was slowing down and I heard my failed attempt to do what Dilla was doing, I had the engineer flip the tape so that I could hear the drum part backward. In the reversed drum part, I heard something new. I used it as the intro music for the *Mo' Better Blues* dialogue that we included on *Things Fall Apart*. It was a mo' meta situation that ended up mo' better for everyone. It's a successful story of creativity, and how Dilla's example led me to some Zen conclusion regarding new ways of creating by using old material in a new way. But it's also a stellar example of the kind of influence and mentorship that lasts into old age. It may not have been a perfectly frictionless process—it was frustrating to go to the studio and discover that I couldn't do what he had done—but it created a frictionless memory that continues to pay dividends.

↓

The Mismatch is the Match
Attach yourself to people who are doing things you don't quite understand.

Getting Started...

A Good Cup of Coffee

Creativity sometimes results in products. But it's always a process. Ideas, including those destined for your brain, are moving past you all the time, in a constant stream. It's a matter of capturing them.

But what happens when you can't get into the stream? What happens on those mornings when you feel sluggish or hungover, or where you've run into your most annoying friend on your way to the office (or studio), and when you sit down to add to your brilliant manuscript (or album or series of paintings), you just can't get the ideas to tumble forth from your head?

In these cases, you need to get the wheels in motion. What's the best way to do that? I have long had an interest in finding out the answers from other creative people. They vary widely. Here are some, in no particular order: coffee, long walk, short walk, climb stairs, look out a window, coffee, jot down the names of everyone you know in reverse alphabetical order, meditate, listen to the radio, coffee, go to a diner and eat scrambled eggs, count to ten forward and backward, read a page of a book upside down, call a wrong number on purpose, type "all work and no play makes Jack a dull boy" a thousand times, whittle, coffee.

So many people say coffee. I don't drink coffee. The only time I have been known to indulge is when I drink two triple espressos before a movie so I can stay awake—and my date still ends up elbowing me midsnore. But let's start there. In *somethingtofoodabout*, I spoke to a chef named Ryan Roadhouse, who started a pop-up restaurant called Nodoguro in Portland, Oregon. Ryan had one of the most interesting creative processes of any chef I spoke to. When he started out, he cooked for people in a kind of supper club. His wife helped him by making the table settings, and he enlisted other artists he knew to design the space. At some point, he thought his ideas were played out. He didn't know what he could do to bring people back a second time or a third. What he did was both convenient and profound. He went to

other people's works to jump-start his own ideas. His first source was the work of Haruki Murakami. He noticed that Murakami's characters ate all kinds of strange foods: in *Hear the Wind Sing*, a man poured Coca-Cola over his pancakes as a kind of makeshift syrup. He used those strange fictional foods as starting points and started to invent his own. After Ryan cooked dishes out of Murakami, he did another month devoted to a Japanese visionary—this time, he cooked foods from the movies of Hayao Miyazaki. The third time, he came back to America, and specifically to *Twin Peaks*, the seminal, disturbing, and surreal television show created by David Lynch and Mark Frost. Everyone who has seen the show remembers Agent Dale Cooper, played by Kyle MacLachlan, and his love for pie—and coffee.

Ryan's *Twin Peaks* menu has a strange and happy ending. While I was writing *somethingtofoodabout*, I thought it would be interesting to have him cook it for Lynch himself. And me, of course—David doesn't like to travel much, so Portland was out of the question, and I arranged for the dinner to happen in Los Angeles, at the Chateau Marmont. And there I was, eating *Twin Peaks*-themed food with David Lynch himself in Bungalow 3. Talk about surreal.

Lynch loved the dishes, which included Coffee Cup Custard (chawanmushu with Black Trumpet gel and freeze-dried corn) and Turnip Waldorf Salad (with miso and fresh apple). He told us a bunch of amazing stories, including the origin of the moment in Twin Peaks where Dale Cooper and Sheriff Harry S. Truman (Michael Ontkean) are about to drink a cup of coffee, and Pete Martell (Jack Nance) runs into the room. "Fellas, don't drink that coffee," he says. "There was a fish in my percolator." The scene came from a real story, in a real diner he used to frequent. One of his friends took a sip of coffee and spit it out. It tasted terrible. They investigated, and it turned out that someone had left a bar of Lava soap in the percolator. Lynch is obsessed with diners and coffee, partly because they help him create a meditative space where he can have his strangest ideas. In *Catching the Big Fish*, his book about creativity, he puts it this way: "There's a

safety in thinking in a diner. You can have your coffee or your milk shake, and you can go off into strange dark arts, and always come back to the safety of a diner."

I appreciate the coffee method, though I don't drink that much coffee myself. Rather than jump-start my ideas, it just makes me jumpy. On days when I feel like I have no ideas in my head, I usually try to go to the track. During track meets, athletes stretch. They've prepared for weeks, for months, for years, but there's still important daily preparation. I've seen them there off to the side just before a meet. They touch their toes. They hop up and down. They crane their necks from side to side. The reason is that no one wants to start the competition with a pull or a twinge. A tiny little malfunction somewhere in the musculoskeletal system can sideline an athlete completely.

I recommend something similar for creativity. It's no less demanding than an athletic competition. In some ways, you could argue that it's more demanding. So learn to stretch your brain, too. Here are some strategies:

—*Garden.* I don't mean this literally, though feel free to take it literally if you have access to a garden. When I've had the opportunity to do that, or when I have met people who do that, they find it immensely gratifying. They notice things they wouldn't ordinarily notice. Their senses sharpen. Their heart rate slows down. Many mornings, I try to do something equally Zen-like, and most of the time that means going into my MP3 catalog and pruning it. I notice song titles. I notice how things are organized. That starts me toward thinking about my own work in a structured creative context. It puts me in contact with other work that motivates without intimidating. That may work for you, if you also have hundreds of thousands of MP3s on your hard drive. If not, try something similar. Reshelve your books. Take the photographs off the wall and hang them up again; you can rearrange them or try to recreate the same arrangement. Put yourself in contact with creative work in some fashion through organizing. It's certain to loosen you up in the right way.

—*Play it backward.* We see things one way, mostly. We are at the mercy of common paradigms. That's why conventional wisdom has such a hold on us. Remember when Donald Trump started to ascend through the Republican primary season? People couldn't believe it because it didn't match what they already knew of politics. (And speaking of politics, I won't anymore. At least not the topic of what's-his-name's unlikely rise into the presidency. As the great philosophers Daryl Hall and John Oates said, some things are better left unsaid.) I have talked in other places about an exercise that Richard Nichols and Ben Greenman like to do, which involves believing the opposite of what you believe. Do you think that humans are affecting the climate? Believe that they are not, just for a minute. Are you sure that Oswald acted alone? Embrace conspiracy, just for a minute. This exercise is something different. Take a piece of art that you love and invert it. If it's a painting or a photograph, it's easy. Just turn it upside down. (If it's on your phone, the screen may try to rotate with you, but you can lock it, and if you can't lock it, stand on your head.) If it's a book, read from the last page forward. Stop at every word: "Girl later Mingus later." (That's the end of Charles Mingus's *Beneath the Underdog*, run backward, and it's also maybe the beginning of something great on its own.) If it's a song, you might need to get some kind of app to play the music file backward, but it's completely worth it. Outros become intros. Rising action before a verse becomes some kind of strange after-dinner mint. (Hearing music in reverse is a time-tried and time-tested tradition. When Run of Run-D.M.C. first heard what the Beastie Boys had done to "Paul Revere"—Adam Yauch had reversed the 808 rhythm track—it was like he was discovering fire for the first time. And Marley Marl, on his production of MC Shan's "The Bridge," accidentally pressed the reverse button when he was sampling a brass stab. Suddenly the all-powerful stab was the horn equivalent of Scooby-Doo's ruh-ro. It went from exclamation point to question mark. Backward asks all questions, and answers them, too.

—*Random plucking.* This is a related strategy, but for it you'll need a specific kind of book: a dictionary. I don't know if these exist anymore in the era of the Internet and phones that know what words mean, but they used to be these big important bound volumes that contained many if not most of the words in a given language. We had them here in English. What I used to do was open them randomly and stab my finger down on a word. Maybe it would be "shabby." Maybe it would be "chock." Maybe it would be "garden." It was almost never "randomly" or "stab" or "word," though they have as much chance as any of the others. But whatever word it would be, it would be my word for that moment, and in the wake of picking it I would force myself to have an idea about it. "Archery"? Okay—that seems easy. Maybe it's a song about how the country keeps missing its target by making the wrong people targets. "Look"? Okay—it's a simple command, one of the simplest, urging people to pay attention. Often those thoughts won't pan out, but that's not the issue. The issue is that there's a thought in the first place. There's an interesting variation on this strategy that I learned from someone famous, though I can't say who. (It's Tom Cruise. It's not Tom Cruise.) It's a little more mathematical and a little more mysterious. Take any book. Pick a number that's less than the number of pages that it has, then a second number between one and twenty, then a third number between one and ten. Go to that page, to that line, and to that word, and then use whatever word you've selected. When I do this one, I like to think the three-number code like it's one of those old Master locks, and I'm unlocking the day.

Yes, and …

That's how the day starts. That's the jump.

But then there's the matter of how to keep an idea rolling so that it becomes something more than the first glimmer. Ideas are collec-

tions; there aren't many composers who compose a whole piece using only a single note. (Are there? That would be interesting in a John Cage–like way.) If you're a young creative, remember this. If you're old, write it down so you'll remember it. Mental reorientation is half the battle, and often it's the other half, too. That's one of the reasons that I have tried to look at creative disciplines that depend upon high-flow creativity. By that, I mean disciplines where people process large amounts of creativity at one time. It's not a judgment on the quality of the creativity, but the rate of ideas passing across the gate. For example, a poet working on a single crystalline image for most of a day—proposing, revising, fine-tuning, trying his or her best to get it exactly right—is engaging in low-flow creativity. This can be just as valuable. At times, it's the only way to go. But high-flow creativity is usually what I need to start my day. It's creativity before filters and governors appear.

Lots of art forms depend on high-flow creativity. Cartooning, for example. If you've ever watched a documentary about a classic panel cartoonist, you know how much brainstorming they need to do before they hit upon the one idea that they think has a decent chance of working. Dog inside air-traffic-control tower? No. Cat in White House? No. Cat at drive-through window? Somehow still off. Dog at drive-through window? Maybe. Every flat piece of paper that has the beginnings of an actual drawing is made possible by the hundreds of balled-up false starts in the conceptual garbage can.

That kind of high flow doesn't come naturally to me. Partly that's because music, where I have spent most of my life, has a cost associated with the big pipe. Recording studios operate like utilities. Every minute of flow is a minute of meter running. But I have also spent almost a decade in and around the comedy world, and that has given me access to the creative discipline that makes the most of high-flow creativity: improv comedy.

I can already hear the sighs. Improv comedy has a bad reputation, partly because it's fashionable to take potshots at it. There's an

81

entire episode of *Bojack Horseman* built around the premise that improv comedy is a kind of brainless cult populated by irritating nincompoops. I'm sure there are some of those people in the improv world. But what has always impressed me about it is the basic principle of "Yes, and . . ." Everyone knows what this is, right? When an improv troupe is working together and one member takes the sketch in a certain direction—say the starting point is a hospital emergency room, and the first comedian to steer the scene introduces the notion that it's an emergency room for extraterrestrials—the other members have to take it up without challenge or contradiction. And if the second comedian takes the premise of extraterrestrials further—he might suggest that the people in the emergency room are acting out a medical drama for the benefit of the extraterrestrials, who are holding them captive—the third comedian has to absorb this into the narrative, too. They must accept those shifting parameters and new ingredients and develop new starting points accordingly.

Mike Birbiglia, who is an excellent improv comedian and storyteller, and also a filmmaker whose last film touched on all these worlds (it's called *Don't Think Twice*, and the title is not only a nod to Bob Dylan, but a nod to "Yes, and . . ."), sees improv comedy as a uniquely collaborative and generous environment. By forcing you to work with the ideas of others, it not only makes you a more flexible and innovative comedian but affects the rest of your life, too. "It changed the way I thought about everything," he told NPR in an interview. "It helped me in parenting and being a good husband and being a good friend . . . any collaborative job." Because Mike is a sane, balanced, responsible person, he chooses to highlight the way that "Yes, and" thinking improves his life with others, and especially his life outside of creative work. My aim here is a little different. I'm not appealing to the insane, unbalanced, irresponsible side of people, but I do want to move a little bit away from the collaborative nature of improv comedy. Or maybe it's more accurate to say that I want to suggest that there's also an internal "Yes, and." When you start work

for the day, be careful not to throw anything away. At least initially, there's no such thing as a bad idea.

Take Eminem. When he first appeared on the scene, lots of the conversation around him dealt with his authenticity. He encouraged that line of thinking because it helped to raise his profile, and also because he must have been absolutely secure in the fact that he was as authentic as anyone—as authentic as D.M.C., as authentic as Rakim, as authentic as Chuck D. He was doing something a little different than any of them, but he was doing it completely authentically.

But what some of those early reactions missed was how much he employed "yes, and" thinking. Take a song like "Stan." Or just take "Stan," because there aren't that many other songs like it. All of us in the entertainment industry—anyone with any level of fame or notoriety—have had encounters with fans that made us feel a little uneasy. I remember one Roots tour back in the late nineties when women kept coming on the bus. They were fans. They had been to the show. They wanted to meet the band. That wasn't as common as you might think. We had groupies who waited for us at the stage door, but they tended to be guys in their twenties with hipster jackets and lots of guesses about where we put the mics when I recorded "Sugar Won't Work." (For the record, I put a Royer ribbon right behind me and then a Shure football mic by the kick drum.) On one tour, in one city, I noticed these two attractive women come onto the bus to say hello. One was tall and one was short. They stood out. Two nights later, in the next city, the short woman was on the bus again, this time with a different tall friend. I said hello but she didn't acknowledge that she was a repeat visitor. And then two nights after that, she came on the bus a third time, with a third tall friend. That time, I didn't say anything. It was like *The Twilight Zone*. That night, I couldn't stop thinking about her, and not in a good way. I wasn't fantasizing. I was fearing. I had an idea in my mind, and it wasn't a good idea. It involved some kind of hostage situation and then complex Saw-type torture of me and the rest of the band. It wasn't pretty. It wasn't pleas-

ant. I couldn't sleep a wink. I kept banishing the idea and it kept re-surfacing. A few years later, Eminem came out with "Stan," and it all came clear to me. You weren't supposed to banish the idea. You were supposed to embrace it. In the privacy of your own home, in the comfort of your own head, you're supposed to play it out to its natural conclusion. The crazy guy loves you as an artist—so much that he loves you as a man—so much that he goes batty when he can't have you—so much that he takes what he can, which happens to be his pregnant girlfriend, and does his worst—car—trunk—bridge. The story fell into place. It was more eerie and more Gothic than "Trapped in the Drive-Through," but it operated on at least one of the same principles, which was not to forget to let your mind go where it wanted to go. Eninem didn't put a should-I-really-say-that cap on his idea. He didn't put a socially acceptable filter on it. He didn't put a good-taste governor on it. And I'm not even focusing on the quality of the final song—though the quality is high. I'm focusing on that first moment of creative inspiration and creative momentum. He went from nothing to something thanks to an idea that he had. Many artists, many songwriters, would have turned away from that initial idea, and many of them would have avoided writing an objectionable and disturbing song. But a few (including Eminem) would have allowed themselves the chance of writing a great song.

Another example here, from the world of comedy but not improv comedy, comes from Norm Macdonald. People say he's the comedian's comedian, but really he's the writer's comedian. All the writers I know love him. When I ask them why, their answers are all fairly similar. They like that he isn't afraid to look at things differently. This is a combination of the brief exercise I have referred to—Rich and Ben's idea of believing the opposite of what you believe, only for a few seconds, but really believing it as passionately as you believe the things that you actually believe—and the broader "Yes, and," which lets you follow an idea down the rabbit hole. Norm Macdonald has a bit about how when people are missing they often turn

You weren't supposed to banish the idea. You were supposed to embrace it.

up dead in a shallow grave. He wonders why the authorities don't just look in the shallow graves right off the bat, since that's where all the bodies end up. If he ever killed someone, he says, the first thing he would do is to be sure to bury them in a deep grave. It's not a joke in the traditional sense. It's a stream of consciousness. But it's a self-directed "yes, and": every time Norm gets to a spot in the story where a different kind of creative person would stop, he keeps going. Interestingly, the same technique worked less well when Norm wrote a book. *Based on a True Story*, which was billed as his memoir, was actually a shaggy-dog deconstruction of the way memoirs worked. There was a ghostwriter who popped up to announce that he didn't really like Norm or find him funny but he was going to try his best to make a good book in exchange for the money he was getting. As someone who has a little experience deconstructing memoirs and working with collaborators—though mine liked me and I liked him and we worked well together—it seemed a little sour and off-putting. But again, the point of getting started creatively isn't necessarily to have a good idea. That will come. The point is to have ideas. And *Based on a True Story* has no shortage of ideas.

If I'm going to mention Norm, I should end with the moth joke. In a sense, it's a joke about creativity—about converting personal pain into creative thinking, about knowing your audience, about subverting expectations. Most of all, it's about the way that jokes build on existing ideas, how they are elaborations and extensions, pearls produced by adding layers and layers. There are shorter versions of the moth joke that have circulated in joke books. In the simplest one,

85

a man goes into a dentist's office and announces that he thinks he's a moth. In more complicated versions, it's a moth that goes into the dentist's office, not a man, and his complaint isn't that he thinks he's a moth (because he is), but that he's dissatisfied with some aspect of his life—maybe his job, maybe his wife. In Norm's version, it's still a moth who shows up at the doctor's office (though now it's a podiatrist's office instead of a dentist's office—much funnier), and the moth isn't just dissatisfied with his life. He's completely, deeply miserable. Nothing makes sense to him. He is like a ghost passing through his days. Everywhere he looks, he sees experiences devoid of meaning. Even his despair can no longer comfort him. Norm's version becomes a kind of bleak short story from Russian literature, a full-blown existential crisis. This version of the joke goes to great lengths to detail the moth's sadness, but it ends up in the same place as the shorter versions. When the moth is done telling his sad tale, the doctor says, "You sound like you need help. But you'd be better off seeing a psychiatrist. Why'd you come here?"

And the moth says, "The light was on."

Giving (and Getting) Props

Most of the techniques I have outlined so far take place in the mind. They are consciousness-stretching exercises, creative calisthenics. You can do them while you sit in a chair or ride in an elevator.

There are more left-field techniques, too, that require props. When I was working on my memoir, *Mo' Meta Blues*, I was talking to Richard Nichols about how to start chapters. It was a strange idea for me to retell my own life. I hadn't done it before. I knew instinctively that it was wrong to just open each new sentence with the phrase "and then" ("And then I was twenty-five . . ." "And then I went to Europe . . ."), but I didn't have any strong instincts about how to do it otherwise. Ben had ideas, and they were generally good ones, but I

wanted to have more of a role in how each individual section started. We talked about it, and Rich brought up cutups. At first I thought he was talking about class clowns. He explained that he meant William S. Burroughs. And then he went back further to the roots of the idea in the Dada art movement. And then he explained how it was sort of the wild third rail of pop songwriting, after you got past the way Bob Dylan used modernist symbolism to make sweeping if indirect statements about culture and the human condition and the way John Lennon used nonsense verse that, because it seemed deceptively light, let him be crushingly dark. And then he explained that idea of the wild third rail over and over again until I understood it. And then he gave a more detailed explanation of cutup, specifically how Burroughs developed a method of his own. He took an existing piece of writing, something that had already been printed, like a book or a magazine article or even a few paragraphs that you have written yourself, and you cut it up and rearrange the words, and you force yourself to see meaning in the arbitrary jumble. And then he identified some prominent songwriters who used the method—I think he mentioned David Bowie and Kurt Cobain, though I wasn't listening as closely anymore, because I was still thinking about the explanation of the method. And then I had a kind of epiphany about the fact that making new contexts for old words made those words new again. And then I started to think about how you could apply that same idea to other forms of creativity. The dominoes were falling.

The more I thought about how Bowie used cutup, the more sense it made. His lyrics are not, for me, the strongest part of his legacy as an artist. That's not to say that there aren't great ones. There are: I am especially fond of "DJ," for obvious reasons, and I love "Queen Bitch" (who doesn't love "Queen Bitch"?), and "Life on Mars," and then, and then, and then. But other songs seem meaningless, sometimes in irritating ways. I won't single out any, except most of the *Tonight* album and all of *Never Let Me Down*. Maybe it's just my bias, but those were some of the first Bowie albums I bought on their

release day, in the period after *Let's Dance* made him a huge pop star, and I was disappointed. On the other hand, Bowie kept going. He kept trying. He was never not a creative, never not an artist, never not a person who believed in the importance of producing. He was cutting up texts and putting them back together, and sometimes they made great songs and other times they made less-than-great songs. But they made songs. Boys keep swinging.

This leads to the second and perhaps most important point about these techniques: they are there to keep you moving forward, because the whole point is to keep moving forward. The point is to generate ideas in a rush, and not necessarily to think too much too early about whether or not they work. They work in the sense that they exist. At the time when the Roots took the job at *The Tonight Show*, I was suddenly immersed in two different demographics: comedy and cooking. Both were new to me. Both of them were people (or at least the types of people) that I didn't hang out with before I entered the television world. I started to observe and notice that both sets of groups had their own creative cultures. Chefs and comedians hung out with one another. But there were differences in the way it happened. Comedians had a woodshed spot to work on their craft. Hanging with Dave Chappelle before his appearance on *Saturday Night Live*, I noticed that he surrounded himself with his inner circle. At the Comedy Cellar, Chris Rock, Jerry Seinfeld, all of them are there working on new material. Woodshedding, testing out new material, bouncing off each other. I don't know if chefs have quite that same freedom. Take a place like Eleven Madison Park. It's been awarded three Michelin stars and was named the best restaurant in the world. It's very creative. But they're almost like a twenty-four-hour operation. Even when the last customer leaves at 2 A.M. and they're done cleaning at 4 A.M., the next chef is in. But they make it happen. I discovered recently that there's a third, hidden floor where there are chefs improvising. Find your woodshed and shed some wood in it.

Calculated Spontaneity

Question: What is the best process for finding ideas?

There are people who say that a creative person should just make things, at any rate, all the time, and that the best products can be located inside that work later. There are other people who insist that most of creativity lies in meticulous planning. Broadly speaking, these are back-loaded and front-loaded types of creatives.

To make for the most confusion, let's look at the back-loaded first. I have a longstanding obsession with the Bomb Squad, the production team responsible for creating Public Enemy's dense and powerful sound in the late eighties and early nineties (and for working with a number of other groups, from Son of Bazerk to Young Black Teenagers). What was most fascinating to me was looking at the group's song notes. They weren't just jotted-down ideas, or hints about what they wanted to do. They were detailed blueprints of individual songs. Back then ProTools wasn't yet used, so someone had to do the yeoman's work of counting out bars, matching piece to piece, and so on. The song map for "Night of the Living Baseheads" is an amazing document that illustrates the level of intellect at work. If anyone still thinks that early Public Enemy is overemotional thug music, these notes disprove that idea—fast and forever. Nick Sansano, who worked as an engineer on that album and has cotaught a class about the record with me, revealed that there was almost no postproduction on the record, which explains the existence of these notes and makes them even more impressive. Other bands at the time—the Beastie Boys, for example—looped everything together and then did lots of surgery after the fact. They went back in and cleaned up and layered. They slowed things down and sped things up. That creates one kind of sound (think of the Dust Brothers' production on *Paul's Boutique*). The other way is the Bomb Squad/Public Enemy way. I know some of the reasons for it. It saved time, which saved money. But the result is that even before the song was re-

corded, these documents offer a bar-for-bar rundown of exactly what's going to happen in the song. Maybe it specifies that the scratch from Run-D.M.C.'s "Sucker M.C.'s" at the end of the first chorus comes in at bar 48. Maybe it specifies exactly where to slow down to fit in the sample from David Bowie's "Fame." Most normal people, even normal visionaries (think Dust Brothers again) would have cut and pasted and edited tape. That postrecording process would have taken hours to do. The Bomb Squad ran ahead of technology, literally and figuratively. They knew they were on primitive equipment. They knew they were using multiple drum machines in series. And despite all of that, the album sounds like it was made on the spot, like they were confronted with Chuck D's epic lyrics and improvised a brilliant soundscape around them. It sounds spontaneous and powerful, which makes it all the more impressive that it was absolutely locked down from the first.

There are many counterexamples to this, but one of the best is Rick James's "Super Freak." The tape was rolling, and Rick and his band were playing. They only had fifteen minutes per tape reel, and right when they started to gel and lock into each other, the tape ran out. Rick was frustrated, almost furious. But he was listening back to it and there's a part around a sax solo that produced eight perfect bars. They just looped that, like a hip-hop record, and made the song over that. I would have assumed that Public Enemy was more like that, partly because the things I have been involved with tended to be more like that. D'Angelo's *Voodoo*, for example, wasn't all laid out in advance. We felt our way through it and found the record.

I'm torn between these two models. I love both of them. Both of them have made for wonderful work in the world. My analytical brain, which sometimes overtakes the rest, knows that the artwork I get off on the most happens when people do their homework. Here, I think again of J Dilla. He had all these weird nuances in his music, but every one was planned. And then, on the other hand, there's the lesson that Jimmy Jam taught me, which he learned from Prince: that a

When you make work you are the creator, but also the eventual audience.

song starts with a drum part and a bass part, and that you go from there, the skeleton of the song lurching forward, the musicians going where their minds tell them to go. When the bass player zigs or zags, the keyboard player (or the guitarist or the vocalist) follows. The band—in this case, the Time—are accidental tourists. That's how they discover new sights, in those side streets. Creative life sometimes means knowing when deviation from the plan should become the new plan.

There's a related idea here. The same way that the Bomb Squad generated intricate and comprehensive documents about the song they were about to make, creative work can begin by imagining the end of the process. Other books call this visioning, or productive imagining. I call it "The Thing I Did When I Was Younger That I Was Both Proud Of and Slightly Embarrassed By." Earlier in my career, before I would start work on a Roots record, I would imagine the eventual *Rolling Stone* review for my record. That was the gold standard then, the way that you knew that you mattered as a creative artist. (That would change later, to *The Source*, then to Pitchfork, but for a while there it was only ever *Rolling Stone*.) I was interested in how many stars we would get. It was hard to get a five-star review, almost impossible. They gave it to the Clash's *London Calling*. They gave it to Black Uhuru's *Red*. They gave it to a bunch of Al Green records, including *Let's Stay Together* and *Call Me*. But that didn't stop me from dreaming. For me, though, it was more than just a five-star pipe dream. It was a comprehensive exercise. I would think as a critic, imagine which songs might be tapped as standouts, which ones were

slow growers, which ones would seem out of step with the rest of the material. But I went further than that. I laid out the review on a sheet of paper, which meant thinking of a headline ("Roots Revival"). I would even sketch out the illustration that accompanied the review. Those were especially funny. I knew we were a big group, so I wondered how the magazine would get all of us in. I imagined *Mad* magazine–style caricatures of me and Tariq, with the rest of the group flanking us.

This is something that I have done forever, though I have never had a great name for it. Protocreativity? Prepackaging? Whatever it is, it can be useful. If you're a writer, imagine the blurbs that will be on the paperback. If you're a painter, imagine what people will say when they're standing in front of your canvas. This is another example of being present but not-present: you are the creator but also the eventual audience. When you're on the outside of your own work looking in, you'll be able to see the overall shape of it, which will help you to realize that you're on the right track (or, alternatively, that you're not). It's also a way of journeying to the center of what the idea will eventually become. I remember those plastic car and airplane models from when I was young. Some needed glue. Some snapped together. Most of them had plastic flash around the pieces: thin bits of extra plastic that were there because the mold wasn't perfect. Imagining ahead in the process is a way of getting rid of that plastic flash, of melting off what's unnecessary. Different creatives have different versions of this. Ferran Adrià, the master chef who pioneered molecular gastronomy and the creative force behind El Bulli, has long made drawings of his ideas about food. They're amazingly intricate things—diagrams of plates, pyramids of flowcharts that detail the dining experience. I have done a few events with him, and one of the most interesting things is encountering this part of his creative brain. How does it relate to cooking? How might it distract him? What if people love the flowcharts but they hate the cooking?

Let's go to Echo. I don't mean the Eminem song, or even the

Echo and the Bunnymen song "With a Hip," which is one of the earliest places many people saw the word "hip-hop" (it's from 1981, and it's about bunnymen). I mean the Amazon product. You know this thing? It's a tiny tower that sits in your house and takes instructions from it. You have to call it by its name, Alexa, which is Amazon's version of Siri or Cortana. It keeps learning from the cloud. It can turn on the lights in your house or order food. Eventually it'll be able to do everything, and at that point, houses might have no humans in them, just lots of Echoes that speak to each other. I raise this not to terrify anyone, but to mention that Amazon has a process that lets its team imagine big ideas. When someone at the company has one of these far-fetched ideas ("I know—let's make a tiny tower that sits in your house and takes instructions"), they don't start research and development, or even test-market the idea. They start by bringing the product to the press department, and they write up a release as if the product exists. It's kind of brilliant. When it comes out, if it comes out, consumers won't care about the nuts and bolts. They'll care about what the product does for them, easily described, with simple metaphors—the kind of thing you can put in a press release. They have said that this idea is a kind of concrete dreaming. I call it creativity. Amazon has called this process "backward thinking." I will go on to mention other kinds of backward thinking over the course of this book, although if you're reading the book backward, you have already seen them.

So what is the answer? What's the better approach for getting started down the creative path? Should you plan and plan before you dive in, or dive in and take pictures of the splash? In the end, I can only answer correctly, which is to answer with a bit of a compromise: you should plan and plan and plan but never forget to leave a little opening in your plan for the human element. Something that sounds robotically perfect, something that is airless, isn't going to connect with an audience and might not even connect with you as an artist in the moments after you make it. You want proof of life. I try to do that

when I drum. I keep the pocket perfectly, but I also throw in little variations. There was one guy online who tried to call me out on "Dynamite!," a Roots song from *Things Fall Apart*. He claimed that it was just a loop. I insisted that I played it through, because I did. He didn't believe me. Everyone becomes an expert on the Internet. I gave him evidence, told him to listen to the second round of choruses at the fade of the song, where he would hear a slight fill. I knew the exact right place to point him to because when we were making the song, I knew that I would have to deal with claims that it wasn't played live. And yes, I'm aware that putting in a little fill just to fend off future Internet trolls is a little strange and defensive, a little caught between those two modes of creativity and not sure which one to embrace. But that's just an illustration of the power of the question. Advance Calculation or Roll-with-It Spontaneity? It's a death match that will never be fully resolved, and which gives so much creative work its life.

Through the Looking Glass
Begin each day by believing the opposite of everything you believe.

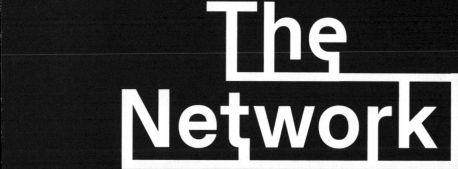
The
Network

You Are Not Alone

Much of building your own creative identity is understanding your-self as part of a collaborative environment. You need counselors, foils, and competitors. You need high-level models for inspiration and flatfoots to tell you the truth. You breathe in all kinds of air so you're never in a vacuum. Prince gets credit as a singular genius, and he obviously was, but if you study him with any level of specificity you see how important all of his creative partnerships have been. Just be-cause he's the one who put them into place, the one with the will to make calls and keep people practicing for endless hours, doesn't mean that his creative relationships weren't a vital part of who he be-came as an artist. Other people are answers to questions, and the big-gest challenge is thinking of what question they're answering. It's like Johnny Carson's old Carnac routine, where he would read the answer and then supply the question. Maybe the singer you know is useful for teaching you about harmonies, but maybe she's actually better for teaching you about how to bounce back from disappointment. Maybe the comedian you know is most useful for talking about geometry. Each creative person has already been through the process of cura-tion. They have already sorted their ideas and selected which ones they're going to show you. Dig for the ones that are underneath the surface, because they may be of great service to you. The majority of my creative life has been spent working with others—in my band, on TV shows, scoring movies.

As I mentioned in previous chapters, when I first met Tariq Trotter, my partner in the Roots, we were high school students to-gether. I knew Tariq a little bit, because on one of my first days, I was down in the office taking care of some paperwork and he was called in to answer charges regarding some funny business with a girl in the bathroom. You didn't do that unless you were the man. He was also a gifted artist and, as it turned out, a fantastic MC. But I'm getting ahead of myself.

In those days, hip-hop was in its infancy, and it was about to be kicked into adolescence by a blind man. This brings us to what I have called "the single most influential moment in the history of hip-hop." Guess what it is for a little bit. No. No. No. Wrong, but close. It's *The Cosby Show,* and specifically that famous episode where Theo and Denise are out driving and they get sideswiped by Stevie Wonder's driver. That kind of thing mostly only happens in sitcoms. Another thing that only happens in sitcoms is that when the driver of a world-famous musical genius sideswipes you, that driver invites you and your entire family down to the studio to see his recording session. The Huxtables don't decline the invitation. Who would? So there they were, on the other side of the glass, watching Stevie sing. Cliff pretended not to be impressed, but he was impressed. Claire swooned. The kids were beside themselves. And then Stevie showed them a new toy. At one point, Theo had said, "jammin' on the one"—I don't even remember now why he said it—and a few minutes later Stevie picked up that sample and inserted it into a song.

When Stevie put Theo's voice down into the sample bed, hip-hop changed forever. There were so many of us out there, so many fledgling rappers and producers who saw that episode and had the tops of their heads lifted. I had known about DJs and turntables for years. But I had never seen anything like what Stevie was doing with Theo's voice. It remade hip-hop production right there, on the spot. And I'm not the only one. J Dilla had the same experience, when he was still the young James Dewitt Yancey in Detroit. Just Blaze had the same experience when he was still Justin Smith in Paterson, New Jersey. Whatever wheels were in our heads started turning.

Santa was also onto it. Right around that time, Casio put that technology in homes with its first sampling keyboard, the SK-1. Do you remember the commercial? It had a white kid noodling on his keyboard and then putting his dog, Rufus, into the song. Rufus barks. The keyboard barks. I don't know if that commercial was some coded reference to Rufus Thomas (the music the kid plays sounds sort of

That's one model of collaboration; put everyone in one place and see what happens.

Memphis-inflected, and Thomas's big hit was "Walkin' the Dog"), but I wasn't doing a deep read of the commercial. I was doing a deep desire of the keyboard. And it came true. I got that thing for Christmas. I used it to take samples of voices, but pretty soon I was also sampling drumbeats. That was the beginning of a new beginning, and a quantum leap forward for my understanding of hip-hop production, though I'm pretty sure I wouldn't have known the phrase "quantum leap" yet, since that show was still a few years away.

Tariq, by this point, was a talented visual artist. He mainly made molds of African medallions. But his creativity had morphed into something verbal as well. He wasn't writing rhymes yet, but he was sitting at one central table in the cafeteria and showing off his skills. By "skills," I mean mostly that he was playing the dozens. Kids would come by and say something to him, causal-like, but with a little edge. You know: the way kids hang out. Maybe they'd take a casual shot at his shoes or his hair. Tariq would look at them, laser-eyed, and then fire back a devastating joke or comment. If a kid was growing too fast and his pants were moving up on his ankles, Tariq would make a comment about a levee, because when levees broke there were floods. If a kid had thick glasses, he would ask them about a nebula, because they were far away, and you needed powerful lenses to see them. These thoughts grew into rhymes. I remember one kid whose sneaker sole flapped around loosely. Tariq told the kid that his shoes were talking, and then, before you knew it, the talking-shoes insult became an image—tongue and all—that he built into a couplet. I don't remember it exactly. His insults were always two

steps down the line, which is to say that they were themselves a great example of creativity.

Before I mastered the SK-1, I was just one of the kids in the circle around Tariq, marveling at his abilities. There's a clip online where the whole early Roots group is in an alley, and we're lobbing topics at 'Riq, and he's firing them right back at us with the most brilliant lyrics. He could handle any suggestion, and did. (He could rap about a table or a haircut or aeronautics. What mattered most wasn't the topic, but the fact that he could take any topic. This is his version of improv comedy's yes-and imperative, and it's nearly perfect proof of his creativity.) Once I had my instrument, though, I was more than an onlooker. I was the other half of something. As amazed as I was by his verbal athletics, he was equally amazed by what I could do with that little keyboard. Kids were already putting some kind of musical backing to Tariq's performances. He would chant his insults, and kids would tap out a James Brown beat on the table. But once I figured that out, I could just put that beat into the SK-1 and program it to back him. He noticed, and I noticed that he noticed, and a bond began to form. It was a bond of mutual respect but also mutual need. He saw that his performances were greatly improved by backing percussion, and I saw how my growing sampler skills could turn into something that had real social and cultural power.

We worked out a routine for our collaboration. He would come to lunch and start razzing kids, and at some point he'd get into a rhythm. That rhythm would suggest, either to him or to me, a sample. I remember one week near the beginning of senior year, Tariq was building an insult that was drawing on everything in the news: maybe Baby Jessica, who had fallen down a well in Texas; maybe Robert Bork; maybe Iran-Contra. His dexterity was a rarity, as they say. At some point, one of us started beatboxing Audio Two's "Top Billin'," which was a song on everyone's mind back then. I suddenly had a purpose. I left the cafeteria, which was on the eighth floor, and ran all the way to the basement, to the recording studio, to drum the beat of

"Top Billin'" into the SK-1. Then I hustled back up to the cafeteria so that Tariq could perform over it. That day, the collaboration didn't work. He hadn't been able to fit his rhymes around "Top Billin'." He had something else in mind, Busy Bee's "Suicide," but we were out of time. The next day, though, he tipped me off earlier, to Big Daddy Kane's "Wrath of Kane," and I went down to the studio and brought it back.

This was a collaboration, a partnership in the truest sense. We each had our roles. We negotiated briefly, but most of the energy in the process was spent participating. He waited eagerly for my beat so that he could get going with his lyrics. I excitedly assembled my beat because I couldn't wait to hear it with his lyrics. Collaborations work best this way, when there's a mutual desire to see what the other side adds. You know that what you're making on your own has value, but the sum is more than the parts, and every part knows it.

Community Activism

That's the traditional definition of collaboration, right? Two creative forces coming to a summit meeting where each benefits the other. And that's how Tariq and I worked for those first years. We added in musicians. They contributed, of course. We added in mentors like Richard Nichols. But the core remained that formative one: his words, my beats. Each creative endeavor develops its own unique DNA, and this was ours.

As we embarked on our career as a hip-hop band, the idea of collaboration broadened. Our second album, *Do You Want More?!!!??!*, was mostly an internal affair: we brought in people like Dice Raw and Ursula Rucker along with M-Base artists Cassandra Wilson, Steve Coleman, and Greg Osby, but we operated within the confines of the group. For *Illadelph Halflife*, though, our scope broadened. From the beginning, we had modeled ourselves on the Native Tongues collec-

tive, the corner of the hip-hop world that included A Tribe Called Quest, De La Soul, and Jungle Brothers. We imagined that we were at the center of a similar world, one called Foreign Objects. Very early on, we tried to set up touring packages that included a number of different groups underneath the Foreign Objects umbrella. But as it turned out, the Roots were the only group in that set that lasted. Still, as we came through *Illadelph Halflife*, we were aware that we all had connections to different parts of the music world, and we tried to unite them all under the banner of the record. That album includes contributions from Bahamadia, from Raphael Saadiq, from D'Angelo, from Q-Tip, from Common, from Steve Coleman, from Joshua Redman, from Cassandra Wilson. People took verses or sang hooks or performed featured solos. But collaboration wasn't a plan that we drew up and executed. It was just an organic fact, if not exactly an Organix one. We knew musicians. They knew us. We made records. They did, too.

For the album after that, though, the idea of collaboration shifted into overdrive. *Illadelph Halflife* sold decently well, around three hundred thousand copies (eventually it went gold.) In today's numbers, that's like a billion. But to a record company at the time, it was a holding-pattern number. You might not kick a group to the curb for selling three hundred thousand, but you wouldn't buy them a mansion and a fleet of luxury automobiles, either. It was just big enough to let the label know that they were on to something. Also, we had been moved within the Geffen family to the MCA label, part of an endless series of label shenanigans. At that time, Rich, our manager, decided that we needed to go to the record company and make some demands about our future. They were modest demands, but they were unconventional. I had moved to a house on St. Albans in South Philadelphia. Rich told the label that they had to start paying for jam sessions at that house, and that the music created there would form the basis for the new album. Paying for jam sessions meant more than just running equipment: they sprang for transpor-

tation in the form of two vans and also for a chef to cook for whoever dropped by. All the factors lined up like a powerful electromagnet, and soon enough we were attracting all the local talent. The Roots were there, of course, but also a bunch of other people at the start of their careers. There was Jill Scott, who was working at a clothing store but knew that she wanted to devote more attention to singing. There was Jamal, who was working as a pizza-delivery guy but was writing and playing songs; he turned out to be Musiq Soulchild. Bilal was there, and India.Arie, and Eve, and Common. It was like a salon. I remember more than once coming home to find a huge jam session already in progress. And not just in progress—getting out of control, with too many people and too much noise. I was the buzz-kill. I would run to my bedroom, grab the telephone (it was one with a cord—this was back in the twentieth century), and call the police to report a disturbance. I narced out the noisemakers in my own house. But I saw how amazingly it created a space where people could work together, where ideas took hold, where they bounced off one brain and into another brain. Early on in the book I talked about cognitive disinhibition, and how a Harvard psychologist developed a theory that creative people filter the world around them differently, or rather less. They see too much. It gets in their head. They then have no choice but to make things. That's what St. Albans was like all the time back then. That pebble went into the pond and rippled. What was happening at St. Albans expanded into two nightclubs: the Five Spot in Philly and the Wetlands in New York. That part of the scene focused largely on the Roots and hip-hop, and not only launched all those careers, but brought us back into contact with Scott Storch. And when that version of the movement went from cocoon to butterfly around 1999—the Roots released *Things Fall Apart*, went platinum, and hit the road, and other artists in that circle emerged—the collective morphed into the Black Lily movement, which kept things going when we were touring. Black Lily focused primarily on female or female-centric artists like Jazzy-

fatnastees, Jaguar Wright, and Jill Scott. Floetry arrived stateside from London to become part of the collective. Les Nubians came from Paris. Kindred the Family Soul led the crest of the second wave of acts. The eight-year-old Jazmine Sullivan slept backstage for most of the evening and then came onto the stage to perform. At the same time James Poyser and I, working mainly with Erykah Badu (and then later with D'Angelo and Common) at Electric Lady studios in New York rather than in the nightclubs, evolved yet another version of this musical collective, which we called the Soulquarians. People like Bilal and Nikka Costa came around. Others came back around. There was an aftereffect that has resounded in the music world in the years since, as well: the musicians who worked steadily through that period as teens—Adam Blackstone, Omar Edwards, and others—have become the backbone for major stars like Rihanna, Jay-Z, Adele, and The Weeknd. And then there are the technical support personnel, the lighting directors and the soundmen and the tour managers—all in all, there are probably a hundred careers that grew out of that fertile soil.

That's one model of collaboration: put everyone in one place and see what happens. There are obviously tons of examples throughout history that have worked this way. But there are other models, too, that have to do with learning how to reach out, how to stretch your arms, how to close your hands around what you find when they're outstretched, and how to bring it back into your world. In the spring of 2017, I conducted a series of conversations at Pratt Institute with other creative artists, and for one of those I spoke to the film director Ava DuVernay. She spoke about the importance of using her films to communicate a personal message, but she also spoke about the strategy of creating a distribution collective to ensure that work made by filmmakers of color reaches its audience. Her organization, ARRAY (it used to be called AFFRM), puts movies in theaters, and also on Netflix. ARRAY has a collective goal, and it recognizes that there is strength in numbers.

Import Importance

The album we put out right around the time of *Voodoo*, *Things Fall Apart*, was our most acclaimed album and our bestselling one, too. It was a watershed moment for the group. When it came time to record a follow-up, I wanted to be aggressive about pushing the envelope artistically. Because of *Things Fall Apart*, most people saw us within the context of neo-soul. I didn't want to repeat that. I wanted to show that we were much more than that, that we could pick up the threads of our past releases (we had flirted with acid jazz on *Do You Want More?!!!??!* in 1994 and Wu-Tang-ish dense hip-hop on *Illadelph Half-life* in 1996) but also weave a new tapestry. There is also a psychological dimension to the departure, a fear of following up or a desire to step away from the work you've already made before the audience makes that choice for you. That's what motivated albums like *Sgt. Pepper's* or *Paul's Boutique*. And that's what was motivating us.

While we were on the road, dream hampton, a poet and friend of the band, gave me a CD to listen to by a new artist. It was a demo, kind of rough and blunt, but I liked it, especially two songs called "Bitch I'm Broke" and "Boy Life in America," which were kind of punk soul, with very blunt lyrics. When dream went into the gas station, I snuck a look at the CD case and saw it was a guy named Cody ChesnuTT, styled that way, with the two capital T's at the end. That was all. Just a name. At that time, there was no social media yet, not really, so the whole idea of expanding your network, or using your network to teach you about how it might expand itself, was foreign. I had started an online community called Okayplayer, a mix between a message board and a chat room, and I went on and asked if anyone knew about this Cody ChesnuTT. Most people didn't.

A few days later, I went to MCA, our label, and one of the guys working there mentioned my Okayplayer post to me. He hadn't seen it, but one of his interns had. (That's another thing about networks—they have to work across levels. If I had been networking only with

artists my age, with similar experience and similar tastes, I would never have learned anything.) The guy told me that he wasn't a huge fan of the record, but that he could find me a disc if I wanted. He went into a big bin that was like a CD graveyard and came up with a few copies of the CD. At that point, I was still in the frame of mind of seeing other people as a collaborative resource. The first thing I thought of when I encountered a new talent wasn't what they reminded me of, or how far they might go, but whether or not the Roots could work with them in a way that made sense. I listened to the Cody ChesnuTT album with that in my head, and the song that jumped out at me was "The Seed." It wasn't the most fully realized song, but it was sticky, like grip tape, with a good groove and plenty of room to grow into a hip-hop version. Collaboration isn't about what's there so much as what's not there. It's the jigsaw puzzle with a few pieces missing and a pile of bright pieces nearby. Tariq agreed, and after a few tries he had new lyrics for it. We set up a session with Cody. The recording session was both a perfect example of the promise of collaboration and a perfect example of the problems of collaboration. In those days, even more than now, I liked to record at night. Cody was supposed to land from California in the early evening and come right over. But someone (maybe it was Rich) wanted us to work earlier in the night rather than subject a new collaborator to my crazy schedule. That would have been fine, except that it conflicted with another kind of collaboration—I had a date to go see a movie. I complained, and Rich said it was fine, that they would just record without me, which he knew I wouldn't accept. I pushed my date a little later, told her that I'd meet her at 8:15, and got ready for an efficient recording session. It wasn't always the way, but this time it had to be the way. Cody got to the studio about 7:30, said hello, hung out, and we didn't get down to real recording until 7:55 or so. I was drumming with my coat already on. We got through the song once and had to go back for a second try, at which point the air conditioner blew my song map to the floor. "Don't stop the tape," I said. You can still hear that on the

tape. That's still on there. Now it was almost eight. We went through the song again, and I went out the door. Those last three beats were done one-handed, with my other hand resting on my bag.

It wasn't an ideal collaboration, like you see sometimes in movies, where two like-minded artists spend the summer creating a series of paintings or figuring out a movie. But as quick as it was, it had a certain feel; it was the product of his energy and our energy in a way that I knew it would be the second I heard his album. Collaborations can be chemical like that, and it doesn't matter if they happen in a mansion over the course of a week or in a recording studio on one hectic night. Sometimes, it's as simple as adding sodium to water and standing back. (Don't do this at home! Don't even really do it in a nearby lake. Just watch the videos on YouTube instead.)

The magic was audible, and not just to us. The producer Don Was said that it was his favorite record of that year, and he played it for the Rolling Stones when he was producing them. "That's the kind of sound we want," he told them. That's the best-case scenario for a collaboration, and it's most likely something that will never happen to me again: hear a song in the car, get the CD dug out of the bottom of the reject bin, call the guy, meet the guy, record with the guy, get a hit, get put in front of the Rolling Stones.

An Elastic Band

At the time we were working with Cody, collaboration happened mostly along those two tracks: first, putting people in the same room for a long time and seeing what happened (often, it's magic; sometimes, it's just time passing); second, hearing something that I knew would make a great combination and making it happen (usually that works out on the plus side of the equation). But as the Roots got older, we started to have a better—or at least more complicated—understanding of how to collaborate on music. A big factor in this

was our day job as the band for *Late Night* and then, later, *The Tonight Show*, where we collaborated with people all the time. Here's how that job works: We come to the office and see a schedule of musical groups that have been booked as guests. Every once in a while, they will bring their own band. But often, the artist's name on the booking sheet means that we are, for that moment, that artist's band.

For me, when I started, that meant that I had to suddenly learn a ton of new things. Not just new material, but a whole world of music. I was always pretty open to new things. As I have said, my dad had THE record collection, and it wasn't a narrow one, either. I heard all the music of the seventies in the seventies. And even my dad's influence was only part of a whole. My sister, who is a few years older than me, went to school and came back with exactly what you would expect: Steely Dan or Boston or Fleetwood Mac. My mom loved digging in the crates for cool albums with cool album covers, which meant that she ended up with records that featured Mati Klarwein's paintings, such as Miles Davis's *Bitches Brew*. From an early age, I was all prepared to be diverse.

And yet, *Late Night* was still a little bit of a culture shock. At that time, in New York, there was a blossoming Brooklyn music scene, and I developed kind of stereotypical ideas about those Brooklyn bands early on. They were hipsters. They played rock and roll but played it ironically, whether that meant touching on seventies styles that they didn't completely embrace or forging into a kind of math rock where the whole idea of traditional verse-chorus-verse songs was challenged.

About six months after we started, *Late Night* booked Dirty Projectors. I assumed just more of the same: Brooklyn band, attitude. They came in and we went into the studio for afternoon rehearsal. The second they started playing, I was internally apologizing for assuming that they would be one way when they were, in fact, so many other ways. They had these three female singers doing complex syncopated vocals and then they would just burst into choir harmonies. I

looked around, trying to catch the eye of someone else in the Roots. It ended up being Kirk, and the two of us just stared at each other. We were so shocked and impressed that when we got backstage we were still humming. Kirk insisted it was ProTools. No one could have done live harmonies the way those women did it. While we were talking, Amber Coffman, one of the singers, walked by us in the hallway. Kirk called her in and asked her if she could do the harmonies live.

"Sure," she said. She went and got the rest of Dirty Projectors and they re-created them. When I posted the video, it went viral.

When it came time for the Roots to make our album *How I Got Over* in 2010, we put them on the record. Other people we met through Fallon were on there, too. We had the Monsters of Folk—Jim James and Conor Oberst and M. Ward. We had the harpist and vocalist Joanna Newsom. These were different kinds of collaborations from Cody ChesnuTT, which happened because I heard a certain similarity. These collaborations happened because I heard certain differences. It wasn't only that we were going for a new sound as a band. We were going for a sound that itself contained multiple sounds, for ideas that were collisions. Those kinds of combinations—unexpected ones, but ones where both parties are determined to produce an outcome that lives up to their respective creative reputations—are absolutely necessary. They may not always make for the best music, but they always make for the best creativity. They force you to define yourself again, which is vital for a midcareer creative. In 2013, the Roots did a record with Elvis Costello called *Wise Up Ghost*. It grew out of his appearance on the show, where he loved playing with us, and we put together a set of songs, some new, some remakes of older material. Over the course of that record, we needed to understand what made us Roots in comparison to his Costello, and he had to understand the same project in the other direction. For bits of both artists to survive into the final product, they need to make themselves visible to one another, and to themselves. Every successful collaboration is also a fight for your own creative life.

It Takes Two

Some ideas are one-person ideas. Once they leave that one person, they go through many other stages—they get produced, or published, or filmed—but they start inside one head. Other ideas are two-people ideas, truly collaborative efforts. Those ideas happen as a result of partnership, and creative partnerships are like other kinds of partnerships: lifelong friendships, business relationships. They have push and pull. They have ups and downs. They have times to speak and times to be silent. I have been in a band for more than two decades that has depended on collaboration, and I have watched other kinds of partnership—songwriting teams, comedy teams, writing teams. Being a collaborator is a constant learning experience. You quickly learn your strengths and your weaknesses. Admittedly, I'm not always a good communicator. I am not always straightforward about asking what I want out of a creative partnership. I am not always clear with myself on the difference between doing the work and running the operation. It can be difficult to deep-dive inside yourself and figure out all the things about you that work and don't work, let alone the things that work and don't work in collaboration with someone else. But here are some general tips for making creative collaborations work.

—*Set aside a time and place.* This is a fundamental principle, and one that is too easily overlooked. Maybe your creative partner works better in the morning, but you prefer evenings. Some people will recommend compromising and meeting in the afternoon. That seems like a weak solution to me. I'd recommend a different kind of compromise. Go morning one day, evening the next. Same with place. You don't always want to be the host. Sometimes make the trip to where your partner lives or works. This may seem obvious, but it's not just about accommodating the feelings of your partner. It's about making sure that the greatest number (and widest variety) of ideas make it out of the brainstorming process.

—*Be open and curious, and expect the same in return.* We have talked about creative disinhibition, and how creativity depends on not filtering your ideas so much that strange or unexpected ideas disappear. The same is true for a partnership. Be receptive to ideas that sound strange. Maybe be receptive to those ideas especially, because the tendency is to be dismissive. When you give a fair hearing to a strange idea, you might loosen up your own idea to the point where it's significantly improved. Say you're collaborating on a song about returning veterans, and your songwriting partner suggests including a kind of calliope sound that gives the whole thing a carnival feel. Don't reject it out of hand. Maybe there's something to that. Maybe it's gallows humor, or it shows the way the government doesn't take its responsibility to vets seriously. And if that doesn't work, maybe the general idea of sound effects or a kind of novelty is a good one. Military drumbeats? Too obvious? Maybe you're right, songwriting partner. But let's keep exploring.

—*Analyze.* They say that creativity is a mysterious process, and that's of course true to some degree. But one of the things I'm trying to do in this book (and, for that matter, in my life) is to demystify it, or at least show certain ways in which the mystery is a myth that people keep alive to avoid dealing with the nuts and the bolts of the process. This goes for creative partnerships, especially. You might think that working with a creative partner is about finding a groove, or jamming, or everyone nodding their heads when they reach that magic plateau where things are sounding just right, but it has to be more than that. Learning to be analytical about your collaboration is an important part of the collaboration. You may illuminate some of the uncomfortable dynamics or solve problems that you didn't even know were interfering with your progress. This is the second layer, the "meta" of *Mo' Meta Blues*. It's also the same principle as meditation. You're always in the booth and always outside the booth watching. Be clear with yourself (and others) about what's working and what's not working.

Every successful collaboration is also a fight for your own creative life.

—*Positive reinforcement works.* One special form of communication is praise. You don't have to be insincere about it. No one likes to have smoke blown at them. But you can be honest about what is working in the creative process. If you are collaborating on a song and you're impressed by the idiosyncratic meter of the lyrics, say so. Your creative partner is taking risks, the same way you are (hopefully), and you don't want to leave him or her hanging. Over the past year, I've tried to train myself to get better at administering praise, to control my trigger finger for criticism and be better at dispensing praise. Because of my dad, I came from the *Whiplash* school of motivation, where saying that someone else did a good job was seen as a weakness. I definitely did not come from the world of participation trophies. I have a tendency to turn up my nose at people who aren't willing to use elbow grease and bloody knuckles to get further in the process. I don't believe in perfection, but I do believe in satisfaction. Still, now that I'm a little older and a little more mellow, I recognize that other people need praise.

Working It All Out

Even when you follow these helpful rules, collaboration is never going to be easy all the time. The most common problems in collaboration, in my experience, revolve around resentment. One person feels that his or her ideas aren't getting enough of a hearing, or that they're being twisted to suit the other person's ideas. The most common

form of resentment, of course, comes at the end of the process, especially at the end of a successful process.

 I'll call your attention to a very odd thing that happened to the Beatles. Everyone knows a number of Beatles songs, assuming that they are human beings. And most everyone knows that when they credited their work, most of the songs were credited as collaborations between John Lennon and Paul McCartney, even when that wasn't entirely the case. Early on, the two men wrote together, but even as they started to develop their own styles within the group, that label stayed. Showbiz. Well, at some point in Paul McCartney's life, that arrangement started to rankle him. I'll let Paul take over here. This particular version comes from an article in *New Musical Express,* but it's a story that McCartney has told dozens of times.

> We had a meeting with Brian Epstein, John and me. I arrived late. John and Brian had been talking. "We were thinking we ought to call the songs, Lennon and McCartney." I said, "That's OK, but what about McCartney and Lennon? If I write it, what about that? It sounds good, too." They said, "OK, what we'll do is we'll alternate it: Lennon and McCartney, McCartney and Lennon." Well, that didn't happen. But what happened was the *Anthology* came out and I said, "OK, what they're now saying is, 'Song by John Lennon and Paul McCartney.'" I said, if you're doing that, it's not Lennon and McCartney, it's not the logo any more. So, in particular cases like "Yesterday," which John actually had nothing to do with, none of the other Beatles had anything to do with, I said, "Could we have 'By Paul McCartney and John Lennon,' wouldn't that be a good idea? And then on 'Strawberry Fields' we'll have, 'By John Lennon and Paul McCartney.' 'Penny Lane,' 'Paul McCartney and John Lennon.' Seeing as we're breaking it up, can we do that?" And at first Yoko said yeah. And then she rang back a few days later and she'd decided it wasn't a good idea. And it became a bit of an issue for me. Particularly on "Yesterday," because the original artwork had "Yesterday" by John Lennon and Paul McCartney and a photo of John above it. And I went, "Argh! Come on, lads!"

Yes, lads. Argh! This is an incredible passage about an incredible chapter in pop music history. Collaborations, even those that are pleasant in the process, can be unpleasant in the product. Maybe you care if your name is first. Maybe you don't give a damn if they alternate. Maybe you are more satisfied by playing the title character than by getting highest billing. Just make sure that everyone's clear. Oh, and get to meetings on time.

When I was writing this chapter, a friend had an interesting suggestion. He said that collaborators should be as creative with issues of credit as they are with the original ideas. "Start from a 50/50 split and then play some games to push it a few points one way or the other," he said. "Or be listed alphabetically, but not by your name— by the word that represents the number of letters in your name." It's worth thinking about, if only because it keeps the collaboration in its comfort zone, focused on making things rather than on the things that have been made.

We've looked at how the process of locating yourself inside of a collaboration can function as a sort of redefinition, how you can come to see yourself anew when you see yourself next to different people. As I mentioned in connection with the Roots-Elvis Costello collaboration, this makes you reassert your identity. But it can also make you revalue it. If you felt tall your whole life and started hanging out with the Knicks, you'd have to adjust accordingly. Collaboration can be like hanging out with the Knicks. You're not as tall as you thought you were. But you have other qualities that you didn't notice until you stopped being preoccupied with your height. This is a thornier issue, and potentially a more profound one: collaboration can not only allow you to place yourself in close proximity with other creatives and watch what happens, but it can fundamentally change you. I mentioned before that some collaborations are like throwing sodium into water. What I didn't mention, because my grasp of chemical metaphors is limited, is that the sodium burns up. It's changed forever.

There are examples of this in my own creative life, and one of them began on one of the most momentous days of our nation's history. On the morning of 9/11, I was in New York. The night before, the Roots had played a big Michael Jackson tribute show at Madison Square Garden, and our hotel rooms downtown didn't pan out for some reason. Our reservation had been dropped, or a credit card number had been transmitted incorrectly. Whatever the case, there were no rooms for me. It was one of the only times in my career that I threw a full diva fit, a four-to-the-floor "Do you know who I am?" And it didn't even work. I was sent uptown to a different hotel in the Bryant Park area, where I went to bed, exhausted and frustrated.

The next morning, I woke to the news. A plane had flown into the North Tower of the World Trade Center. A few minutes later a second plane had flown into the South Tower. My first impulse was to run to the front desk to make sure I could extend my stay. My second was to run outside and get a cab. New York was as silent as *Vanilla Sky*'s first ten minutes, but I managed to find a cabbie. I gave him a hundred bucks and told him that I only needed to make a short drive over to the Virgin Megastore, and that I'd pay him to wait and drive me back. I loaded up on music. I can't remember all the records I got, but one of them was Jay-Z's *The Blueprint*, which was released that day. It became my post–9/11 soundtrack. I had mixed feelings about Jay-Z at that point. He had immense commercial success, and he didn't seem to have the necessary self-reflection or self-doubt. The gangster face put me off. But when I listened to *The Blueprint* in the wake of 9/11, I started to feel such a deep connection to it. I realized that Jay and I had plenty in common, including East Coast roots and a love for the music. We also had people in common, including the writer dream hampton. I told her that I had come around to Jay and to *The Blueprint*, and she passed the news along to him. He was thrilled, she said. That mattered, too: I didn't know that he cared what I thought. That process was the beginning of a kind of collaboration, though it was mediated and abstract.

It also helped me to develop another one of my important theo-
ries about creative work. I had always believed that there were two
types of artists—Type A, achievers; and Type B, creatives. If I had
written this book back in 1998, I would have depended upon that dis-
tinction. They were two different tribes, two different kinds of artists.
The Type A artists are very directed toward product. They produce a
tremendous amount of work. Often they are looked down upon by
the Type B artists, who think of themselves as something more pure.
Jay-Z, of course, was the classic Type A. That was part of the reason I
was suspicious of him. But about a month later, he sent out word that
he wanted the Roots to back him on his *Unplugged* album. When we
got the offer, I panicked. I had listened to *The Blueprint* solidly for a
month. I had immense respect for him, a million times more than I
had before. But I still wasn't sure about collaborating with him. We
had our fans, and they saw us as a certain kind of thing—in the short-
hand I'm using, hardcore Type B. For a little while, I avoided Jay's
calls. Then I gave in, still a tiny bit against my better judgment. It
ended up being one of the best decisions of my creative life. As I have
said, I have worked with hundreds of artists in my three decades in
the business, and each and every one of the collaborations has had its
own strange mix of ego jousting and creative strategy. Sometimes
you have to rep for the idea you don't want, because you know in ad-
vance that the creative process will reverse your suggestion. Some-
times you have to agree with everything you're presented while
you're putting a third party up as a kind of agitator. Collaborating
with Jay was the easiest thing in the world. He listened to everyone,
asked questions, and then gave his opinion. The first few times we
came to decision points, I couldn't believe how simple it was to work
with him.

In fact, that collaboration made me rethink my entire theory up
until that point. During the year before the Jay-Z collaboration, as I
have said, I spent most of my time and most of my energy with a
group of like-minded artists who convened at my Philly house.

Spending time with those artists was wonderful in nearly every respect, communal and miraculous, but it could also be backbreaking. Everyone was the same type of creative person, inspired and driven but not conventionally self-confident, passionate about the ideas they wanted but not straightforward and lucid in communicating those ideas. There were constant battles about listening and credit and all kinds of things that were central to the creative process—or so I thought until I worked with Jay. I had, in my mind, put him on the other side of the line, stereotyped him as an achiever rather than a creative, but we got so much creative work done with him, with a minimum of friction, that it changed my way of thinking. It taught me that different styles, not just different ideas, can be complementary rather than contradictory, and that creativity is a larger idea than I might have thought when I was a young art punk.

Later on, I ran across an interview with Björk from the German show *Why Are You Creative?* Björk is talking with the host, Hermann Vaske, and he mentions the British artist Damien Hirst, specifically an interview in which a reporter said something to Hirst about a piece of his, that he could have done it. "Yes," Hirst said, "but you didn't." Hirst's quote seemed defensive; I was more interested in where Björk took it.

> I think everybody *could* do it and for me maybe I'm not so concerned if it's creative or not. Maybe because I'm brought up in such a working-class situation and the people I admire most, like my grandmother or my family, if you would look at their passport no one of them says artist. But for me all of them have been very brave and completely stood by what they have made. To take care of a lamp shop is a very creative thing, or to feed eight children can be a very prolife statement with all the hindrances and everybody wanting to stop you. My grandfather, he would show me a fireplace he has just made and he is as proud of it, just as proud as if I was playing a song.

Achievers and Creatives can stand in the same place and erase the idea that there is any real distinction between the two.

For me, that crystallized some of the things I had been thinking since the Jay-Z experience. Maybe he wasn't as hung up on whether what he was doing was creative. I mean, it was, and he knew it was, but there's also that other personality—the hustler, the CEO as top-dog hustler, the get-things-done guy, the person who instinctively recognized that people who weren't Artists in the capital-A sense were also doing things that they could be proud of and should have been proud of. It was more inclusive and maybe a little kinder in some ways. Artists who kept their capital A also kept a sense that they were somehow different from everyone else. That could be valuable. I knew that more than anyone. But maybe it could be a drawback.

I know that this returns to something I said early on, which is that everyone is creative in some ways. If you think you're creative, you are. And maybe the more arty you are, the more you need to yin-yang it with an achiever: it produces results and reduces anxiety. I have seen versions of this principle many times over the years, but I didn't feel the full force of my Jay-Z revelation again until the 2016 Roots Picnic, when the band backed Usher on a full set of his hits. Going into it, I had some concerns. Would it be a good match? Would we fit together? Usher had a reputation as a guy who was more like Jay: a hitmaker, a chart dominator, a commercial presence who wasn't necessarily connected to the art on a deep level like, say, the Soulquarians. (Again, I'm not saying this in a judgmental or mocking way in either direction. I'm just differentiating between two approaches to creativity.)

As it turned out, it was a dream.

Usher was completely out of his comfort zone. He had been a solo act in the classic sense, whereas the Roots consistently work with different artists. But Usher had no fear. He gave us carte blanche to take his music to new places. In other collaborative environments, I was accustomed to seeing people say "NO" to me, brazenly, *Electric Company*-style. I saw the word coming out of their mouths. I didn't see the word "NO" coming out of Usher's mouth once. From the second I knew we'd be working with him, I started to have ideas about what needed to be done to his music. I was pursuing an idea, which was to return soul music to its spiritual basis. It used to be a music with uplift, a music that instilled survival strategies in African Americans. I wanted to work Usher's catalog with those goals in mind. And when you talk about his catalog, you have to start with *Confessions*, which sold more than ten million records. It's a textbook example of how to make pop that works. I wanted to muddy it a bit. I wanted to take the flash away and put him in an environment that was more of a legitimate seventies concert, to trade some of the things in the songs that were synthetic for things that were emotional. I had peanut butter intended for the chocolate of *Confessions*. We played him our idea. We explained it. We worked through it. And then, because this is how collaborations work—and how the best ones work best—he started to contribute in ways that I couldn't have expected. He started to have ideas about arrangements, about performance, about pauses. We discovered to our surprise that he had a baritone. He was doing some Barry White-type ad libs. It occurred to me that with more time, we could really do something with that. But there was a schedule. We had to keep it. The show itself was about 70 percent of the way to being the perfect rethink of Usher, but it was an amazing illustration of how Achievers and Creatives can stand in the same place and erase the idea that there is any real distinction between the two. Later on, I had Usher on my Pandora show, *Questlove Supreme*, and he was just as sharp there, just as willing to talk about creative limits and rethink his earlier work. My cre-

ative relationship with Usher, and my respect for him, has gone a long way toward changing my understanding of the difference between Achievers and Creatives.

Social Networks

These days, collaboration has a second meaning. There's a shadow collaboration that takes place online. When I discussed Cody ChesnuTT—how he came to our attention as an artist, how we reached out to him—I mentioned that I went on Okayplayer to ask fans if they knew anything about him. That was in the early days of the medium. We had the Web, but we didn't have anything close to the social-network environment of today, which is rich with (or rotten with, depending on your perspective) Twitter, Facebook, Instagram, Snapchat, and more.

I use technology as much as anyone. It starts in the morning, when I wake up and check my phone. It ends at night, when I check my phone and go to sleep. In between, I'm online like most people, which is to say I'm online all the time. When I'm on there, I'm interacting and interfacing with people in a variety of ways. I'm reading other people's posts, noting who is reading and responding to mine, piecing together a tissue of sources and authorities. The Internet has indisputably changed the way we read and think and converse, so why wouldn't it change the way we create? It has, of course. And it's natural to worry that it's changing it for the worse.

One of the things I read recently online was a spirited defense of the Internet as a creative environment. It was written by a marketing professional, so I approached it with more than a little skepticism, but it also made good sense, so I felt my skepticism draining as I went through it.

I don't remember the guy's name, but he made an argument that most real creativity comes from the combination of unexpected

things. It's the Reese's Peanut Butter Cups theory of how things get made, and it has some validity. He talked about Picasso and African art as one prominent example. If I'm going to quote the guy, I should go find the piece. Hold on. Okay: got it. It's from *Forbes* online, from 2014, and the writer is named Greg Satell. He used Picasso as one example, and also mentioned how Darwin "[combined] insights from economics, geology and biology to come up with his theory of natural selection." He went on to say that the very notion of combination comes up in most theories of creativity, including Douglas Hofstadter's theory of strange loops. I didn't know much about strange loops, so I took a little time to read about them. Hofstadter wrote about these loops in the context of M. C. Escher, whose drawings seem to take you all the way around a certain mental or physical journey only to return you to the same place where you started. Hofstadter talks about how this takes you through several levels, where you think you're moving down or up but are in fact not moving; it's your perception that is moving. He takes it into complicated ideas of mathematics, but also into simpler ideas of psychology. The self, he says, is one of these loops: we pass through a bunch of layers on the way to coming back and being the same self, and we only make symbols about our existence, and stories about ourselves, because of these loops. The Internet, Satell argues, is a great and efficient vehicle for creating these kinds of loops and for connecting us to other loops. Maybe in passing someone would mention something to me, a strange reference like Hofstadter's loops, or the way a certain Roots record reminds them of Roland Barthes or Ishmael Reed. It used to take a significant amount of time and effort to get me to track down those references and then to figure out how they fit into what I was working on. Now, it all happens in a few mouse clicks. Networks can (and do) form more quickly than they once did, and people can (and do) see connections more easily than before. In that sense, all the benefits of networks that I sketched out above are right there in front of us.

One good example of this is coming up with song titles. I have a friend who is a songwriter. He doesn't like to name his songs after words in the lyrics. I don't know why he doesn't just take the easy way out. It worked for Al Green and James Brown and the Beatles. But he wants to name his songs weird things. He used to have a complicated way of finding words. He would drive around town, noticing words on signs, and when he saw a word twice, he would use it. It was a variation of that game kids play on long road trips, where they have to find a word that starts with A, a word that starts with B, and so on. Maybe people don't think of that game as creative, but it is—it's giving shape to a set of words that are otherwise randomly scattered on signs. And his driving around was also creative, because it attached titles to songs. In the last few years, he's started adapting the title-finding strategy for the Internet. Now, he'll type the chorus into a search engine and pay attention to the kind of sites that come up in return. I don't want to step on his work, so I'll illustrate using a Roots song: say "The Seed 2.0." If I search on "seed" and "push" and "life," what do I get. Hmm: most of the results I get are links to lyrics for the song. Let me do it again and subtract "Roots" from the search. Now I get results for skateboarding sites, for something called PUSH ("Persevere Until Success Happens Through Prayer"—really, isn't that PUSHTP?), for Five Tips to Help with Tomato and Pepper Seed Germination. If I were titling songs the way my friend does, I might call it "Tomato and Pepper Germination," a perfectly good, strange name for a song. And because the Internet works by odd association, it also sparks odd association. The fan who sees that a song is called "Tomato and Pepper Germination" goes backward through the same loop, thinks that it's strange or gets used to it, but does his or her own version of hitting all these different levels and combining them into something new. This is just a new form of free play that became possible because of the capabilities of search engines, but remember: free play is one of the most important forms of creativity.

That's the good news about the Internet. Well, it's not all the

good news. We didn't get to economics or distribution technologies or the way in which it has pulled in the distant corners of the world. But for each of these pieces of good news, there's a piece of bad news. What's the bad news with creativity and the Internet? As luck would have it, the bad news is also on the Internet. As long as I have been going online, I have had the suspicion that it was doing something to my brain: not necessarily making it weaker, but transforming it into a different kind of instrument. Rather than stay inside itself and cultivate ideas, it knows that it has to go out into the world and find ideas that match some impulses and instincts that are beginning to stir. With the help of the online world, the brain is more a hunter-gatherer and less a farmer. At some fundamental level, that seemed less creative—or, at the very least, less of the process of creation was taking place inside my own head.

The most complete version of this theory came from a guy named Nicholas Carr, who argued that the Internet actually changes the shape of our brain and how it works. Or at least that's what I think it says. Carr wrote a book called *The Shallows*. I didn't read the entire book, though I read the article in *The Atlantic* that became the basis for it. (Is that shallow?) It was called "Is Google Making Us Stupid?," and it came out all the way back in 2008, when the Internet's hold on us was weaker than it is today. In the piece, Carr says that he noticed that his experiences with the Internet were changing the way his brain felt to him:

> I can feel it most strongly when I'm reading. Immersing myself in a book or a lengthy article used to be easy. My mind would get caught up in the narrative or the turns of the argument, and I'd spend hours strolling through long stretches of prose. That's rarely the case anymore. Now my concentration often starts to drift after two or three pages. I get fidgety, lose the thread, begin looking for something else to do. I feel as if I'm always dragging my wayward brain back to the text. The deep reading that used to come naturally has become a struggle.

Luckily, that was at the beginning of the article. There seemed to be thousands more words, but I didn't read it. I'm kidding. I did. An article, I can still handle. But I know what he means. We've all felt it. Reading is a different experience than when we were young—each word offers the possibility for linking out to something else, and the main text just doesn't have the same gravity it once did. But is this larger network actually providing us with a larger understanding? Toward the end of the piece, there's a consideration by the playwright Richard Foreman of the new way of processing information. Foreman noted that while our minds hold more information than before, they are more than ever a series of connections to information outside of our minds. And too much is about information: locating it, retrieving it. This, said Carr, quoting Foreman, is alarming: "As we are drained of our 'inner repertory of dense cultural inheritance,' Foreman concluded, we risk turning into 'pancake people'—spread wide and thin as we connect with that vast network of information accessed by the mere touch of a button."

Everyone agrees that creativity is a privileged form of thinking. But is it immune to this effect, or is it even more vulnerable to it? I have said before that creativity can be defined in many ways, and that one of the ways is that it's the attempt to answer a question that is itself in question. If a question comes into perfect focus, answering it isn't a creative act anymore. It's more a matter of information retrieval. The Internet, if you believe Foreman, if you believe Carr, is a menace to creative questioning. The second a question comes into view, the research process starts. We begin our research, our search for facts to satisfy questions, almost immediately. And just as Carr noticed his reading changing, I have personally noticed the way that research sprints ahead of idea formation. When a certain soundscape appears in my mind, I match it immediately to a song on Spotify. When a certain faint picture of an old TV show appears, I find the original show on YouTube. When a lyrical phrase pops up, I google it and find that it's from a Schoolly D song, or an Ice Cube song, or an SZA song.

The best illustration, maybe, is the exception instead of the rule. Recently, I was thinking of a song from the eighties. I didn't know exactly which song I was thinking of: it was one of those nostalgic twinges. I thought at first that it was Baltimora's "Tarzan Boy," but then a split second later I realized it wasn't that at all. The song I had in mind was something slower, more mysterious. But I didn't have any way to find it. Beyond that, I was at a loss. I didn't remember what month I had heard the song, or else I could have gone and looked up the Billboard charts from that month. I didn't remember even a few words of lyrics, or else I could have searched for that phrase. Maybe in the future, there will be a way to mine your mind for a snatch of melody and reverse-Shazam it, but I couldn't retrieve the song. Because of that, I just sat there and thought about it. I got further and further away from the reference job at hand, and closer and closer to an idea of my own. Denied the ability to complete the research task, I instead pursued a creative goal. I started to invent a new song that matched the characteristics in my head. I put down a little drumbeat and added a little melodic figure. I started to sing nonsense lyrics. They were about a new chair in my apartment, and they went something like "New chair / there you are, there / I don't mean to stare / But I'm aware / You're a new chair." I'm not claiming that it was a Johnny Mercer special. But I heard an entire new song coming to life in my mind, and I knew that wouldn't have happened if I had been able to quickly locate the song in question.

Now, it's true that my brain, in making this pre-song, was drawing on a network of its own. It was doing something similar to what a person does during the surfing process. But it was drawing on a deep well of various kinds of things. William Klemm, a professor at Texas A&M University, wrote an article where he looked at the creative process from a neurological point of view. Much of the stuff he said is above my pay grade. As I have said, if you want me to be a neurologist, send me to the neurology academy, or whatever it's called. But one part I understand. He defines creativity as the process of drawing

If a question comes into perfect focus, answering it isn't a creative act anymore.

water from a deep well. I'm paraphrasing. He said that "creativity comes from a mind that knows, and remembers, a lot." We don't have those brains anymore. Instead, we offload our knowledge to our phones and computers, to Wikipedia, to Shazam. It's a great convenience, but what's lost in the process?

And I think that Klemm's answer is only partial. Creative minds know and remember a lot, but that also means that they have to know, and remember, selectively. One of the things that's being lost, along with the ability to really focus and concentrate on the bottom of that well, is the ability to establish hierarchy, a confident sense of knowing which events (or ideas) are the big planets and which ones are the small moons orbiting around them. I probably just mixed a metaphor: consider it a mashup. Dave Chappelle, in one of his two comeback specials on Netflix in the spring of 2017, talked about when he was young, and one of his middle school teachers wheeled a television into class so that the students could watch the launch of the *Challenger* space shuttle. I'm a little older than Dave, and I remember it, too. It was 1986, and it was a big deal. There was a teacher on board, and every other teacher wanted to share in the glory. Of course, it all went horribly wrong. The launch went fine, but a few minutes later, the shuttle exploded. All the astronauts were killed. Students and teachers across the country watched, stunned. The punch line to Dave's bit about it is subtle: the teacher, staring at the screen, dismisses the class for the day: "You all can go home." But after that, Dave makes a point that's deeper than a punch line. He starts to needle the younger people in his audience. These days, he says,

you guys get so much more news, so much more data, that everything is the space shuttle, so nothing is the space shuttle. Just when you've filled your mind and your heart with the horror (or, in other cases, the joy, or the significance) of an event, another one comes along to wipe it away. How do you grow up in an environment like that? For creativity, things need to settle in. Take root, flower, bloom, grow, tangle. The skim, the superficial, the way things get replaced so quickly, is the enemy not only of deep thoughts, but of creative thoughts.

I guess I want to leave all Internet users—in other words, everyone—with words of caution. Of course, use technology. No one is suggesting that you unplug, or that you wander the earth only as far as your landline cord will let you go. But don't think that the giant hive mind out there is a replacement for your own mind, and don't forget to have the courage to set aside most of what you're being delivered (and deliveries, as Chappelle says, come in constantly). When we network with other people, we learn to use them as trusted resources. When we network with technology, we learn that the resources are countless, but not all trustworthy. It's a balancing act. Stay upright.

↓

The Connect Effect
Think of two artists you know, who you consider to be very different, and imagine what project they would make if they collaborated.

Unblock Party

Getting started on an average day can be a pain, but it's a pain that most people can deal with, like a slight headache or a sore heel. For some creative people, though, the pain of not being able to be efficiently creative doesn't go away. It just stays and stays, getting worse—or worse, not getting worse at all, just staying and staying, until you're numb from it. When that happens, when you can't feel your extremities (creatively speaking), you might be in the clutches of writer's block—or whatever the equivalent is in your creative field. Songwriter's block? Painter's block? Chef's block? Filmmaker's block? They all sound bad, except maybe sculptor's block, which sounds like it could be the start of something promising.

For years, I would hear people talk about writers' block. I didn't encounter it firsthand or even secondhand that often, so I had a kind of superstitious feeling about it: I didn't want to know. But the more I went on in the music world, the more I saw it, and sometimes I saw it close up. When D'Angelo was young, he was in a group called Precise: they came up from Richmond, Virginia, to play at the Apollo Theatre in 1991, and that led to a publishing contract, and that led to work for Black Men United, which was a vocal choir that had almost everyone in it—Gerald Levert, Raphael Saadiq, Boyz II Men, R. Kelly, Usher. D'Angelo got launched. He recorded *Brown Sugar*, his debut, and when it came out in 1995 everyone knew that he was one of the most creative forces around. You could feel it in the way he arranged vocals, in the way he let songs drift but never became aimless. He had a great voice, but lots of people could sing. He had a perspective. He had force. He had ideas.

But in the wake of that album, he had something else, too, which was trouble writing new material. There was pressure on him for a follow-up, because *Brown Sugar* had been such a big hit, but a follow-up didn't happen easily. It wasn't that he couldn't go back to the well. He went back there. But when he went back, it was dry. I'm not telling

tales out of school or anything. He's talked plenty about that period. His first album had summed up everything that he thought and felt. He had found a way to express his entire soul. That's why they call it soul music. So how are you going to bounce right back up with a new record? There's a phrase that people like to use to describe these situations. They say "sophomore slump." But that's a little bit of a misnomer. No one's in school anymore. It's just a slump, period. D'Angelo really suffered while he struggled to get more material together in the wake of *Brown Sugar*. He was completely blocked, locked up tight. For a guy who had woken up day after day for years with new songs blooming in his mind, to suddenly be looking at an empty flowerpot was a terrible feeling.

He kept on, though. What he did mostly was release cover versions of other people's songs for soundtracks. He and Erykah Badu did a Marvin Gaye–Tammi Terrell duet, "Your Precious Love," for *High School High*. He did "Heaven Must Be Like This," the Ohio Players ballad, for *Down in the Delta*. He had done covers before, of course. One of the big hits from his debut was a version of Smokey Robinson's "Cruisin'." But these were one-offs. They weren't destined for the follow-up record, though people may have thought so at the time. They were just hanging there in the space between records. Some people will say that it was a business move or a branding move, a way of keeping a new star visible for a little while he got his act together, creatively. Some people did say it. But to me that's too cynical. Or rather, it's irrelevant.

Those covers were fully creative works, ways of making things without recording his own songs. He weaponized another aspect of his creativity and temporarily vaporized the issue of writer's block. I think there was a kind of psychological freedom in them, too, at least a little bit. Creativity is a privilege and a blessing, but it's also at times a burden. The pressure of coming up with your own ideas—or rather, Your Own Ideas, with all the capital-letter significance that implies— can be a problem. It's not that the pressure crushes you. I don't think

Creativity is a privilege and a blessing, but it's also at times a burden.

that's what happened to D'Angelo. It wasn't like he read an early draft of a press release that talked about the follow-up to *Brown Sugar* and suddenly felt paralyzed. I think that his block was more about having emptied out the tank in a very comprehensive and exhausting way, then promoting that album around the clock for two years. It was difficult to get other things to float to the surface. So he did the next best thing, or rather another best thing, which is to make something that is already made. I recommend this to any creative person in any discipline. If you're a painter and you can't think of anything to paint, copy a landscape or a portrait by a painter you like. If you're a writer and you feel like you're not capable of writing something new, find a poem you like and type it out again. If you're a chef and you're drawing a blank in the kitchen, try to make a classic dish of your mentor's. People with limited ideas of things call this cheating. It's not. It's inspired imitation. Making your own version of existing works keeps you on your toes. It keeps your machinery humming along.

Take another one of the covers from that period: D'Angelo's version of the Prince song "She's Always in My Hair," which he contributed to the *Scream 2* soundtrack. I know it well. I played on it. To make his version of "She's Always in My Hair," D'Angelo had to find within himself a reason to make a version of "She's Always in My Hair." The songs he picked weren't arbitrary. He wasn't turning in D'Angelo-style covers of Johnny Cash songs or the *Banana Splits* theme (though now that I say that, I want to hear them both immediately). The songs he selected were songs that mattered to him and to the people around him (present company included). They were songs that were in him

in some form already. If you x-rayed his creativity, you would see those songs in there, glowing in his bones. And by the time he was done with his versions, he had repossessed them to some degree.

And even then, it wasn't straightforward. Even then, it wasn't simple. Even then, all the creative choices had to be identified, addressed, wrestled with, resolved. "She's Always in My Hair" is a perfect example. From the start, there was a question of how faithful to the original it should be. If I were making it on my own, I might have leaned in that direction. But when I'm working with D'Angelo, I'll filter some of my own ideas and default to his creativity. I wasn't about to drag D'Angelo to hell with me and put him in a position where he was putting out a version that competed directly with the original. We ended up taking another approach, going away from the chilliness of the original toward something super funky. That decision had its own set of problems. What if we made it so funky that it was perceived as a way of showing up the original version? (This may not have been a realistic fear, but it was an anxiety in my mind, a point of pressure.)

I have thought often about that period of D'Angelo's career, what it meant to him, how easily it was misunderstood as merely transitional, as the dead spot between Point A (*Brown Sugar*) and Point B (*Voodoo*). So here's my advice to anyone, in any field: when you feel you can't make work, make work from work that is already made. Don't duck and cover. Cover without ducking. Do it proudly. It keeps you active. A little bit after that, D'Angelo started working more diligently on the material that would become *Voodoo*. Those songs were a huge leap forward. They reminded people that he was a visionary, and then some. What accounts for the empty well suddenly being full again? In interviews, D'Angelo credited the birth of his son Michael, and that may have been a big factor. But he also kept himself in shape, creatively speaking, even when he wasn't creating. *Voodoo* wouldn't have happened without the period after *Brown Sugar*. Maybe that's self-evident. But it wouldn't have happened the way it did if he hadn't used the period after *Brown Sugar* the way he did.

Thinking about "She's Always in My Hair," returning to the choices we made during that period, also gets me thinking. Deep down, I think that there are pure creatives and then there are privileged observers. In some way, I still think of myself as that the lucky observer who gets to spend time near pure creatives to see them in action. When I hang with someone at that level I'm amazed at their inability to act like a sponge or observe their surroundings. When I remember D'Angelo, that's what I think of. Or take Prince. I think of a typical late-nineties night at Prince's house, where there was always a jam session with a bunch of younger musicians (again, present company included). He might start with a riff to a cover song and all of a sudden we were launched into it. It happened one night with the Ohio Players' "I Want to Be Free." The funny part was that Prince didn't even know the lyrics. That blew my mind. It kicked over my Jenga. How could that be? Why would he introduce such an iconic song if he didn't know it inside and out? It occurred to me that with Prince, maybe he feared being too derivative. As I discussed earlier, I don't really have that fear. I think that my creative identity is unquestionably made up of parts of other people's creativity. I have lived my life being referential and reverential. But I have also seen cases where artists at an elevated altitude don't want to work that way. They hold the idea of covers at arm's length. I'm not saying they're wrong. I'm not saying they're right. I'm saying that making things is about making choices.

I, Me, Mimic

Copying, or covering, is always a valuable creative exercise. It gets you going. It restarts your brain and encourages you to look for the way things are built. Go and retype those last three sentences. The first two have lots of alliteration: copying and covering, gets and going. The third one doesn't have any at all. That's one thing to think about.

But how does it work as an exercise? Not everyone is satisfied by

Çopying, or çovering, is always a valuable çreative exercise. It gets you going.

also possibly the future seat of world power. There are strange things there that I can't describe, or won't, for my own safety, but one thing I can mention is this dinosaur's tail that Nathan built to prove a pet theory of his that dinosaurs flicked their tails like bullwhips.

Anyway, we ate there. And one of the things I noticed is that Nathan loves the idea of masquerade. At least three of the dishes pretended to be one thing but were in fact something else. There was a pasta that turned out to be geoduck. There was a stick of binchotan, a hard charcoal, which he tapped on to show us how hard it was, and then he served it to us—but it wasn't that at all! It was pâté. And then there was a quail egg that turned out be mango and passion fruit. These were like magic tricks. They were illusions. That's one kind of creativity, maybe the oldest, when art imitates life but then throws a wrench into that process, thereby proving that it's not life at all. But the food that Nathan served was also a kind of parody. The thing that it looked like, but wasn't, communicated a set of expectations. That level of trickery seemed baked into the way that he worked. Nathan was already making delicious food, but he felt as though he wanted to increase the degree of difficulty by forcing another creative challenge upon himself: not only should this taste good, but it needs to look like something else. When I started to ask around, I found that this was more common than I thought—the idea of layering ideas over ideas, especially if there was a joke loaded into the process. Often, that trickery took place at the end of the process. The original work was done, but packaging it created an opportunity for parodic treatment.

I collected many examples of this principle while I was writing

this book, but one of the best came from the music world, from the pub rocker Nick Lowe. I remember 1977 as the year that my dad listened to pop constantly in the car, such as Andy Gibb's "I Just Want to Be Your Everything" and the Emotions' "Best of My Love." I was too young to see all of the other things that were happening: punk records like the Sex Pistols' debut and the Ramones' *Rocket to Russia*, high-modern classic rock like Pink Floyd's *Animals*, political reggae like Bob Marley's *Exodus*. It was also the year that David Bowie released the first record in his Berlin trilogy, *Low*. Nick Lowe took offense, not seriously of course, at Bowie using a misspelled version of his last name, so he did the same, releasing an EP called *Bowi*. The first time I heard that, it sounded silly, sure, and snotty, but also like one of the most purely creative things I had ever heard. He was turning tables that I didn't even know were there.

I thought about these kinds of tricks often during the writing and editing of my food book. The cover of that book is based on the artwork of Giuseppe Arcimboldo, a sixteenth-century artist who made portraits of people as assemblages of gourds or trees. When I first saw his paintings, Arcimboldo reminded me of hip-hop—he was taking existing images and reordering them into something new. For the cover of that book, a version of an Arcimboldo portrait was made of me. The act of making a food-face for myself wasn't completely serious, in the sense that everyone knew that it was ridiculous. But it was completely serious as a creative act. The artist had to find shapes and textures and colors that matched, and then had to assemble the thing so that it was a plausible photograph. In a sense, this was harder than Arcimboldo, since he could paint a face made from food. For our book cover, we had to find food that looked like features. There's radish in there, and squash, and a doughnut for a bow tie. It's a parody of an existing style (Arcimboldo's paintings) that gains meaning by also incorporating elements of another style (hip-hop sampling).

The other example I ran across recently is *Documentary Now!*, a show that was cocreated by Fred Armisen and Bill Hader. Both of

them were on *Saturday Night Live* (Fred played Prince, of course), and both have done excellent work outside of it. Bill has done voice-overs for Pixar movies and written for *South Park*, and Fred cocreated *Portlandia* with Carrie Brownstein. The two of them loved movies, and in particular they loved documentaries. What they decided to do was remake them. They did a version of *Grey Gardens* called *Sandy Passage*. They did a version of *Nanook Revisited* called *Kunuk Uncovered*. They did a version of *The Thin Blue Line* called *The Eye Doesn't Lie*. And they did a massive two-part takeoff of the massive two-part Eagles documentary, *History of the Eagles*, called *Gentle and Soft: The Story of the Blue Jean Committee*.

When you are parodying a world, you need to pay attention to details. It teaches structure. It teaches rhythm. It teaches nuance. It also demands an incredible amount of specific technique. In the case of *Gentle and Soft*, Bill and Fred recorded an album for their fake band. When they did their takeoff of *Grey Gardens*, their directors, Rhys Thomas and Alexander Buono, used the same camera lenses as the original so that the movie looked the same. And in their parody of *The Thin Blue Line*, they shopped around for a courtroom artist to make their sketches look similar. As it turned out, it was the same exact guy. That's one of the coincidences that warms my heart.

My final anecdote about copying and parody goes back to the world of music, and to an article that my cowriter Ben Greenman wrote for *The New Yorker*. There's a British band called the Wombles that isn't exactly a band. They are costumed characters from a kids' show, sort of an across-the-pond version of the Banana Splits. They came into existence back in 1973, which was right around when I came into existence. The main singer and songwriter for the Wombles was a man named Mike Batt, who went on to have a long career in the music industry. One of his other bands was a classical group called the Planets, and at one point they had a track on an album called "A One Minute Silence." The composition was only silence, just like John Cage's famous conceptual piece "$4'33''$"—the only difference is

that the Planets' piece was, like the title says, a minute long. Batt credited it to "Batt/Cage," though the Cage in his credits wasn't John Cage, but Clint Cage, a pseudonym that he created just for the occasion of the recording of "A One Minute Silence." John Cage's publisher, Peters Editions, wasn't amused. Peters sent a letter demanding that Batt pay royalties and saying that the idea of the silent song belonged to Cage. Batt didn't agree. He released his one-minute silence as a single, and went a step further, registering hundreds of other lengths of silent songs. "If there's ever a Cage performance where they come in a second shorter or longer," he said, "it's mine." I remember seeing the piece (the article, not Batt's silent song) and laughing, because it was such a ridiculous idea. But I have rethought it slightly. The dispute between Batt and Cage's publisher revolved around issues of copyright. But they are just as powerfully ideas of creativity. If you thought of something first, does that mean the same thought can't occur in someone else's mind with as much power and as much authenticity? If someone else thinks of something first, does that mean the same thought can't occur in your mind? And is it even the same idea if it grows in a different mind?

These aren't new questions. People have asked them and answered them millions of times. But part of what creative people do is keep reopening them. Parody is new but never new. It's funny but also tries to identify some serious issues. It's accessible (because people have to get the joke), but it can't be too accessible (or else you are settling for the worst jokes in the *Scary Movie* franchise). That means that it requires exactly the same creative skills and sensitivities as making the original artworks.

Physician, Copy Thyself

The example of *Documentary Now!* raises a question that requires a little more consideration. Who should you copy? In that case, they're

copying some of the best and most important documentaries in movie history. On the face of it, that makes sense. Why would you want to copy something terrible?

But you should also copy yourself. This doesn't violate the rule, which is to remember to copy the best, because you are the best. In an earlier chapter, I explained that every creative person is ultimately his or her own judge, audience, and role model. You occupy these stations at different times in the process. But don't demean or diminish your own work when it comes time to practice parody. This sounds circular, but it's actually an arrow that stretches out into eternity.

Let's go back to the example of D'Angelo, and how he dealt with the creative paralysis that settled all around him after *Brown Sugar*. When he was blocked, he started copying existing songs. When he was unblocked, though, he didn't start basing his new music on influences that drifted in from the furthest reaches of left field. He was working off his own touchstones and keynotes. When he sat down to make a record, he was sitting down to make a D'Angelo record. There were glissandos he owned. There were vocal intervals he owned. Other people may have owned them also, or thought that they did, but for his purposes, he was sole proprietor.

I have been lucky enough to meet George Clinton. At the Miami Book Fair in 2014, he and I did a joint interview onstage with Ben Greenman, who was also Mr. Clinton's cowriter. Ben knew that Mr. Clinton and I had overlap in our careers, that we shared some of the same foundation, so he wrote questions for Mr. Clinton and questions for me and then swapped them. He asked me about the importance of doo-wop, which I could answer easily since my father was a doo-wop singer. He asked Mr. Clinton about the evolution of hip-hop, which he could answer easily, since his music provided the basis for much of West Coast G-funk. It was an interview about creativity that was also itself creative. Afterward, we were hanging backstage, talking and taking pictures, and Mr. Clinton mentioned something

about his creative process. My ears went up like a dog who hears the food dish rattling. I know when a genius is in the room and talking. He said that one of his methods had always been to revisit his old work, without reservation, without fear, without shame. His doo-wop group, the Parliaments, had its first big hit with "(I Wanna) Testify" in the late sixties, after years of working the seams of Detroit soul. A few years later, because of the flowering of the psychedelic era, the Parliaments had morphed into a pair of bands: Parliament, a kind of pop-soul outfit, and Funkadelic, a so-far-out-you-can-see-in black rock concern. Both of those bands reused Clinton's early compositions. Parliament would go on to rerecord "Testify" on its *Up for the Down Stroke* album, and Funkadelic's debut contained reworkings of "I'll Bet You" and "Good Old Music."

Partly Clinton wanted those songs to get a hearing, now that his platform was bigger. But it was also a creative method, as he kept proving in his career and his life. In the mid-nineties, during one of the golden ages of hip-hop, Parliament-Funkadelic released an album called *Dope Dogs*. It was a concept record about a drug-sniffing dog that incorporated commentary about addiction, identity, lust, and the hypocrisies of federal drug policy. Clinton produced that record himself, with a technique that was both retro and groundbreaking. He explained in his memoir, *Brothas Be, Yo Like George, Ain't That Funkin' Kind of Hard On You?*

> I had listened to lots of hip-hop by that point, and certain styles in particular impressed me. I loved the Bomb Squad and the work that they were doing with Public Enemy, so I started to do my own version of the same thing, sampling older P-Funk records. I tried not to use the most obvious samples—other people had mined the ore right out of them—so for the most part, I drew from outtakes, rarities, or live tracks. I produced that album myself, in the most labor-intensive way possible. I took a loop of three or four seconds and ran it from the beginning of the song to the end, after which I muted the parts of the loop I didn't want to use.

Clinton knew that there was more sophisticated technology available to him. But he didn't want to use it. It didn't fit his metaphor, which was gene splicing. He had been playing with that idea since the mid-seventies, on *The Clones of Dr. Funkenstein*, and here he played with it again. There was a quality present in every single second of P-Funk music, and if you moved it to another compositional body, it remained. You could snip a hair—a metaphorical hair, so a note or a phrase—and still identify it as P-Funk. He had already created, and he used those creations to make new ones.

Sometimes, though, George didn't even use pieces of old songs. He used old pieces that never found their way into songs. Maybe in 1974, Bootsy Collins had played a bass part for "Ride On" that was abandoned as the song evolved. Maybe in 1977, Junie Morrison had come up with a keyboard squiggle that couldn't find a home in "Groovallegiance." George called these pieces of music seeds and stems. The idea is that when the smoking was done, those were the leavings at the bottom of the bag. They weren't the real dope, but they were from the same plant. George figured that he might as well get use from them. He might as well grow new songs from them.

I urge everyone to revisit earlier work. I know lots of actors who say they never watch themselves in movies. I know lots of authors who say they never reread their books. I don't understand that. I can understand not sitting in a penthouse repeating your own lyrics to yourself over and over. I can understand not being slouched on a couch in front of a huge TV watching yourself on screen. But I think that you have to go back and look at your own work with a clear eye. And, hopefully, with pleasure. It should keep you feeling good about yourself to know that you completed projects in the past. I was talking to the New York–based portrait painter Kehinde Wiley at one of my food salons. He said that he would sometimes walk by one of his paintings and just have a flash of appreciation, not in an egotistical way. But he would see the size of it and the complexity of it and remember not just the work that went into it but the fact that he had

Revisit earlier work.
Go back and look at your own work with a clear eye.

survived that work and lived another day, to make another thing. In the last year, Tariq and I have followed a similar philosophy. As we started to get ready for the next Roots album (titled *Endgame*, out in 2018), we made a conscious decision to take a half step back and listen to our own body of work at a slight remove, listen to our records the way a younger artist like Thundercat or Kamasi Washington might listen to them. We would be Roots fans, and we would make a record in that spirit.

Luckily, we had everything. The whole photo album, musically speaking, was available. This is one of the most important principles—don't throw anything away. Technology today makes it easy to keep your old ideas at your fingertips: the half-baked ones, the ones that seemed to peter out. You will be able to go back to them, and you should. There's no such thing as garbage. One of my favorite restaurants to visit is Next in Chicago. I developed a kind of friendship with Dave Beran, the chef there. Once, Dave told me that he wanted me to try a new dish. I was excited. He came out with a plate that looked like what you'd see in a Warner Bros. cartoon to communicate the idea of trash—a fish carcass, mostly stripped to the skeleton except for the eye staring outward, a clump of garbage next to it, and a piece of what looked like broken glass. It had everything but a fly buzzing around it and stink lines. "Try it," Dave said. He was deadpan. I did, and it was one of the most delicious things I had ever eaten. No such thing as garbage.

When you are recycling parts of past works, be smart about it. Recognize that there was a reason an idea didn't pop the first time

146

around. Maybe the time wasn't right. Maybe the context for it didn't yet exist. But also realize that many ideas flower eventually.

This loops back into the idea of parody. If you reuse your own old ideas, you shouldn't always be so stone-faced about it. You can approach it, at least initially, as a kind of self-parody. George Clinton didn't suffer from block like D'Angelo. He's never been blocked in exactly that way, as far as I can tell. Just take a gander at his discography. But he must have felt pressure to live up to his old works. When you achieve a certain amount in this (or any other) business, getting crushed by expectation is inevitable. Whenever I look at Pitchfork and see that a band has a new album, I am always on the alert for this kind of sentence: "This work represents an advance over the last one in this way." It's usually there, but is it usually true? Why is every new work an advance? Is that just how time works? I think it's part of the creative psychology. No one wants to do worse than they did the last time out. No one even wants to be the one who accuses someone else of it. And yet, we are at the mercy of our past work.

Generally, be willing to be lighter. The consequential work—the work that eventually ends up weighing something—isn't always undertaken with such paralyzing seriousness.

Sample Sale

The George Clinton examples demonstrate how important creativity is to hip-hop, or maybe how important hip-hop is to creativity. Throughout this book, I've been making an effort to branch out and look at a broad set of disciplines—at other kinds of music, but also at cooking and comedy and painting. But I want to come back to hip-hop for a little while. I want to think of it in light of all the things we've been talking about: stealing from others, stealing from yourself, making the old new, and discovering ways to jump-start and sustain your creativity through all of these behaviors.

The earliest hip-hop singles, like "Rapper's Delight" and "The Breaks," used studio bands, though those bands were just re-creating music from existing records. Then hip-hop entered an era of sampling. Technology made it possible, and aesthetics followed technology. For a little while there, most bands bit pieces of existing songs, both melodic and rhythmic, and arranged them into sonic beds over which MCs would rap. It was simple at first and then, in the hands of masters like the Bomb Squad, it became elevated into high art. There's a moment on "Rebel without a Pause" when they take a second of Clayton "Chicken" Gunnells's screeching trumpet. Clayton was in the J.B.'s—James Brown's backing band. In its day, it was a kind of imitation of the far-out sounds of John Coltrane. It was a funk appropriation of the liberating principles of the headiest jazz. But then the Bomb Squad found it and gave it to Public Enemy, and it became something else all over again, a warning, a call to arms.

I could write a whole book on the supreme creativity of the Bomb Squad. Maybe I will. Until then, I'll mention them whenever I feel like it in the books I write. They were able to take existing materials and make something bracing and new from them. You might think that a definition of pure creativity includes the idea of creating something from nothing, but that's also a little bit of a dodge. Nothing is nothing, really. That seems like a paradox, but what I mean is that when a saxophonist plays a note, he's using an instrument manufactured by Selmer or Yamaha or Keilwerth. Which manufacturer depends on level of experience and price range and lots of other factors, but the noise comes from somewhere. The same is true, and maybe more true, of filmmakers: the cameras, the lights, the film. Most directors don't fabricate those things by hand.

But wait, people say. Those are only the tools. That's only the hardware. The creative person writes all the software. When that sax makes a sound, that's a sound that comes straight from the player's heart and soul. This is even less true. There are notes. There are scales. The most experimental jazz player still has to reckon with

them, partly because the destination of that sound is yet another piece of equipment that came predesigned: the human ear.

This is a little far afield. The point is that creativity has ideas, but it also has materials. And the Bomb Squad's materials happened to be certain pieces of technology, samplers and sequencers, and a world of recorded music that they could feed to that technology. They didn't play any instruments, but that meant that they played every instrument.

The Bomb Squad perfected a certain kind of sound bed. Their production on the Young Black Teenagers album—a white group discovered and nurtured by Hank Shocklee and supported by Public Enemy—remains one of the crowning achievements of production in any era. It's George Martin level, Brian Wilson level. It'll blow your mind out when you start to see how they assemble the bricks.

That came out in 1991. The same year, there was another release that completely turned my sense of the genre on its ear. Since 1989, MTV had been broadcasting a show called *Unplugged*, where bands went onstage and played stripped-down versions of their hits. It was a way for rock artists (and sometimes pop groups) to show that they had real chops and that their songs had real structure. The series started with acts that were naturals for the treatment—Squeeze did the first episode, Graham Parker did the second one—and then they started to branch out a bit. I remember the Hall and Oates episode in 1990, because they were Philly superstars, and because when I heard about it I imagined exactly what it would be—the leanness of the melodies and syncopated rhythms preserved, and Daryl and John getting back to their roots as basically white soul singers.

Then, in 1991, the series tried an experiment. The first stretch of the season included a bunch of usual suspects (Sting, R.E.M., Paul McCartney). On April 10, though, at Chelsea Studio, the show assembled a number of hip-hop acts, including MC Lyte, De La Soul, and A Tribe Called Quest. They set about performing their hip-hop material in an acoustic setting. There was political capital invested in

149

this, of course—this was in the middle of a period where much of white America, including music stars who should have known better, dismissed hip-hop as something less than music. But there was also a creative dimension, which was to let the artists rethink their songs in this new acoustic setting.

All the acts on the bill performed admirably, but the undisputed star of the show was LL Cool J. His set was beyond amazing. It was transformative. For starters, there was the way LL looked—he dominated the stage, ripping through performances of songs like "Jingling Baby" and (especially) "Mama Said Knock You Out," white deodorant clearly visible. The audio was as exciting as the visual. Under the music direction of the guitarist Mike Tyler (whose band, the Philly outfit Pop's Cool Love, backed LL for the show), the songs were reborn and renewed. Re-creating the riff of "Mama Said Knock You Out" rather than playing the original Sly and the Family Stone sample made it somehow more organic, earthier, almost a folk music. That was obviously the touchstone for the Roots when we backed Jay-Z on his *Unplugged* performance in 2001. But I also think that the unplugged hip-hop game is a uniquely effective way of flexing creative muscles, of taking songs that are already Frankenstein's monsters and giving them another shot of electricity.

That original LL Cool J performance has stuck with me in important ways over the decades. When I think about its effect, I think I can distill it down to one short, sharp piece of advice: change your materials. I know writers who mostly write on their laptops—maybe that's every writer now—and when they switch to longhand, or an old typewriter, or a tablet with some weird Bluetooth keyboard, they enter a new creative phase. It's not just that they get a new perspective on their own work. They actually have to adjust their creative habits. Maybe things that were easy before (like spelling, say, which was corrected by the computer) become more difficult and require more of their attention. But maybe things that were hard before (like setting aside a page when it's filled with words and moving on to the next

page) become easier. Material changes matter because they change the process of creative production.

On *The Tonight Show*, Jimmy Fallon and the Roots have this recurring bit where we accompany singers on classroom instruments: recorders, xylophones, wood blocks. We've done it with Mariah Carey, on "All I Want for Christmas Is You." We've done it with Adele, on "Hello." We've done it with Idina Menzel, on "Let It Go." When we play those songs, it makes them fun and approachable. Big stars become somehow more human-sized. But it also forces us to re-create these polished, manicured ballads in more modest and rough-hewn conditions, and that means creating them again. "All I Want for Christmas Is You" on classroom instruments isn't the same song as "All I Want for Christmas Is You" on the most expensive professional instruments. This is why D'Angelo keeps his studio setup anchored in 1997 technology and feel. It maintains the purity. It doesn't corrupt the process with modernization. There's no trivial future to chase.

Look Over There!

The modern world is an improvement over other eras in many ways. We have smartphones and smart houses. We have top-of-the-line scripted TV. But in other ways, it's a problem. More than ever before, we're distracted. My life is incredibly packed and overprogrammed. I work at *The Tonight Show* and make albums with my band and produce other artists and teach a college class and produce television and film and occasionally write books. I don't have much time to be distracted. But I feel the pull of it all the time. Fifteen years ago, I didn't have a little hum at the base of my skull reminding me to check e-mail or Twitter or read the latest gossip about the celebrity couple of the moment (Are they really in love? Is it just a publicity stunt?).

The problem is trivial, of course, but for creative people it's also consequential. The one thing you can say about creative work is that

it requires your time and effort. More than ever, these days, that's difficult to guarantee. The very same tools that let you work so efficiently—word processing, Wikipedia—are connected to other tools that rob you of efficiency and focus. They don't destroy your will to live, but they do destroy your ability to live in the moment.

Homer Simpson: Wait, I'm confused about the movie. So the cops knew that internal affairs were setting them up?
Man 1: What are you talking about? There is nothing like that in there!
Homer: Oh, you see, when I get bored I make up my own movie. I have a very short attention span.
Man 2: But our point is very simple. You see, when—
Homer: Oh, look! A bird! [Homer runs away, giggling.]

We think, or tend to think, that creativity is the enemy of distraction. Or at least some of us think that: Charles and Ray Eames certainly did. In the middle of the twentieth century, the Eameses were one of America's premier creative forces. (They were a husband-and-wife team, by the way, not brothers. Ray was a woman. You may already know that, but if you do, you're in the minority. I can't tell you how many fancy events I've been at, including some from the design and art world, where people say "the Eames brothers," like they're the Wright brothers or the Chambers Brothers. The Eameses designed the Eames chair, but also made the famous film *Powers of Ten*.) And the Eameses didn't like having music in their office. They thought that it distracted their employees. They didn't even like having the idea of music around, really. It led to humming and whistling, also massive distractions. Charles said that to him it was like chewing gum. But they also recognized the human need for organized sound. They designed a sound tower. It was a kind of Rube Goldberg contraption. You dropped a marble down it, and as gravity rolled it along its track, the marble struck different tiles and produced different sounds. They commissioned a piece by the composer Elmer Bern-

We think, or tend to think, that creativity is the enemy of distraction.

stein. In theory, the tiles could be swapped out to create a new piece. It worked in their office to create background music, but also to eliminate distractions; they thought that they could program music that contributed to concentration rather than disrupting it. It showed creativity in producing sounds that, in other forms, they thought undermined creativity. That was how the Eameses solved things.

A Swiss design publication asked me to rethink the design and composition of the Eames tower. I thought about the lazy Susans I had made for my food salons and sold in a small shop in SoHo, large Corian spinning discs that were designed using strobe disc patterns, and how I had imagined that one day there would be a second generation of them that actually functioned as music-making devices as well as art objects. I had imagined actually putting the lazy Susans up on the wall and using their rotational speed to create a beat. That hadn't happened yet, but the Eames tower project gave me a chance to do something similar. I worked with designers and created an updated version of the tower. My version is actually two towers. The reasons have to do with the way that hip-hop works at its foundation. In its early days, it took existing songs and used them as the foundation for new songs. I thought the best way to duplicate the DNA of hip-hop was to build not one but two towers, and then to let users mix and match them the way hip-hop producers mixed and matched samples into a new song, the way that DJs mixed and matched turntables.

I thought the best way to make music—hip-hop music specifically—was by doubling the Eames equation and placing a rhythm tower next to a melody tower. I chose the song I wanted to

re-create. It seemed difficult to think of one at first, but then it seemed obvious: "Good Times," by Chic. The song was a major hit in the disco era, but also became the foundation for one of the first hip-hop anthems. The bass line of "Good Times," played by Bernard Edwards, was the basis for the first huge rap song, Sugarhill Gang's "Rapper's Delight." After that, it has reappeared in dozens of hip-hop songs over the years, sometimes in the same form, sometimes in slightly altered form. I wanted to let one tower stand in for that basic Chic sample and let the other tower add accents that would call to mind some of the many songs that used "Good Times" as their basic sample: not only "Rapper's Delight," but also the Beastie Boys' "Triple Trouble," Queen's "Another One Bites the Dust," Blondie's "Rapture," and Vaughan Mason & Crew's "Bounce, Rock, Skate, Roll." "Good Times" is one tower, because it's a towering achievement. The other tower permits variation. You can see both from anywhere in the office, or you can see one from the other. They are towers, but they are also pillars. They are structures, but also foundations. They are building blocks in the same sense as DNA. All life, all music, all creativity comes from those same basic ingredients.

The towers, in the end, were a lesson in production, in assembly, in mixing and matching, in fun. They both produced and represented creativity. Most important, they fought boredom without creating distraction, in the same way the original Eames tower did. At least that was the theory: If you were sitting in your office and you heard the plink of the vertical xylophone, you might find it pleasantly diverting. And at least you wouldn't be making that infernal whistling noise. But they also provided an object lesson in the way early hip-hop was created. Finally, they worked as a kind of metaphor for distraction, and how it didn't have to defeat creativity. When those early hip-hop artists were sitting around their garages or their bedrooms, burning with the desire to make something, and they heard "Good Times" on the radio, they didn't resent Chic. They didn't worry that the time spent listening was somehow detracting from

That's another thing that creativity is—taking the existing world and making something new from it.

their own creativity. Instead, they heard the song and decided to use it to make their own. They reinvested what they heard in a new artwork. The process began to pay dividends almost immediately. The two towers re-created that process of creation. There was no such thing as distraction. There was only traction.

When I was in D.C. at the Kennedy Center being interviewed by Eric Deggans, he asked me an interesting question about the difference between musicianship and musicality. In his view, one was chops and the other was the ability to access that ability. I thought it was worth submitting that to a little class history. In the fifties, families of color started fleeing from down south and went to industrial places: Michigan, Ohio, Indiana. Families got these well-paying jobs that allowed them to purchase houses with garages, and they had extra income for instruments. That helped bring bands into existence. Funk sprung up in Dayton, Ohio. But soon enough, factories shut down and there were foreclosures. There was no room for the music room. If you were born after that, the circumstances were different. You had to find your way to music. Grandmaster Flash desperately wanted to play instruments, but he couldn't do it. He couldn't make much noise in the projects.

We have just discussed how creativity can come from distraction, how it can be an outgrowth of the process of recognizing which things are taking your eye off the ball. That was what brought the Eames tower to life. But the distractions can work differently. They can be a matter of seeing the whole world around you, then using this power—this energy—to identify a new particle, a new spark. That's

another thing that creativity is: taking the existing world and making something new from it. Andy Warhol was able to take preexisting logos and icons and recontextualize them. Jagger and Richards were able to do the same with blues. Hip-hop artists were able to see the world not as a familiar set of limits, but as an exciting spray of possibilities. Eames Demetrios, the grandson of Charles Eames and the son of Charles's daughter Lucia, defined creativity for me in a way that harmonizes with this idea. "Somewhere at its heart," he wrote in an e-mail, "[creativity] is the ability to see something else. In the end everyone looks at essentially the same words, notes, colors, problems, answers, numbers, cities, people—all, or at least meaningful subsets of each, are in some sense available to us all. But creativity has to do with how you arrange and construct what you pull out of those familiars." I would add to that that it has to do with how you pull yourself out of those familiars, which Eames gets to in the second part of his definition: "The astronomer and cosmologist Vera Rubin, who found 90% of the matter in the universe, often said the role of the observer was to confound the theorist. I think creativity in a sense is confounding yourself in both roles as if in an endless chase—when you are satisfied with what you have imagined, you confound it with new patterns you see, and then when you are pleased with that, you conjure up an impossibility, which in turn will be challenged by your new perceptions—always surrendering to the journey." You lock in to what is there, you see things that others do not, you create, you distract and disrupt yourself with what is not there, and you start the process over again. It's a cycle: specifically, it's a life cycle.

Distraction and Traction

Every creative pursuit has its own kind of distraction. I have said several times that where I work is almost as important to me as what work I'm doing, and that the move to *Late Night* and then *The Tonight*

Show was important for the Roots because it gave us back a small, scrubby practice room that we could use as a recording studio and took us away from the increasingly cushy, increasingly fancy studios where major labels try to stash their acts. The smaller, sparser room created a feeling of leanness, and also minimized distraction. It didn't eliminate it, of course—Kirk might ask a question, and Mark might make a joke, and someone else (I won't say who) might have their head turned by something on Twitter or Instagram. But at least the distractions are happening within the space rather than happening as part of the fundamental character of the space.

There's also another kind of distraction that I have had to endure away from the band, on my own. I remember when I was working on *Mo' Meta Blues*. There were days when I would wake up, start a document called "Today's book thoughts," and then a cloud of nothing would settle. Ten minutes would pass. Twenty minutes would pass. I couldn't write a word—and that was a book where what I was mainly doing was relating the circumstances of my own life.

Well, it wasn't really a cloud of nothing. It was a cloud of distraction. I had, all around me, the Internet. With just a single mouse click, I could listen to an Outkast demo or read about zoning in Philadelphia or hop back in time and find a vintage interview with Wilson Pickett. The one I liked was from the mid-eighties, when he was performing in the kind of package shows that my parents played in when I was a kid, a group of artists banding together to bring back audiences from the past. His was called Night of the Living Legends, and he was on the bill with Lloyd Price and James Brown. James Brown wasn't up for doing press, but Pickett and Price went on TV with Bill Boggs, a New York–area TV host. They reminisced about the old days, about the chitlin circuit, about soul superstardom, and they compared their package tour with Michael Jackson, who was at that time the biggest star in the world. Michael could draw a crowd of a hundred thousand in a night, they said, while they could draw ten thousand a night seven nights a week. Either way, it added up. His

When the distraction shifts into boredom, that's the seed of something creative.

math was a little suspect, because Michael could have played to the same crowd of a hundred thousand every night, but I knew what he meant. There was more than one way to skin a cat.

Why did I bring that interview up? Distraction. But it was for more than giving you an example of my own distraction. One of the things that Wilson Pickett said has stuck with me. He was long past his prime as a commercial force. There wouldn't be another "Mustang Sally" or "Land of a Thousand Dances" or "634-5789." But he was eager to get back onto the air. He told Bill Boggs that it was all a matter of material. At his height, he could command the best songwriters, and he fully understood the kind of songs that were hitting the charts, because the songs that hit the charts were Wilson Pickett songs. He was a pace car. People said, "Get me a song that sounds like Wilson Pickett!" More to the point, he wrote some of those songs. He created songs whether or not he was a songwriter—what he did to "Land of a Thousand Dances" was different from what Chris Kenner had done, and it was unquestionably creative—but he also wrote some of his biggest hits. He wrote "Mustang Sally." He wrote "Ninety-Nine and a Half Won't Do." He wrote "I Found a Love."

By the time of the mid-eighties interview, he was more tentative, both about finding songs that were right for him and about writing his own. He said that he was playing shows all around Europe, making a living, but that when it came to getting back into the studio he didn't know what to record. He was a dynamo, still—a powerful man with a powerful voice. But he couldn't lock in. He couldn't get what we called traction. I imagined him sitting around backstage and

158

feeling a kind of numbness that he wasn't connecting with the songs people were sending him. What was he supposed to do instead? Read history books? Go for long walks? He was a singer. He was designed to sing songs that he was designed to sing, if that's not too circular. In their absence, he seemed frustrated and uneasy.

At one point, Pickett said something optimistic to Bill Boggs. He said that he was hopeful that he could find his way back into the studio. When I was trying to write *Mo' Meta Blues*, and instead finding my way into the Wilson Pickett interview, I thought about that simple idea, getting back into something, and how what I was dealing with was almost the opposite. I was always in the Internet. I was always in the middle of all the mouse clicks. What I had to learn was how to get out of something before I got back into anything else.

Because of everything that technology has given us, it prevents us from seeing that the Wilson Pickett feeling—that nervous sense of creative disengagement, that restlessness where you can't locate any new ideas within yourself—is still everywhere. But that emptiness is now cluttered and crowded. I remember a passage once from a pulp mystery novel where a character said he had emptied a liquor bottle and now felt just as empty as the bottle. That's sometimes the exact effect of darting around the Internet. You are into everything but you are into nothing.

I have started trying an exercise to help myself untangle this knot. When I find myself going to more than one site in rapid succession—when I'm nervously bouncing from that Bill Boggs interview to the Outkast demo to a commercial for European telecom providers that I find funny because it includes a little bit of music that sounds like Yo La Tengo's cover of the Parliaments' "I Can Feel the Ice Melting," then I stop. I shut the computer, or at least shut my eyes for a second so that I can't feel the computer. I let the distraction become boredom. And when the distraction shifts into boredom, that's the seed of something creative. On the face of it, that doesn't make sense. Boredom seems like the least creative feeling. It seems like a

numbness. But it's actually a way of clearing space for a new idea to spring back up. The poet Joseph Brodsky has a famous essay about boredom where he urges students (I think it was a commencement address) to embrace it.

> When hit by boredom, go for it. Let yourself be crushed by it; submerge, hit bottom. In general, with things unpleasant, the rule is, the sooner you hit bottom, the faster you surface. The idea here, to paraphrase another great poet of the English language, is to exact full look at the worst. The reason boredom deserves such scrutiny is that it represents pure, undiluted time in all its repetitive, redundant, monotonous splendor.

Brodsky goes on to say that the point of learning about time is that it reminds us of our total insignificance. He is speaking to college students, who are convinced of their own significance. They are big in their own minds. He wants to reverse that, wants them to realize that they are nothing. They are dust in the wind. That seems a little bleak and mean to tell kids. Aren't we supposed to be propping them up and encouraging them to have their own ideas? Forget about kids, even: Isn't that what this whole book is about, to remind people that they're not nothing, that they are something and can make more things? But Brodsky has a trick up his sleeve. He says that when you realize you're insignificant, you can start feeling two things: passion and pain. Passion is the way you fight meaninglessness. If you were significant, you wouldn't necessarily need passion at all. You could just sit back and experience things as they came. And pain is the acceptance of the truth of that insignificance.

Boredom, that sense of being disconnected, is what makes you bounce back with a renewed commitment. That's what Brodsky was saying about Wilson Pickett, even though he wasn't talking about Wilson Pickett at all. Let yourself go to the sense of being disconnected and meaningless. Let it wash over you and drown you a little bit before you come up gasping for air. Creativity is a fight against

that insignificance. That's all good advice, along with being very high-end philosophical thinking. The only thing I can add to it is that you kids who are growing up in the grip of the Internet have to approach it a little differently. Boredom for all of you now is about putting down the phone and letting a little silence into your day. It's about not being so compulsive about listening and watching and participating. It's about hanging back and then extending yourself into the space that's created. I remember being in Hawaii, staying at the house of Shep Gordon, the legendary music manager, and having an extended period of just unhooking from all the technology that usually connects me to the world. It was terrifying at first, but then it was elevating. It was a reminder that the world needs ideas. In a way, this is the opposite of Brodsky's idea. You have to remember that you're insignificant, but also that you are potentially more significant than all the noise that's being supplied to you at every moment. This is my commencement address to you. Graduates, class of now, as you enter a world that will be increasingly filled with links and apps, take some time to be bored. Take some time to navigate both distraction and boredom. Take time to make time. Now go forth into the world. I wish it was a little cooler today. This robe they made me wear is hot.

Widen Your Circle

But say you have tried all these things and nothing has worked. Say you have put your nose to the grindstone and all you're getting is a sore nose. When that used to happen to me, I didn't know where to turn. This feeling could creep up on me that was something like desperation: I had tried everything I knew to try, and I was still coming up empty. But as I have gone further in my career, I have seen that there's one great option still available.

Here it is: If you're feeling like things aren't going anywhere (you know the feeling—stalled, lost, paralyzed, a little desperate, can't

keep food down, long walks at night), make a point of hanging out with people from different disciplines. When I started working in the food business, or rather working around the food business, I liked talking to chefs. I briefly had a restaurant called Hybird in Chelsea Market, but more lastingly, I have been hosting a series of food salons in Manhattan. I pick chefs from some of the country's best restaurants to cook at my salons. Some of them have come from other countries, actually: Matty Matheson came down from Canada, and we've had people who have worked in London, France, and Tokyo as well. The afternoon before they cook, they sit around and talk, sometimes to me, sometimes to each other. I started to like listening to their conversation, and I profited from it. At first, it was just normal enjoyment— I liked hearing people who used different verbs and nouns, and who all seemed to have a similar set of experiences. But after a little while, the part of my brain that subjects everything to analysis kicked in, and I started to notice that they were acting their way through a different set of creative stimuli and responses. That led to a long-term interest in the way chefs function as creative professionals. The biggest difference, obviously, is in the relationship with their audience. Musicians have audiences making demands on them, but not in the pure sense. If the Roots don't release an album tomorrow or next week, no one suffers. Chefs are supplying a creative product that is also a survival product. When it's time for dinner, people open their mouths, and it's necessary to put something in there. Chefs don't have the luxury of not delivering ideas. As a result, they have, over time, devised a number of strategies for shaking up their creativity when they feel like a stall is coming. Sometimes they do versions of the things I have already talked about. They try to copy an existing dish down to the last molecule. Or else they line up a set of ingredients, pick one, and go from there. Or else they limit their time or their kitchen tools, or they cook with only one hand. They're expert at the various cooking-show tricks and stunts, but turned toward their own ends.

But the other thing they do is shake it up. They go elsewhere.

If you're feeling like things aren't going anywhere, hang out with people from different disciplines.

And elsewhere isn't where you think. When I first overheard these chefs talking about their excursions, I thought they were kidding. One chef, who I won't name, was talking about his highly acclaimed New York restaurant. "One day I was trying to think of a new menu," he said, "and I was just fried. I couldn't think of how to put it together, let alone how to take it apart and put it together in a way that would move things forward. So you know what I did?" The other chefs didn't know, and they said so. He paused for effect. "I went to a Chinese buffet." People laughed. But he was dead serious. "Listen," he said, "I know it sounds stupid, but that's a place where you have a million trays and a million ingredients, and someone is thinking about how to order them, even if they're thinking about it in a way that we don't normally value. There are visual choices: do you cluster all the green vegetables? There are narrative choices: What if you notice that people are spending too much time at the hard-boiled egg tray, and that's interfering with the spinach tray right next to it? There are utensil choices: maybe you thought a spoon would be better for the chicken pieces, but maybe tongs are a better solution." The other chefs were starting to get into it. "Yes," one of them said. "I have a similar habit, though I don't do it with food. I go to those giant candy stores. I'm fascinated by how they let you see so many things at the same time." They all started talking excitedly about the places they went to think when they couldn't think in their own place. I had to leave that conversation pretty early that day, but I started asking other chefs about this idea. The answers I got were surprising, in the sense that they advanced this theory. Ludo Lefebvre at Trois

Mec told me that he goes to McDonald's, because he loves their french fries. They give him inspiration. "What do you mean?" I said. He started to explain, then stopped, then started, then stopped again. "I don't know if I can be very clear about it," he said. "But they are doing something, and doing it well. If I see it up close, I can understand it or at least absorb a sense of it." He didn't need to be very clear about it. I understood what he meant. It's motivation. I feel the same way when I listen to an especially good superficial pop song, even if it's nothing I would ever try. But the takeaway here isn't necessarily to depart from your comfort zone to spark your creativity as much as it is to be around people who are discussing the process of having done that.

Elsewhere, I have talked about woodshedding and how artists in different creative disciplines brainstorm. This isn't exactly the same thing, but it's related. Comedians, for example, are famous for hanging out backstage, not necessarily trying out material on each other, but just working through the process of being a comedian in the presence of other comedians. In January 2017, the night Michelle Obama was a guest on *The Tonight Show* in her final late night TV appearance as First Lady, there was a surprise show later that night at the Comedy Cellar. It started as a show by Dave Attell, and then Jerry Seinfeld performed, and then one by one other comedians came out onstage: Dave Chappelle, Chris Rock, Amy Schumer, Aziz Ansari. I was there, and I was around them all backstage, watching them interact. Like the chefs, the comedians had their own unique shorthand when they spoke to each other. Sometimes the point was to make each other laugh. Sometimes the point was to get rid of butterflies. Sometimes, the point was woodshedding, trying out material before it was ready for a larger venue or a more polished destination. That was the point for them. For me, though, it was watching the process as it unfolded, and it was amazingly liberating. I feel the same way on weeks where I hang out around *Saturday Night Live*. Tuesday and Wednesday are big days, because there are pitch meetings to try to

figure out the makeup of the show. For the writers, I'm sure it's a se-
ries of minor heart attacks around the mechanics of trying to make a
sketch work in the context of the larger show. For me, it's like the best
and most rewarding vacation ever. I get to see how things work when
other people are working. Whenever I have done that, I feel cre-
atively rejuvenated.

Keep Your Comforts Close

Not too long ago, I was listening to a podcast on the edge of sleep.
The guest was Seth Rogen, the comedian and actor. Rogen was
talking about how he got started, and what kind of comedy he pre-
ferred, and how he learned to take risks: many of the same things that
I've been talking about in this book. He also talked about something
very different from what I talk about: drugs, and his lifelong interest
in them. He started smoking pot and taking mushrooms with his
friends when he was a young teen, thirteen or fourteen, and he had
continued using drugs in one form or another throughout his adult
life. As a kid, they were useful because they helped him deal with his
social anxiety—which he realized was not simple anxiety, but a kind
of enhanced sensitivity to the environment around him. That was the
same set of skills that let him observe things and become a good co-
median, so it was important for him to find some way to keep it con-
trolled and focused rather than let it control him.

As he became older, as he became a professional comedian
and comic actor, he noticed a shift in the way people used drugs and
the way drugs affected them. On film sets or in comedy clubs, he no-
ticed that some people reacted to getting high in ways that sepa-
rated them from the work they were doing. They fell inside
themselves, or became unnaturally attuned to everything that was
going on around them. The drugs didn't work to their advantage.
For him, he said, they were something different. They continued to

be a source of relaxation and a way of producing comfort—they could give him a feeling of well-being that kept him profitably connected to the work he was doing. Sometimes he didn't use during movie shoots because he was nervous about how a director or co-stars might react, but he didn't think for a moment that the drugs themselves were interfering with his ability to work. He even made a joke about his tolerance, and how he could smoke with friends and they'd be out of commission and he'd be no more affected than if he had just had a glass of water.

I already knew that different people reacted differently to drugs. I've been backstage with musicians, and I've seen the ones who could barely stand right next to the ones who seemed like they could still do their taxes and not miss a penny. But there was one thing Rogen said that really stuck with me. He said he had worked with actors who purposefully decided not to take drugs while they were working. They worried that it would be unprofessional, or that it would incapacitate them somehow. Those actors, he said, spent their entire workdays not wanting to be on set, because they wanted to head home so they could light up a joint. They would have been better served if they had permitted themselves drugs on set, because it would have kept them in their work. Otherwise, they were separating the idea of comfort and pleasure from the idea of creative work, and that resulted in a kind of split state where they were never really engaged in their acting. Rogen, because he's smart and thoughtful, went on to discuss how many an actor who felt uncomfortable could achieve certain depths in a performance that might not otherwise be available, but I didn't go on with him in his analysis. I was still stopped at that moment when he said that those actors who resolved not to get high on set were keeping themselves away from their happiness.

Extend that argument into more general creative work. Let's say you like exercise. Let's say you like eating. Let's say you like listening to music. Let's say you like hearing the voices of other people. Let's

You might think certain things are a distraction, but going without them can become a larger one.

say you like being inside. Let's say you like being outside. Let's say you like wearing fuzzy slippers. Whatever your personal preference, no matter how significant or how trivial, if it's a source of pleasure, and in denying yourself that pleasure you'll be entering a state where you think about it all the time, then you are working against your own creativity. You might think certain things are a distraction, but going without them can become a larger distraction if you are thinking all the time about the time when you will be returned to them, or them to you.

That was an interesting and lasting insight, and it leads to a kind of rule. Make your environment reflective of your tastes. Eliminate distractions, including the distraction of being without any of the distractions you need. I want to thank Seth Rogen for this insight. I also want to use this opportunity to clear up the pick controversy. A few months after I heard the interview with Seth, he went onto social media and posted a picture of himself. Well, it wasn't just of himself—it was of himself standing next to a framed Afro pick that he had taken from me when he was a guest on *The Tonight Show*. People got angry at him for all kinds of reasons: that it was cultural appropriation, that he was turning a historically significant artifact into a souvenir, that it was uncool to make a Questlove Museum as if I were somehow an object of curiosity. I posted right back at Seth to let him know that it was all fine with me. I even included a picture of the bucket in my dressing room that contains dozens of picks that are identical to the one he took. The dustup was not that dusty, and it was over. (Seth: the second I release my Afro pick line, I'll send you a case for your collec-

tion.) When I did give it a few seconds of thought, I realized that the (non-) controversy reinforced the point Seth made on the podcast. If playful, affectionate pranks are your wheelhouse, stay in that wheelhouse. Don't let people make you feel that you're something you're not, or else you'll get in your own way.

Unblock Party
When you're having trouble thinking of new ideas, go to one of your old ideas and rework it.

The Wired Brain

I remember reading about Leonardo da Vinci. I was in Germany with the Roots, where our manager, Rich, had taken us so that we could get established as a cutting-edge American hip-hop band over in Europe, before returning triumphantly to America and claiming the fame that was rightfully ours. It was a strategy, and though it didn't work as perfectly as Rich made it sound like it would, it wasn't a total bust, either. We came back. We had a reputation. The rest was history, assuming that by history you mean another fifteen years of hard work and a steady climb into the public's consciousness.

Back in Germany we were at a restaurant, and someone had left a biography of Leonardo on a table. I didn't read much of it, maybe a page or two, but I remember the cover art. It's the picture of Leonardo that everyone knows: the Rick Rubin one with the big beard and the hat. The main thing I remember was thinking about how different his world was from mine. He was incredibly learned, versed in art and science, but his world was more limited: he spent most of his life in Italy and France and went to other countries occasionally, but there were giant parts of the world that he never saw or even knew about. This wasn't a bad thing, obviously. He was able to focus and think and create.

Leonardo died in 1519. Five hundred years later, it's a completely different world. We have access to almost everything. I'm not speaking in terms of a human network. We have access to other people, but they still have to be cultivated. You still have to put in time to make connections with individuals who matter to you. But there's an impersonal version of it—the Internet—that makes it all too easy to find anyone and find out anything. Any time of day or night, I can take my computer—or, increasingly, my phone—and look up anything. I can read a newspaper from almost anywhere in the world. I can read yesterday's news and last year's news, too. I never have to be without the definition of a word, which is discountenancing (dis-

turbing in a way that changes the expression on your face). I never have to wonder about the population of the United States (325 million and counting, according to the Census Bureau's Population Clock).

What this means, of course, is that our brains are changing. They used to be containers. Now they're retrievers. It's a fundamental shift. I remember reading an article somewhere that explained how humans, as a species, are starting to use the Internet and the cloud as a kind of external hard drive for our consciousness. The article said that it wasn't just that technology made these things possible; it made us dependent on those things. I don't remember where I read it, but I can look it up. Okay, got it: *Scientific American*, from December 2013.

The entire expedition to find that out took about thirty seconds. The real Leonardo couldn't have gotten his pens and ink ready to start a sketch of the flying machine in that amount of time.

Lots of people have written lots of articles about the effect of the Internet on the human brain. Container-versus-retriever is only one of the things that are changing. We're also better able to multitask but less able to engage in the kind of task-free meditation that can help make tasks more pleasant when we do perform them. We're constantly bombarded with side rails and related links, which means that distraction is both more of a threat than ever and also something a little different than it's been before—if someone pushes you to a related link, and it's actually related, is that a distraction, or is it some kind of supplement?

These are all important issues. I have looked into some of them at other points in the book. Distraction is an especially interesting one. I'd ask you to flip through the book and try to find the other places where I have discussed it, but that would be more of an illustration of the principle than a helpful piece of advice. Here, though, I want to talk more about the specific ways in which technology changes creativity. I said that Leonardo's world was completely different from the world I was living in when I picked up his biography in

Germany in the early nineties. But the world now, twenty-five years after I read that biography, is completely different all over again.

The first and most obvious effect is that technology drives a stake into the heart of originality. I talked about originality before, in the chapter about getting started with your creative day, and about how certain kinds of imitation can give you a much-needed jump start at the beginning of your day. But they can also drain the battery. At *The Tonight Show*, I get to interact with a variety of comedians. When we first started on *Late Night*, Twitter was just a baby. After a few years, it grew up, and I started to see that comedians were using it as a platform to test out and shape jokes. Then there was a turn, when they noticed that everyone else was doing the same thing. When Ryan Lochte got caught with his pants down—not literally, but in the not-telling-the-truth-about-something sense—jokes were all over the Internet within seconds. People who weren't comedians, but were funny (or lucky, or persistent) went down the same avenues of exploration, and sometimes hit on the exact same setups and punch lines. The first person to make a joke somehow claimed ownership. The second had to make an excuse, even when there wasn't a reason to make any excuse. Media critics and psychologists started to talk about "parallel thinking," the theory that if you put a million people on the same path, some of them will end up at exactly the same destination.

All of this made the comedians I know start to back off from the medium. Sometimes they wouldn't read Twitter, because they wanted to preserve their own process, keep their heads clear. Sometimes it was for reputation purposes—they didn't want to be seen as joke thieves. One year at the Edinburgh Fringe Festival, a comedian named Darren Walsh performed a bit about deleting all the German names from his contact list so that his phone was "Hans-free." He won a prize for it, but then another comedian named Pete Cunningham said that he had tweeted it years before, and that he knew that Walsh had seen it, because they corresponded about it. It turned out to be true. There was evidence.

The result, of course, has been to change the face of comedy. The growth of the Internet was accompanied by the growth of alt-comedy, where the issue wasn't the jokes you told but the way you told them—your stage presence, your performance, the perspective you carved out, your entire persona. At some level, this is just an industry story. But in other ways, it's an important metaphor for how technology is shifting the terms of creativity.

I have another example, not from comedy, though from something comic: weekly newspaper headline writing. My cowriter, Ben Greenman, used to work for newspapers and magazines. One of his early jobs was writing headlines for a paper in Miami called *New Times*. It was a weekly paper, and Ben tried hard to come up with the best headlines for his articles. When he wrote a movie review of Gus Van Sant's *My Own Private Idaho*, his headline was "Boise Will Be Boise." When he wrote an article about a pair of hot-dog-cart owners competing for a busy corner in downtown Miami, his headline was "Wiener Take All." He thought of both of those jokes himself, late at night, with caffeine. Today, "Boise Will Be Boise" has more than a thousand hits on Google. "Wiener Take All" has more than three thousand. (When we were writing this section, he told me that one of his puns had survived unscathed—when he wrote about *Awakenings*, the medical drama based on Oliver Sacks's book and starring Robin Williams and Robert De Niro, his headline was "Mork and M.D." That doesn't turn up anywhere else in Google, as best as I can tell.)

Okay. I admit it. I didn't Google them. Ben did. It's a little self-absorbed, but I can't completely blame him. We were working on this section of the book. It's relevant. But the fact of the matter is that originality doesn't mean what it once did. Parallel thinking is real, but so is the sinking feeling of seeing your idea paralleled somewhere else.

I want to suggest a remedy. Creative people need to start thinking of themselves a little differently. Now, in the twenty-first century, creative life also includes some management of other people's cre-

ativity and the overlap between yours and theirs. To put it a different way: you can be an artist, but you also have to be a curator.

You have to occupy both of these roles at the same time.

Think of your creative choices as if you were curating an art exhibit. Some of your ideas or influences immediately go on display. They become part of the version of yourself that you present to the outside world. Others are waiting for similar things to become a useful group, after which they can be displayed. And then there are the pieces of information or experiences that go into storage. You know that they're helping you to build your collection, but they aren't there for others, at least not yet.

Creative people take in more than the average person—or, rather, they are less able to shut out parts of their environment. In the modern world, that's an even more intense problem, because so much information, so many signals, flow across our brains.

Björk has come to my food salons. She was the earliest person to arrive one night, and I was scared to talk too much to her. She has an otherworldly aura about her, even in person, though one of my guests was on the street with her afterward getting a cab and said that she was very down-to-earth and normal. I spoke to her briefly and listened in on one other conversation she was having, and it confirmed my theory that the most creative people are both making things and curating them. Let's go back for a second to that idea of cognitive disinhibition.

I have had conversations about the way she has integrated science into her work, especially biology. She knows more about biology than the average person, but it's not on display. Sometimes it's in the back, in the warehouse, waiting for a future exhibit. Curation also gives you a lens through which you can see the rest of the world. If you're working on a novel about how technology is changing people's interaction with each other, you'll be able to pass through each day actively watching and listening, because you know in the back of your head that you're working toward that project. You're hanging

Creative life also includes some management of other people's creativity.

that show. I've learned that from my comedian friends, people like Neal Brennan. They get material from existing in the world, from sharp observations, but they're looking within a framework.

Curation also teaches you principles of display. You hang things on the wall next to each other (in your mind). And when you do, pay special attention to what they are saying to each other (again, in your mind). Height on the wall matters. Size matters. Order matters. When you have multiple pieces of an idea, they communicate with each other in various ways.

There's a presiding metaphor here of assembling an art show, but I want to shift it for a second into something that I'm more familiar with, which is DJ sets.

For years, I have done two main jobs. The first one is to drum for the Roots. But I am also a DJ, which means what you think it means—after we're done playing our set, I go to nightclubs (or sometimes stay at the same club) and play music for a crowd. There are older-fashioned versions of this that involve two turntables and vinyl, and there are newer versions that involve a laptop and a playlist. In either situation, the goal is the same: to get people moving. And not in a herky-jerky way, or a kitschy way, or a hyperactive way. It's not all just about playing C&C Music Factory on volume one million. It's a different enterprise: you want the crowd to be moved spiritually and psychologically and physically all at the same time, and for an idea to start to form around the idea of that movement. You are thinking about people and how they are affected by music. When I look out over a room, I'm figuring out how the third song will hit them, maybe

There's so much other stuff being made. Your responsibility is partially to process.

a little sideways if I do it right, and then I will schedule the fourth song to move them a little higher in their energy cylinders, and then a fifth to bring them back down. It's a process described at some length by Eric B. and Rakim in "Move the Crowd. So leave it up to me, my DJ is mixing / Everyone is moving or eager to listen."

And yet, when you are playing a DJ set, you are not exactly making anything. You are contending with work that other people have already made, reorganizing it, repurposing it. It's creation, in the sense that I'm bringing a mood into existence, but it's curation in the sense that I'm looking through existing songs to see which ones I'm going to select. It's also a chance to wonder about the psychological effects of music—how people react to it. I always find that one couple where the husband wants to leave and the wife wants to stay for one more song. I just laugh because I know what I'm playing next, and I know it will seem like a letdown or a curveball. It's easy to have a captive audience playing the hits like that. That's 101. It's so much more amazing to watch them try to figure out why you're playing Kermit the Frog.

Let me give you one example. I sometimes will troll the audience using the *Golden Girls* theme. It's not really punking them, to be completely honest. It's experimenting on them. And the experiment isn't just that it's a nostalgic theme song from an old sitcom, or that the original was a hit in April 1978, the same month that Prince released his first album. It's something more than that. I want to see how a group of people engaged in nighttime activities like drinking, dancing, and Assorted Other Whatnot respond to the sound the tele-

vision would be making if they had decided not to go out at all that night. I'm creating a night that sounds like staying in.

There's another experiment I do. Late in the set, as people are getting worn out, I'll downshift to a slower song. But not just any slower song—Phil Collins's "In the Air Tonight." Everyone knows the song, but think of how it starts: Daryl Stuermer, who played guitar with George Duke, playing that buzzing chord, and Collins layering up keyboards and drums. But the moment everyone knows is later, when the crashing rubbery drums come in: da-dum, da-dum, da-dum. Collins got the effect by playing while the talkback circuit was still activated—it's the technique I outlined in an earlier chapter, being open to the possibility that the accidents might be better than the plan—and then Hugh Padgham, his coproducer, recorded it using compressed and gated microphones. It's the sound that drives an audience crazy. (The modern version is "Can't Stop Won't Stop," from Philly's own Young Gunz, a song just as sparse and minimal and then just as loud and devastating. It uses the same elements, a Roland CR-78 for quiet effect and then reverbed rolls for powerful impact.) When I play "In the Air Tonight" in a DJ set, I can see everyone tensing up, waiting for it—and just as the song gets to that moment, I switch to the other song. You should see their faces. Go take a look at your face in the mirror right now. It's like that, but times a million. (And all the times I've used that song in my DJ sets couldn't have prepared me for the moment in October 2016 when Collins himself, promoting his memoir, came to *The Tonight Show* and performed "In the Air Tonight." Guess who got to do that drum part? That's right.)

The two examples I outlined above are planned stunts. They're like magic tricks. Other times, though, DJ sets are opportunities for spontaneity. If the mood of the crowd seems too mellow, I might hit them with a burst of Eric B. and Rakim—or Playboi Carti, depending on their age. If they seem too close in on one another, I might create some space with Kraftwerk or Rare Earth or Kojo Funds or Gavin Turek. Those create a different kind of arrangement on the floor. I'm

improvising, but I'm actually curating—I'm using what I know about existing artworks to arrange them in such a way that they affect an audience. Or, to quote Parliament, "The desired effect is what you get."

I think of something else Björk said. This one wasn't at my food salon. It was in her interview with Hermann Vaske on German television. He asks her whether her creativity depends more on discipline or chaos. She gives an answer that explains how curation is always part of the process, even for an artist who also depends so much on capturing moments of oddness and whim. "Right now my discipline seems to be mostly when I arrange music or when I'm doing collecting libraries of beats. The studio process is very disciplined and very focused. My voice and songwriting is sort of the opposite. I would never let the analytical side of me in there. It can be very destructive."

This answer really struck a chord with me. That idea of collecting libraries of beats, that's something that many musicians do. As a DJ, though, I take it a step further. I collect libraries of songs. I have terabytes of hard drive space devoted to hundreds of thousands of songs, and as time goes on, as technical standards change, I have to monitor it and improve it. I have to curate it. Around the first of this year, I decided that one of my goals was to get rid of two hundred gigabytes of doubles and triples of songs that I no longer needed. That means good-bye to all the Jodeci songs that are on both greatest-hits collections and on regular albums. That means good-bye to all the redundant copies of Run-D.M.C.'s "It's Tricky" from soundtracks and compilations: all I want is the original version from *Raising Hell*. And why exactly do I have eight copies of "Crazy in Love"? (On the other hand, all the various permutations of Michael Jackson's "Wanna Be Startin' Something"—the seven-inch edit, the twelve-inch, demos 1, 2, and 3, and the regular album release—are essential for collecting.) Obviously, I want to keep the highest-quality copy—I'm up to AIFF standard now, which chews up a tremendous amount of space—and I want to make sure that I don't accidentally get rid of a twelve-inch version or a rare seven-inch edit. Maintaining the collection defines

most of my days. When I wake up in the morning, I spend about two hours scaling down and cataloging. (Even as I am writing, I'm Shazaming all the titleless "Track 1" files in my collection—almost nine hundred at the moment!) When I go to bed at night, it's the same. Maybe this makes me the cat lady of music. I don't know. What I do know is that some nights I fall asleep in a chair and wake up with my computer on my lap, still playing. It's not a terrifically exciting pursuit in some ways, but it's vital in others. It's a form of gardening, maybe: Is that a better metaphor? To end up with beautiful flowers and healthy plants, you have to be in regular contact with them. You have to prune. You have to tend. That's the duty of the curator. In my guise as a DJ, there's a real benefit to it, but I think it's creatively vital as well. This brings me back to the Björk quote. Sometimes you want to be spontaneous. Sometimes you want to embrace chaos. But in a world where there's so much other stuff being made, where your responsibility is at least partially to process it and arrange it before you go on and add to it, it's vitally important to locate (and, hopefully, love) your brand of curation.

Curatorial Thinking

Right when I was starting this book, in September 2016, Twitter had an Ask a Curator hashtag in conjunction with a daylong program of bringing actual museum curators before the public. Mostly, they were from brick-and-mortar museums: art museums, natural history museums, specialty museums. I followed along a little bit through the day, then wrote parallel questions to help people ask questions of their own internal curators. Here are some of the real questions and then, in brackets, my own Questlovian versions:

—What object most reflects your community's heritage? [What creative project that you've worked on most reflects your own cultural heritage?]

—What objects do you have in your personal collection? [Which of your own works would you buy first if you were a consumer?]

—What's the smallest object in your collection? [What's the smallest idea you have ever had, and did you record it in some way?]

When you think like a curator, you're already thinking about how to take the creative choices that other people made and arrange them to your advantage. Curation can be a way of seeing through to the parts of things that matter to you. It's like a large-scale, immersive version of cutup writing. You're collecting things that help to remind you of who you are.

But curation isn't only about arranging. It's not just about what goes on top and what goes underneath, what goes near the entrance and what goes near the exit. That's part of it, of course—and if you're losing the metaphor, back up a section.

But a big part is what's in the show at all. Curation is inseparable from the process of selection, and selection is inseparable from the opposite of selection: discarding. It's an echo of that David Byrne thought—before you decide what kind of artist you are, you have to decide what kind of artist you're not. There's a parallel process that's just as important and a little easier, which is deciding what kind of art you care about and what kind of art you don't care about. Curators do it every day. You should, too.

I used to think that I should have an opinion about everything. I listened to albums and every time I had a reaction. But then one afternoon I was in the band dressing room at *The Tonight Show*, and in the outer room, someone was playing a top pop album by a major star. I won't say which one. It doesn't matter. It sounded fine to me: pleasant enough. But I realized that I had no real opinion about it. I had nothing to say about it, positive or negative. If I had weighed in, it would have been only talking that talk, not feeling any feeling or thinking any thought. It left me entirely blank. And that was okay. It wasn't this artist's fault. There was no fault involved on any side of the issue. This artist had created something, and it was something

that passed me by. It was a strange sensation to be freed from the obligation of having to say anything about the record. It was liberating to not feel the pressure to have an opinion.

How would this work as a curator? It's almost alarmingly simple: the album's not in my show. Maybe there comes a time later when I start researching how that particular artist evolved. Maybe there comes a time later when I develop an interest in certain kinds of synthetic beats. But that has to happen organically. At that moment, in 2015, I was a curator who would not hang that album on the walls of the museum of my mind.

In other words, you need to understand your own curated set of creative impulses in that way. Don't be surprised when you find yourself favoring some of them over others. Be pleased. Again, this is not intended to say anything negative about a pop star and his or her record. It is intended to say nothing about the album, nothing at all, but to stress that that album should only matter to—should only be curated by—people who feel a connection to it. You have to throw things away so that there is some value implied by the act of keeping other things.

The Pick

When you curate, you select. You are making a pick. More to the point, you are making The Pick. The cover of my memoir, *Mo' Meta Blues,* was based on the famous Milton Glaser poster of Bob Dylan (which was in turn inspired by Marcel Duchamp's famous 1957 self-portrait—inspiration can come from anywhere and should). Dylan's hair was a riot of ideas. Mine was, too, with one important difference: my pick. It's a black thing, and a black-hair thing. (And, as Seth Rogen discovered, it's a perfect way to start your own personal Questlove collection.) But there was one other reason, too. I think of the pick almost as a staple, holding those unruly ideas in place.

The Pick is a foundational part of modern creativity. It is what happens. You put your hand on something and it becomes part of your creative profile. But pay attention to the specifics about how it happens. Curation in the modern sense, even though it builds the self, is slightly impersonal. When you go to see a show, it was painstakingly put together by one creative talent, who assembled works from other creative talents. But except in rare occasions, the curator doesn't get anything close to a byline. The primary identity of the group of works is the name of the show that the curator has attached to it.

Looked at from a slight remove, then, curation can be seen as a form of assuming a persona. You assemble a version of your creative interests, the works that inspire strong responses, and then you put that version forward. Other people come and see those works, and through them they understand something about you.

That's how you should function with regard to facts, with regard to works. Ultimately, you're working toward a time when you can function that way with regard to your own works. Some things you make get shelved. Some get hung next to other things. The recombination principles at work—reduce, reuse, recycle—continue to apply.

You are both present and absent. You are both in the moment and out of the moment. This is another version of taking a beat. In the first chapter, I talked about how taking a beat via micro-meditation is important when you first think of an idea. We're in a world that's loaded up with things to think about. But the beat is just as important here. Hang back from your own work. Decide how much you need it at the moment, how much you might need it later. That step back lets you step forward into other work.

Notice When You Notice

In an earlier chapter, we talked about managing your network to your advantage. Then, a few pages ago, we talked about setting up your

show, in which you internally hang all the works that you need to move forward creatively. Setting up the show required you to learn the Art of The Pick, the talent of knowing which parts of the world to filter out.

But once you're done, once the show is assembled, once the little title cards have been typed out and affixed to the wall, then you have to learn how to move through it and make the most of what you see.

On a podcast I heard the comedian Kate Micucci talking about how when she was young, and an aspiring visual artist, she used to go to museums often. She said something about standing in front of paintings. She said she didn't give them all the same amount of time. How could she? That's not how you visit a museum: stand in front of work 1, count to twenty, stand in front of work 2, count to twenty, repeat until dissatisfied. No: you should go through a museum at a clip until something demands your attention. Keep on the move until you are asked by a work to stop moving. Here, the only metaphor I can think of is the way people walked in early Spike Lee movies. Remember his glory days? Spike would put actors on a rolling dolly, with the camera shooting up from below, and pull them along the street. The story onscreen suggested that the characters were walking, usually through Brooklyn, but it would look like they were gliding. Once you have set up your works, once you have wrapped up the curation phase, move with steady smoothness. At some point, something will speak to you. I mean this metaphorically. If one of the ideas in your head actually speaks to you, you might not be getting enough sleep.

When it speaks to you, reward it. Give it a minute. A minute might sound short, but it's not. Try looking at something and studying it intently for a whole minute. That's pretty taxing.

This is another small hint about the modern world: slow time down. I mentioned micro-meditations, how you need to step back from moments of crisis to collect yourself. This is true even when there's not a crisis. The world is filled with so many signals and so much more noise, and simple concentration on something that you

You put your hand on something, indicate it powerfully, and it becomes part of your creative profile.

have already selected is something that's more valuable than you can ever imagine. Someone bought me that game Quinto once. I read the instructions, grasped them, and then never really played. The board stayed on the table as a kind of art object, a futuristic chess-type thing. Then one day I was not quite working on something and half-staring at the Quinto board, and I just zoned out. But I didn't really zone out. I zoned into it. I started looking at the pieces and seeing what I intellectually already understood to be there: some cylindrical, some squared off; some taller and some shorter; some of lighter wood and some darker; some with an open top and some closed. That opened up drastically, just for a moment, into a set of ideas that had to do with Black Lives Matter, Sly Stone's "Everyday People," *Blade Runner*, and old cigarette ads I remembered from my childhood. And just like that, they were gone. The whole thing took a minute at most.

Then, of course, there is the matter of how well you understand what you're seeing. Let me say this right off the top: It doesn't matter. Or, rather, it doesn't matter in the way you think it does. How well you understand the original idea isn't the issue. It's how well it moves within your head. You're not being tested on your comprehension in a classroom setting. You're being asked to move out into the world and make something new.

Let me give you an example. Years ago, I was beginning work on the project that would eventually become *somethingtofoodabout*. I knew a little bit about the food world, but I wasn't an expert, and I thought I wanted to be. To that end, I spent hours looking around the

Internet for food stories of all kinds. One of the stories I ran across was about a Japanese scientist who was developing ways to help people grow fresh vegetables in their cramped urban apartments. People before him had experimented with rooftop gardening, but not everyone had rooftops. They had also experimented with closet grow-rooms, but those ended up being used for different kinds of plant life. (Actually, in Japan, that's probably rare. I remember when I was little and Paul McCartney got busted for weed at the Tokyo airport. He was in jail for nine days—I wonder if they kept him that extra one just to prevent all the headlines.) But this scientist I was reading about had another idea. He developed a kind of special plastic wrap that was loaded up with nutrients. You dropped a seed on top of it, added a little water, and went to bed and before you knew it, the plant was budding right there on the plastic wrap. It was like transparent soil. That's all I know about it. I don't remember the guy's name. I don't remember exactly how it worked. I don't remember if it was a prototype or something that he was selling, or something that he was giving away to urban Japanese and people in other developing countries. Mostly what I remember is the thoughts that it put in my own head. I was thinking about plastic wrap, and then rap, and then I was thinking about the seed taking hold on the sheet by putting down roots, and then I was thinking about the Roots. For me, that plastic wrap became a metaphor of how your creative environment didn't have to be obtrusive. It could be as subtle as a transparent sheet. But that was just the first metaphor. Where it really helped me was the next time I started to work on a record. I had the idea, somewhere far back in my head, that the best way to be creative was to set up a kind of invisible barrier that would catch and nurture ideas. That's how I collected rhythmic ideas, and how I approached Tariq about his new lyrics.

The original idea was only a thing hanging on the wall that I saw for a minute. Remember: the minute of viewing means that it's one of the important ones. It wasn't a five-second skim. A minute went with my Quinto set. My plastic-wrap minute was a little different.

The first was associative thinking built on the back of observation. The second was a kind of exploration built on the back of poor understanding. I'm not ashamed of it. I wasn't in it to provide a full account of how seed-encouraging Saran Wrap works in modern-day Japan, and why would I be? I was in it to understand how that process and that produce might profitably interact with my own processes and products.

You are both curator of this exhibit and the first—and possibly only—visitor. You have dual responsibilities, like Alexander Hamilton. (Whoever that is.)

How Your Best Self Might Be Your Worst Enemy

I want to issue a caution about curation. You are always curating your life. That's true. But I have noticed a disturbing trend. I'm not the only one. Everyone has noticed it. It came to a head during the 2016 presidential election, when people started to voice their opinions and make themselves known primarily through their online presence. The online world is all about curation. But it's a deceptive version of that principle. You get to present for people your best face, your best look, your best day. Everyone becomes a product, a package. And the reason is that we're all afraid of not getting attention, and the way you get attention is by positioning yourself in a way so that you get it. There are obvious versions of this, and it seems almost silly to attack them: teen starlets who post filtered duck-lipped pictures, or politicians who pander to whoever the last person was to contact them on Twitter. There are now apps that let you change your onscreen face in real time before you take selfies.

This can't be helped. People who are purely presentational will remain that way. I'm more worried about the effect on creative people. The goal of creativity may be to learn to present yourself to oth-

ers, in part, but it's not to present yourself at the expense of truth. The second you become your own product, you're heading down a chute rather than up a ladder. I will give you an example, but I won't say who I'm talking about, because I don't mean to attack anyone. There's an artist I know. She's either a musical artist or an author or a painter. That's how vague I'm going to be. She was always introverted and quiet. She kept to herself. If you asked her for her opinion on politics, she wouldn't tell you. If you asked her what she was reading, she wouldn't tell you. It was frustrating to try to draw her out. Then, in the age of Twitter, something changed—suddenly, alarmingly. She started posting pictures of her food and linking to her Goodreads reviews. Early on in this transformation, I felt happy for her. I'm a shy person myself in some ways, and I know it can be painful, and I liked seeing her come out of her shell. But then at some point it became a problem. I heard that she wasn't doing as much work. The business of orienting herself, or presenting herself as a product, had become, in fact, her work. This may sound a little hypocritical, and with any luck it is. I use social media as much as anyone. I am tweeting all the time, and Instagramming, too. But I'm careful (if not always successful) about making sure that it doesn't step on my work. I also like to show warts. Not literally. That would be gross. But I like to show the entirety of my human experience. Sometimes that means that I blunder and speak out of turn. I have offended people who thought a joke I made was inconsiderate or flirted with broad stereotypes. Look it up. But I don't like the idea of the Internet scrubbing all that away. I also live in a world that proves this point a second time: the world of show business. Every day, before *The Tonight Show* goes on the air, we get hair and makeup. I wake up beautiful, of course, but beauty needs a hand to move it along. I get work on hair and skin and nails. They know that a camera is going to be on me, and that millions and millions of people will be watching. Not even just watching: scrutinizing. Technology has allowed people to see the tiniest details, so now that's what we focus on: the tiniest details. (On TV, it's visual scrutiny via

HDTV. On the Internet it might be a typo. But the principle is the same.) When we focus on those tiny details, we lose sight of the larger issues. We just do. It's just the way it goes. And when it comes to making art, both of them have to be working hand in hand. You need to think of the small things, no question. You need to be able to get that pitched-down cymbal just right. But as I've said a hundred other times in a hundred other ways, "just right" isn't necessarily about flawlessness. Sometimes it's about the flaws. It's about letting that sound go a little flat or a little wobbly, about letting it carry humanity. The era of curation, which is the era we're in, the time of picking, which is the time that we're in, isn't an excuse to selectively edit our humanity and show the world a happy face (or a fresh face or a put-together face) that doesn't have much, if anything, to do with our essential real identity.

Rant done. For now.

Sticking to Your Guns

DJing may be the purest form of curation. It affords you the opportunity to build a collage of the world's sounds. I tend toward the arty end of the spectrum, and toward the black-arty end. My whole stance toward modernized commercial music is that I love it. I'm unashamed to love it. I love Drake. I love Future. I love Migos. I like Earl Sweatshirt, Logic, Kendrick, Cardi Chance. D.R.A.M. might be my favorite new belter in hip-hop since ODB. I'm wide open! I'm not a snob about anything that's on the charts. But I am also devoted to exploring the connections between the different parts of music: national and international, American and British, rock and soul and punk and funk and folk, nineties and eighties and seventies and before. I'm aware enough of connections to demonstrate that you can play Duke Ellington and Remy Ma and Led Zeppelin and Millie Jackson and it can all work together. It's like string lights, or the opposite:

when you illuminate one light on the thread, they all go on together.

I build all the music I have into megasets. I clean up and refine. I shuffle songs and polish up the whole set. Usually around March of each year, I start cleaning out my DJ set. I look at the new music I've put in there, think about the music that hasn't changed for more than a year, tighten pacing, calibrate. I also try to arrange it to accommodate new things I have noticed about crowd habits. For example, a few years ago I started putting in power boosters just before hour marks. When people are out at a club, they look at their watches as the time draws near to midnight, and again when it draws near to 1 A.M. That's when they're thinking about paying the babysitter and getting enough sleep for work. So that's when I hit them with a killer record. It obliterates the whole idea of leaving. They never even make it to the coatroom. I keep them another hour, at which time I can give them another killer record.

This past year, clearing out and tightening up my DJ set took on an entirely different meaning. To explain, I have to go back to the presidential election of 2008. During that time, the Roots were campaigning for Barack Obama. We agreed with his political stances, but it wasn't only that. We connected at some deeper level, without ever meeting in person. The more I saw of him, the more I knew I wanted to share music with him. He was so smart, so receptive to the way that American culture worked, so interested in the intellectual links between things. I started sourcing and collecting songs like crazy, and they evolved into these elaborate playlists: evening-chill music, spooning-in-bed music, up-to-beat-the-world music, what you would listen to while you were eating or while you were reading a book. I knew that if it was music to chill by, you wouldn't want loud drums or too much screaming. I had it all worked out. I programmed an iPod with special music on it for Obama—and gave it to Jay-Z. I programmed a second one and gave that one away, too. I never got the music into Obama's hands.

Through 2016, I started to use my regular gigs at places like

Brooklyn Bowl as a means to experiment with playlists. I even fine-tuned when I had more high-profile gigs, like celebrity weddings. But it wasn't just refining my DJ set. I was working toward something big, a Unified Theory of Everything As Explained Through Music. I debuted that new set, or a version of it, at the *Hamilton* after-party. That was a seven-hour set at Tavern on the Green, from 11 P.M. until 6 A.M., and it went even deeper into my sense of American music and American history. I started playing Nintendo themes, *Mike Tyson's Punch-Out!!* I was the museum curator hanging a Roy Lichtenstein next to an Andrew Wyeth to raise issues of nature and artifice, history and media. I was out there on the Tilt-a-Whirl, and the audience stayed with me. Afterward, the actress Lupita Nyong'o wrote me a love letter—well, not to me, exactly, but to my set. I was emboldened by that. How can you not be emboldened by a love letter from Lupita Nyong'o? I had started with the idea of wanting to make a perfect playlist, but now I was on a cultural-historical mission. I would relate the perfect overarching story of America—of humanity—through a DJ set. It was the same as hanging a great museum exhibit, but instead of paintings I would use songs.

At the beginning of 2017, I played a high-profile event. I can't say much more about it than that. Hush-hush. Suffice it to say that it was attended by several luminaries in several fields, and that for the week leading up to the gig, I knew that it would be my chance to debut my Historical-Cultural Megaset. I was ready for my close-up as Black Super-Art DJ, starting in the present, then shattering time and place as I stepped back through the past, working in everything from seventies rock and soul to Mingus to Les McCann to show tunes to jazz standards to classic disco. I would weave a tapestry out of all of it.

The night came. The show started out great. Everything was humming along. Then, at some point, I felt a presence at my elbow. I turned. It was one of my hosts. "You're doing a good job," he said. "I love the music you're playing." I sensed a correction coming. He waved toward the crowd, and specifically toward a knot of kids right

Learn to present yourself to others, but not to present yourself at the expense of truth.

near the front of the room. "But I was wondering," he said, "if we could shift it over a little bit so that the kids could dance more." I thought about a guy who used to be my driver. He was one of the most reckless drivers in history. Any woman who got in the car with me had to learn to close her eyes, hold my hand, and blindly trust. I wanted my set to be that driver. I wanted complete trust. I wanted to hold course stubbornly, which has generally been my practice. For the most part, I will risk people getting conniption fits from hearing my sets. I will risk them feeling like they want their money back. I will risk having my set cut short while someone else plugs in an iPod (hello, Solange).

But for some reason, at this event, for reasons I can't quite explain (I'm not being coy—like I said, hush-hush), I decided to veer off the course I had planned and give the people what they wanted. I had French Montana. It wasn't the radio version. It had profanity. It had sexually explicit lyrics. Was that appropriate for the kids? But I had been asked, and I had decided (it seemed) to cave in. The second I did, the dance floor was flooded with two times as many people, and then three times as many.

With that larger audience all-in on the altered set, I became my worst nightmare. People started whispering suggestions to me. People passed me requests. I went on Spotify to see what the most popular songs were, and I played those songs also. That excited the crowd even more. They loved what they were hearing. Even familiars, people who had witnessed many of my sets over the years, told me that it was one of the best they had ever seen.

As much as the crowd was into it, I was out of it. I was miserable. I had betrayed myself. I had planned to use my DJ pulpit to hold forth on history and culture. Instead, I had given people a great dance set. And yet, what was wrong with that? (That's what the other half of my head said.) Creativity is context. Audiences are a context. A performing artist always has to take a measure of the crowd. Maybe I had done the right thing. So why did it feel so wrong? Why did I feel so drained and sad, so splintered and defeated?

I think of *Purple Rain* here. I'm often thinking of *Purple Rain*. In this case, I mean the movie more than the album, and I'm thinking specifically of the difference between the music of the Kid (the character that Prince plays) and the music of the Time, the rival band led by Morris Day. The Kid makes complex, emotional songs that help him deal with his own troubled home life. He works it out onstage. The Time makes party anthems, and brings them to the stage to give the audience a workout. For much of the movie, the Time seems to be reaching the crowd more successfully—the crowd in the nightclub, I mean. The audience in the movie theater or at home, the audience watching the movie, knows that the Kid is the superior artist, but we're frustrated with his inability to balance his own needs with the needs of the crowd. That leads to one of the most famous lines in the movie. Billy, who runs the nightclub in the movie—a fictional version of the real First Avenue—comes to the Kid to lodge a complaint. "Nobody digs your music but yourself," he says, pointing judgmentally. The Kid's response? Expletive deleted.

In the months where I was frustrated that audiences—well, non-*Hamilton*-Tony-after-party audiences—weren't immediately leaping forward to embrace the brilliance of my playlist, I sometimes felt the same way: expletive deleted. But in the movie, the Kid comes around to Billy's point of view, or at least comes around to the halfway point. He realizes that he has to incorporate the needs of the audience into his formula. And what happens? He beats the Time at the band's own game. He connects emotionally

In a performance, an artist must insist on his own plan and recognize the needs of the crowd.

(with "Purple Rain") and also delivers a pair of smoking funk anthems (with "I Would Die 4 U" and "Baby I'm a Star"). There's a moment where artist and audience are balanced, but the question of their relationship isn't solved so much as acknowledged as impossible to solve for more than a moment. Ultimately, it's the knottiness of that question that untangled the whole issue for me. In these cases where I was unable to curate a DJ set the way I wanted, there was a melancholy that hung over the entire experience. The audience wasn't sad, but I felt sad, both in a melodramatic way and in some real ways also. In those moments, as I worked through (and hopefully as I worked out of) my sadness, I experienced something equally illuminating, a demonstration of the tension between the needs of the many (the crowd) and the needs of the few (me). True creativity, or at least the version of it that happens during a performance, requires an artist to both insist on his own plan and recognize the needs of the crowd, and to live inside the tension between the two.

I didn't figure this all out right away. After the disastrous night where I caved in and played a dance set, I reassessed. I pulled way back on DJing. I didn't stop entirely, but I said no to many opportunities. I was still a little bruised from my failure to reach the answers and my readiness to back off from important questions. Toward the end of 2016, I started a partnership with Pandora, the online radio and streaming service, on a show called *Questlove Supreme*. The show includes an interview component, where I speak to important figures from pop culture, both present and past. It's music-nerd nirvana: I

can have an episode with Ray Parker Jr., and then one with Shep Gordon, and then Alan Leeds, and then MC Serch. The guests on my show are all living links to history. Each of them tells a part of the story. If I could project the Pandora show ten years into the future, it will end up being a version of the perfect DJ set I imagined, but built from interviews instead of songs. If I was disappointed, almost even devastated, over the failure of my DJ set, *Questlove Supreme* offers a solution. It's curation, and it's a cure.

↓

Hanging the Show
Imagine creating an exhibition of all the things that inspire you, and imagine how you would arrange the works in the show.

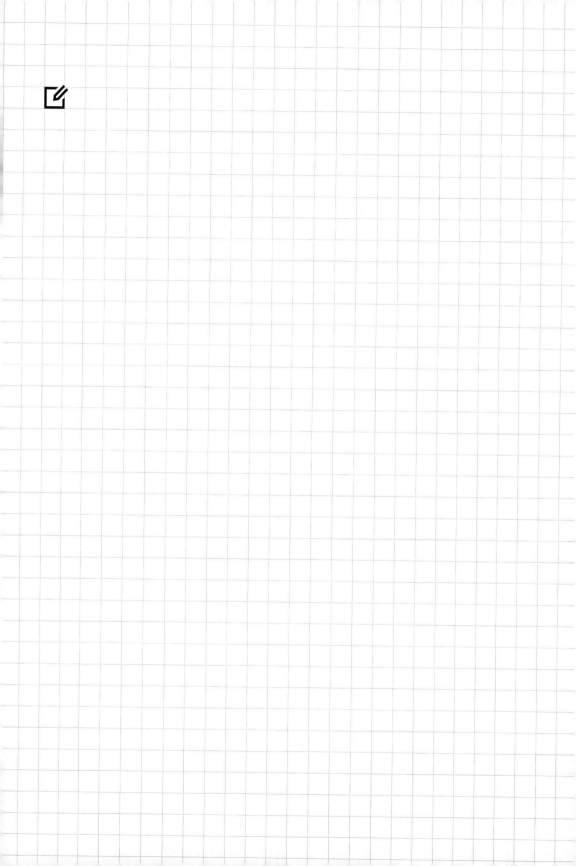

The
Departure↗

Get Out of Your Comfort Zone

Creative people have specialties. But they also have restlessness. That's part of the paradox: how do you keep your talent sharp while still exploring ways to expand your talent? How do you keep doing the thing that you've been doing while also doing other things?

The answer, at least as far as I can tell, is a version of the principle I outlined in the section on micro-meditation. The trick there was to simultaneously be present and be absent, to immerse yourself in the moment but attain a state of mind that momentarily suspends you and takes you away from the task at hand. There's a broader, less internal version of this same strategy, and that's something I'll call "the departure." Make an effort to make your life different. It's the only way that it will stay the same in terms of creative inspiration and creative energy. Meditation helps you switch the channel when it comes to what is moving through you. The departure helps you switch the channel when it comes to how you are moving through the world.

Singers obviously sing, but one of the other things they commonly do is paint. I remember reading an interview with a famous singer who was also a painter. It might have been Joni Mitchell, who made paintings for a bunch of her album covers. It might have been John Mellencamp, who has done the same for some of his albums. It could have even been Tony Bennett. Whoever it was talked about how painting was more than an outlet, how it was a translation of their musical ideas. The paintings they made were not bad. Critics liked to call them "accomplished." (That's always the word that gets used when they want to say that a singer is a good painter but not as good as someone who has devoted their entire life to painting.) This singer talked about the way that music and painting share some qualities. You have to pick a palette, whether it's hot and energetic or cool and controlled. You have to pick a rhythm, whether it is rapid and frenetic or slow and languid. You have to pick a volume. You have to decide if you're organizing everything in an easy-to-

understand way, like a pop song or a figurative portrait, or in a more difficult way, like an art song or an abstract. I don't remember exactly which singer was talking about painting, but I know for a fact that it wasn't Miles Davis.

During the late 1970s, Miles started to paint regularly. He painted faces, and bodies, and his idea of what music sounded like. There are two quotes from Miles that stick with me. One is about his clothes. "I've been painting and sketching all my life," Miles said. "For my tailor I used to draw my suits, 'cause he couldn't speak English." I like this quote because it makes me laugh. The other one is more useful: "Painting is like therapy for me, and keeps my mind occupied with something positive when I'm not playing music." Therapy isn't only about solving problems: it's about pacing out the process of wrestling with problems. During the period where he took up painting more seriously, Miles was hobbled by health problems and addiction issues, and he took an extended break from playing the trumpet. He wasn't performing. He wasn't recording. People wondered if he'd ever release another record. He didn't, however, take a break from making things. He knew instinctively that he had to keep his mind occupied, but he didn't really mean his mind—he meant his creativity. He meant that he needed to engage with the process of encountering a blank space, whether in time or in space, and filling it in with his sense of how things should be.

Again, a new skill doesn't mean a new talent, necessarily. Often, you're dealing with the same talent. You're just putting it into a new place, where it can acquire new energy. There's some scientific basis for this. Neurologists have proven that brain plasticity matters, and that when you broaden your life even in small ways, you broaden the brain that helps you to understand your life. Monomania may sometimes seem like the answer, but only if you don't think about anything else. It's not about taking breaks, or pauses, or naps. It's about excursions. It's about departures.

Even as I make this point, I step away from it, to some degree.

After all, this works against the ten-thousand-hour theory popularized by Malcolm Gladwell. Or does it? I want to suggest a correction: for every hour you spend doing something, spend at least a few minutes doing something unrelated. That's Questlove's corollary to Gladwell's Ten Thousand Hours. Getting into a groove can be dangerously close to getting into a rut. There have been times when I have worked for hours and hours on a drum part, only to realize that it was no longer nurturing me, even as I got close to perfecting it. I needed to go elsewhere to be able to make the most of my time behind the drum kit.

This is somewhat abstract so far. What does it mean in real terms? Start by thinking of the specific places in the world that encourage creativity in the broadest sense. The great creative director George Lois was a big fan of museums. He used to recommend that everyone in advertising or magazine publishing or fashion who worked in New York City spend an hour after lunch walking around a museum. Even if it wasn't your thing, it could energize your thing. That's much less dirty than it sounds.

Today, the world gives you a million different kinds of museums. Search through Spotify by random keywords. When you're choosing a movie to watch on Netflix, watch the next one in the alphabetical list instead. Taking unexpected turns will yield great rewards. For a creative person—a person who's following this overall path toward ideas, and the other steps in this specific process—those unexpected turns are often reinvestments. Michael Solomonov, one of Philadelphia's top chefs, told me that most of his food ideas come when he's experiencing different kinds of art: when he's listening to music or watching theater. The artist Wangechi Mutu told me that she likes to listen to audiobooks, or at least to recordings of authors reading their own work: "Right now," she said, "I am listening to Derek Walcott reading his poems. *Tiepolo's Hound* in particular. His voice is like an ocean brain. I also recently loved hearing Ngugi wa Thiong'o talk about memory and the power of erasing a people's

memory in order to replace it with new memories so that their past shall no longer exist. When frustrated, I try putting mysterious things and pieces together, creating a whole that is tougher and more beautiful, and makes more sense than the individual bits." The way tradition gets used, conserved, and extended is central to the way creative minds work. Cornel West often calls himself a "bluesman in the world of ideas," by which I think he means that he draws on existing traditions, injects a deeply personal dimension, and tries always to locate the universal component of his idea. The best way for him to explain himself is through a metaphor. We have metaphors because people's minds try to make two unlike things like each other. We have creativity largely because of metaphors.

Shaken and Stirred

All of us have places where we feel comfortable with our surroundings, and we hope that we'll find our way to at least some minor inspiration if we stay there long enough. Moving away from those familiar spaces and places raises the stakes. It puts us in a position where we will find either major inspiration or no inspiration at all. It's an adrenaline rush. It renews the risk.

Shaking it up doesn't need to be dramatic. It can be simple. The Bee Gees famously wrote "Jive Talkin'" because the causeway over Biscayne Bay had an interesting rhythm under their car tires when they drove across it for work every morning. Barry Gibb started hearing it in his head: tun-ticka-tun-tucka-tun. That became the basis for their biggest hit up to that point, and an important transitional song as they moved from chamber pop to disco.

Be receptive to ideas all around you. When I walk through my food salons, I'm listening for fragments of conversation that I can incorporate into new ideas. It's like being in an airport. Whenever I am in one, I think about the final scene of the first new *Planet of the Apes*

movie—the one with James Franco. At the end, there's a scene in an airport, where a pilot who is sick with a virus is about to board a plane. The final scene shows a red line that illustrates where the pilot is traveling, and that shows the rise of simian flu, the virus that will kill off much of humanity and lead to the rise of the Planet of the Apes and the next movie in the series. So that makes me a little nervous—call me paranoid—but also, when I think about it, it makes me excited. There is no simian flu, as far as I understand. But there are hundreds of thousands of other ideas, and they spread in real life the way the flu spread in the movie. I hear snippets of conversation that turn into rhythms. I hear references that spark other references. I hear words I don't understand, which motivates me to go and look them up and create new ideas. I'm not unique in this, nor are airports. They are nexus points. But they are also gateways to departure.

Get Actively Away

These examples of departure so far are relatively passive ones. That doesn't mean they're not good examples. They are. And they come with advice. If you're a musician, don't forget to look at paintings. If you're a songwriter, read about subjects that are unfamiliar to you. Those departures will inform you. They will enlarge you. They will shape your sensibility, or reshape it. They will nourish you in moments when you might otherwise feel as though you're starving, creatively speaking.

But there's a second level of departure. When you're practicing a creative discipline, practice another one. If you are a singer, draw cartoons. If you are a writer, try to sculpt a little bit.

There are some familiar channels of expansion and outreach. Many jazz musicians paint—there's something about the way they see songs in their mind that lends itself to reforming and reorganizing pigments on canvas. And many painters branch out into filmmak-

It's not about taking breaks, or pauses, or naps. It's about excursions. It's about departures.

ing. They already understand visual composition and working with light and color.

What's really interesting to me, at least in terms of creativity, is what skills they bring across from one art form to the other. From my unscientific—but not unartistic—survey, I think they make a point not to bring all their skills across, but rather to learn new skills. In the mid-nineties, there was a movie about the painter Jean-Michel Basquiat called *Bold Strokes*. Just kidding: it was called *Basquiat*. The movie was directed by another painter, Julian Schnabel, who was trying his hand at becoming a filmmaker.

People loved *Basquiat*. Or rather, some people did. Some people didn't, for pretty specific reasons—the filmmaker Jim Jarmusch boycotted it because he remembered how Basquiat himself hadn't liked Schnabel when the two of them were painters. Creative lives are complicated. But many people accepted Schnabel as a director after they had accepted him as a painter. (It didn't happen for everyone. Robert Longo, another decorated artist, branched out into film with the 1995 movie *Johnny Mnemonic*, which very few people liked, and which didn't succeed commercially.) With Schnabel, it's interesting to think about how he embarked on a second creative career and succeeded. Were certain skills transferable? Did he see moving pictures a certain way once he had spent a life with still pictures?

At around that time, David Bowie gave an interview. He had just finished acting in *Basquiat* and some other movies, and the interviewer asked him how Schnabel was as a director. Specifically, he wondered how a painter translated his creative skills into the world

of film. He asked Bowie to compare Schnabel's filmmaking approach to the approach of Tony Scott, a much more commercial director who Bowie had worked with some years before. (The Tony Scott movie was a vampire movie called *Fangs for the Memories*. Just kidding: it was called *The Hunger*.) Bowie's answer was interesting:

> Tony's priority was creating a complicated and asymmetrical frame. And the visual was nearly all of what he was doing. He didn't particularly instruct me or have great ideas on the throughline of the story. It was about moving one interesting visual against another. One would have thought that's how Julian would work. It was about narrative, about forms. I wouldn't say that the visual was secondary with Julian but definitely the momentum of the story he was trying to tell had equal priority to the visual.

What I learned from this quote was that people travel from one art form to the other in complex ways that put all kinds of fascinating pressure on their creativity. A painter making a film doesn't just set up painterly frames and then turn on the camera. In fact, as Bowie suggests, Schnabel's motives for going into film in the first place might have had nothing to do with relying on his visual ability. He might have been confident about that and wanted instead to strengthen his storytelling or his sense of building character. This returns to one of my earliest points, which is that creative people are creative. I thought of that! What I mean by it, as I've been saying, is something a little bit less obvious and idiotic than it might seem at first (but, sadly, only a little). I mean that creative people have some impulse inside of them that compels them to approach material. That material can vary. But when they approach it, they approach it with a certain attitude. It's an attitude of change, or of active engagement, or of balancing reason and irrationality, or of channeling personal passions and obsessions and fetishes. There are lots of options. But if you have one of these creative attitudes, you're a creative person.

And if you're a creative person, then the things you make are by defi-nition creative. A Schnabel movie can potentially articulate a set of ideas as completely as a Schnabel painting.

That doesn't mean that it's just as good. That's a discussion for another time. Maybe Jim Jarmusch was right to boycott *Basquiat*. The point is more about the departure. When an artist in room A goes down the hall to room B, what does he learn there? Is he bringing all his tools and notes from room A, or is he just walking in cold and pre-senting himself as a new student? There are lots of answers, depend-ing on who you are, where you are in your career, how far apart the rooms are from each other, and so on. But the departure itself is a vi-tal part of any creative life. Otherwise, you're trapped in one place.

Speaking of trapped—and this will seem like the most obvious segue in history—Schnabel would go on to direct *The Diving Bell and the Butterfly*, which is an amazing movie about creativity and depar-ture in its own right. It's about a French journalist, Jean-Dominique Bauby, who was the editor in chief of French *Elle*. Bauby suffered a massive stroke in his early forties and found himself locked into his own body. He was completely aware of everything around him, but he was also completely physically paralyzed. He couldn't move his arms. He couldn't move his legs. He couldn't speak. All he could do was blink his eyes, and one of his eyes had to be sewn shut because of a tear-duct problem. The man couldn't even cry. He developed a code that involved blinking his left eye to send messages. And then he wrote a book. It took him, it is estimated, two hundred thousand blinks to write it. I get dizzy after ten. Without the ability to move or speak or really even touch anything anymore, his other senses sharp-ened, especially memory. Is memory a sense? If it isn't, it should be. (This idea, that blocking up one path in life enriches another path in interesting ways, isn't new. In fact, there's a common notion that blindness makes musical ability more intense: Blind Willie Johnson, Ray Charles, José Feliciano, Stevie Wonder. I could have just used Stevie Wonder as an example. You don't need more examples than

Travel is as much about the place you're leaving as the place you're going.

that. Stevie wasn't blind from birth. He was put in an incubator and got too much oxygen, and it damaged his eyes during infant development. One thing that I like to think about with Stevie, and it doesn't exactly belong in this section, but I'll put it here anyway, because I don't need an excuse to think about Stevie Wonder: How do his songs have images in them? In a song like "Bird of Beauty," he's writing about a bird, and he talks about colors. Where do his visuals come from? Does he hear them in other songs and move them over to his songs, knowing that colors have certain emotional content even if he can't see them?)

Schnabel adapted *The Diving Bell and the Butterfly* into a movie. This was about a decade later, and it was something different all over again. If the first movie was a departure, this one was a kind of synthesis. You can see all the things that Bowie was talking about, but because it was an adaptation of an existing book, Schnabel could also focus more on the things that Bowie said Tony Scott was doing. Bauby remembers much of his life in flashback, and those scenes are sometimes composed like paintings.

The writing of *The Diving Bell and the Butterfly* is the most extreme case I can think of where someone abandoned one creative pathway and started off down another, only to find that the second one had its own rich set of benefits and drawbacks. But it's not only about the extreme creative resourcefulness that Bauby needed to write his story in the first place. It's also about his sense that life is all about being trapped in certain environments and habits and trying to break free of them. That's what the diving bell in the title is—it's an

old-fashioned compartment that's lowered into the ocean. In the movie (and I guess in the book, too, though I haven't read it), there are portraits of other people trapped by fear or by conservative thinking. They're in diving bells of their own. The butterfly represents freedom and the beauty of that freedom. When you escape your diving bell, you enable yourself to become a butterfly.

No one would recommend locked-in syndrome as a form of creative motivation. That would be crazy. But Bauby's forced departure from his old life had interesting creative consequences. You can stage a version of that in your own life. You can artificially force yourself into a certain departure, then see what effect that has on your work. It will have some effect. And because I've spent so much time roaming around in other people's life stories, I'll end with a story of my own. When I first started working on *Mo' Meta Blues*, I had never written a book. I had written before, both in school and out. I had written blog posts and online essays and some newspaper and magazine pieces, but I had never taken the time to sit down and write a book. It was a collaborative book, which was a perfect way for me to do it at the time, because it let me both teach and learn at the same time. But it was a departure. I started to think in different rhythms. The unit changed. It wasn't a bar or a measure; it was a page or a chapter. The idea of revision changed. The idea of how I could or should incorporate other people's thoughts changed. Rich, my manager, was more experienced at writing, and Ben, my cowriter, was more experienced than both of us. But I got out there and did it. I went into that world and made that thing.

Wherever You Go, There You Are

A departure is never quite what it seems. Or rather, travel is as much about the place you're leaving as the place you're going. I know a woman who grew up with me in Philadelphia. She went to Rome

when we were in our early twenties, and when she came back, she told me about it. Her description was good and detailed, but it was also based on Philly. This plaza reminded her of Rittenhouse Square, a little. There was a building that had some of the same feel as the Academy of Music. It wasn't just that she had a limited context, though that was part of it. It wasn't just that she was talking to me, who also had a limited context, though that was part of it. It was that new ideas grow out of old ones.

If you think about it, they don't have much choice. Pick your metaphor. Pick composting, where organic materials (including some unmentionables) become powerful fertilizers. Pick an echo, where you send out a sound and it comes back to you at a slight remove, to the point where you can (and should) imagine that it's someone else saying it. Hey, that's a good idea that's being suggested by that other voice. I should do something with it. I have, throughout my career, seen so many examples where I stepped into a new field—embarked on a departure, in the language of this chapter—only to find that it was deeply connected to something I had done earlier.

That's how I got to the lazy Susans. Lazy Susans, of course, are those circular platforms that sit in the middle of a dining room table. They spin around, which means they can be used to pass things from corner to corner without reaching through the middle. I have mentioned them before, but I will mention them again. Time is a flat circle, just like lazy Susans are. In 2015, I manufactured a few limited-edition lazy Susans made from Corian, a countertop material, and displayed them at my food salons. But they weren't ordinary lazy Susans. They were decorated with strobe-disc patterns, so they are lazy strobes. Strobe disks are tools of the trade for DJs—they are record-size discs that have, printed on their surface, black-and-white patterns. The patterns look nice, but they're also functional. When they're spun at a certain speed, they look like they're not moving at all. It's a way of checking the running speed of your equipment, verifying that the RPMs are accurate. The lazy Susans I manufactured

didn't spin at turntable speeds. If they did, the food would fly off onto people's laps. But they drew on music, technology, and food in ways that connect all three disciplines. They reminded me that music is divided between artifact (the disc) and experience (the sound) in much the same way that food-art is divided between the permanent (the dish) and the temporary (the food). They also reinforced ideas of circularity and slight returns, in the *True Detective* sense—time is a flat circle, whether it is in the recording studio or the kitchen. Most important, they reminded me that I was forever in the position of being reminded. I thought I was having a completely different idea, but it turned out to be an idea that connected to ideas I was already having. Creatively speaking, that's often the case—the more things travel, the more they stay at home.

Take Me to the Other Side

But when you depart, you also have to be open to what's on the other side. You have to be willing to pack for the trip with everything you think you need, but also to use what you find when you get there. Rich Nichols, the Roots' late manager, my mentor, used to travel with us all the time. He was on the plane. He was in the bus. At some point, he developed a strategy for packing. He would only take a day or two of supplies. Anything else, he figured, was easy to acquire. He could buy underwear. He could buy T-shirts. It turned out, later on, to be a good practical calculation. If the airline was going to charge (or overcharge) for checked bags, it made sense to cram everything inside a carry-on. But Rich didn't do it for financial reasons. He did it for creative reasons. He needed to rethink himself in that new environment, even for a minute. He needed to experience real change, even if it was fleeting.

This is the other element of the departure. Allow yourself to change. Rich devised a packing strategy, but he was always that way,

Expect change. Demand change of yourself. Try, as always, to keep it within the bounds of the attainable.

and because of that, we were always that way also. No matter what you already have, understand the desire to remake yourself. This is part of the creative constitution, a restlessness. When the Roots have made records, we've tried each time to strike a different tone, to use a different approach, to employ a different process. We know that this is the way we'll end up with a different record. We aren't afraid that it will be less creative. We want to see what happens.

Expect change. Demand change of yourself. Try, as always, to keep it within the bounds of the attainable. There are many stresses in the creative life, so it's important to limit the self-inflicted ones.

One example springs to mind. In 2014, while working on my book *somethingtofoodabout*, I spoke in depth a few times with the chef Dave Beran. Dave and I became friendly. At the time, Dave was working at Next, a Chicago restaurant with an innovative setup. Every three months, Next became a completely different restaurant. They might be a steakhouse for a little while, and then become a Thai place, and then become a French bistro. Change was built into the DNA of the establishment.

What this meant was that he had to hire a certain kind of cook. I assumed that he would need people who were generalists, rather than people who were good only at one thing. Dave agreed, and then he disagreed a little bit. He didn't necessarily want generalists. He wanted people who could see themselves as a specialist in one thing and then, a few months later, see themselves as a specialist in another thing. They had to have passion, but that passion had to be convertible to other passions.

There's another, considerably different example that also springs to mind. In 2016, Spike Lee made a documentary about Michael Jackson, specifically about the years in his career spanning the late 1970s and early 1980s, when he went from being the frontman of the Jackson 5 (and then the Jacksons) to being a solo superstar with *Off the Wall*. In the documentary, Spike shows a handwritten note that Jackson wrote to himself.

> MJ will be my new name. No more Michael Jackson. I want a whole new character, a whole new look. I should be a tottally different person. People should never think of me as the kid who sang "ABC," "I Want You Back." I should be a new, incredible actor/singer/dancer that will shock the world. I will do no interviews. I will be magic. I will be a perfectionist, a researcher, a trainer, a masterer. I will be better than every great actor roped into one. I "must" have the most incredible training system. To dig and dig and dig until I find. I will study and look back on the whole world of Entertainment and perfect it. Take it steps further from where the greats left off.

I forgive him "tottally" and "masterer," and even the weirdness of "I will be better than every great actor roped into one." And I am not sure that this is the right mix of self-awareness and self-protection. Remember: we're dealing with someone with limitless talent and drive who burned himself out in every way that a person can burn himself out—unhealthy habits, bad associates, questionable choices, disrespect for reality, and in the end an early death. But even as I warn everyone else (and myself) against this letter, I start to see its appeal again. There's something amazing and affirming about a person who sees so clearly how he's going to change, who sees the cocoon and the butterfly coming out. It's the best line in the letter: "I will be magic."

And yet, don't allow yourself to change too much. Departures have to be handled judiciously.

Who are the most creative people in human history? Duke Ellington? Picasso? It's hard to say, because the most creative person in human history might be someone you never heard of. It might be someone who moved restlessly from new challenge to new challenge, always flitting, never alighting. Departure is not a license to go away and keep going away. You still have to make things along a consistent line, to return to the site of your principal project, even if pure creativity keeps pulling you further and further afield. The purely creative Ellington might have made music in the morning and then turned to a quilt, after which he wrote a comedy sketch and drew a cartoon. Creativity is at least partly about discipline, about staying on the same line. Well, more or less staying on it. It's like a closeup of a rope. Mostly it's the rope, sturdy and thick, holding things in place, but there are fibers shooting off in all directions. You can shoot off in all directions, but don't forget to also be the rope.

Or maybe it's more accurate to say that departures are not relocations. You depart, but the countermovement is a return. You're not a nomad. You're not rootless. You have to preserve your sense of your original mission and the importance of coming back to it. It's not so much "Wherever you go, there you are." It's "Wherever you go, there it is." Your central creative ideas move with you, and you move through them. Departures don't upend that apple cart. They just cart it around.

Speed Is Distance Over Time

Departure can be dangerous, in theory. People worry about becoming different things. Artists, especially, worry. They know they should branch out. They know they should take risks. But how far? And when do they know they have gone so far that they are somehow jeopardizing the integrity (and even the existence) of that original artistic being?

An obvious example here is Liz Phair. When the Roots were just starting out, Liz Phair was an indie-rock darling for her first record, *Exile in Guyville*, and she put out two more records in a similar style, *Whip-Smart* and *Whitechocolatespaceegg*. Then, in 2003, she changed. Her fourth album, *Liz Phair*, was almost shockingly different than the three that had come before it. It was slick and overproduced pop in the service of songs that had none of the rawness or toughness of the ones she had been writing before. Many of her fans hated the record. The *New York Times* attacked her for the shift, accusing her of becoming boring and riskless. This seemed like a little bit of a paradox to me. Moving away from what you had done—from the only thing that had earned you your fame—seemed like a tremendous risk. I can't say for certain what Phair's reasons were. Maybe she was fed up with being an underground recording artist and the limited commercial gains that came with that life. Maybe her record company was fed up with her limited commercial gains. Maybe she was genuinely interested in a more polished kind of songcraft. Maybe she was evolving personally and wanted to make music that reflected that change. Maybe her motivation was even more complex, bringing in elements of self-sabotage and preemptive undermining so that her audience (which had sprung up fairly—and Phairly—quickly) couldn't take her down. I can't get into her head. But I can say with confidence that she embarked on a departure.

There's another example a little closer to my heart: Chubby Checker. Everyone knows him for "The Twist," of course, and for his name, which is a weird variation on "Fats Domino." He was one of the stars of early rock and roll, when it was uncomplicated dance music. In the early seventies, he was living in Holland, where he ran across some young rock musicians. They were simpatico enough that Chubby Checker decided to make a record with them. And what a record. It's a bizarre psychedelic artifact that has at least one song, "Goodbye Victoria," that's a little-known masterpiece. It's derivative of some of the other music that was happening at the time, like Hen-

drix, like Lee Moses, but for Chubby Checker it represented a major departure. I don't know if he ever considered recording it under the name Ernest Evans, his real name. I do know that it ended up in the rubbish bin of his career, forgotten by all but the deepest collectors. But it's just as authentic a Chubby Checker record as "The Twist," and arguably more so, since "The Twist" was an artificial novelty record. These cases are part of a broader genre of Sounding Different but Still Sounding records. At the height of his fame as a hitmaker, Stevie Wonder made a mostly instrumental record, *Journey Through the Secret Life of Plants*, as the soundtrack for a nature documentary. The Beastie Boys picked up their instruments and played live. Some people didn't like those departures and dismissed them as experiments. Other people understood they were part of the Journey Through the Secret Life of Art and went along for the ride. Who gets to determine when an artist is on track and when an artist is off track? The artist is the track.

Moonlight Mile

The other thing about departures is that they let you do multiple things in the same vein, or in nearby veins. Back when we first started touring, more than twenty years ago, with the Beastie Boys, Mike D would disguise himself with a beard and DJ between the opening act and when the Beasties came on. People wanted to know why he was doing that. He had a reason. He wanted to set the mood and the atmosphere for the audience. Eventually they found out. When I was DJing, I didn't disguise myself. It had an effect on the rest of my work. Suddenly what was once my hobby was threatening to become the thing I was best known for. It was a strange reversal.

And when you depart, come back. In 2016 I started *Questlove Supreme* on Pandora. It was a departure for me, in a sense—I have talked about how it gave me a new way of using the DJ part of my

brain and activating the formal curatorial impulse. One of my favorite shows was interviewing Stephen Hill, then the president of BET. We talked about how he started as a DJ at Brown University, and how he remained interested in the energy of being a radio personality. I'm fascinated by his passion for radio. As the president of BET, his fantasy was still to be an afternoon jock. That's someone who understands that departures work in two directions: that when you move on to something else, that earlier thing becomes your departure, in a sense, as well as your anchor. You need to both push toward new ideas of yourself and push back toward the earlier ones that encouraged you to push toward the new ones. I think of it as a road. I have been to places where the sides of the road drop off into deep ditches. That's terrifying, and it limits creativity. When you are making things, you can't worry too much about the ditches. You need an infrastructure that allows you to stray productively from the middle of the road. If you have that, if it is sound, if it is properly maintained, you can go as far as you want over toward the edge, which is as far as you need.

This princple has a related political component. I don't want to use this space to be too explicit about those matters. This isn't the space to litigate Russian interference in the election, or to identify the forces that swept our forty-fifth president into office. But I do want to talk about the immediate effect the election had on the very notion of our nation's creativity.

By the end of November 2016, everyone in the arts community was in full crisis mode. Everyone wondered how the new president was going to affect the things that we do. Would it make us more empowered? Would it recharge us? Would it put us at risk? How do you make art in uncertain times?

Just after the election, I participated in a keynote event at the Kennedy Center on the NEA's Day of Creativity. I was talking onstage to Eric Deggans, NPR's TV critic. (Before the event, I found out that he was also a drummer, and in fact he had interviewed me all the

way back in 1994, when I was in Germany, right after the release of *Do You Want More?!??!!.*) Jane Chu, the chairman of the NEA, introduced us and raised some important questions. How can communities be strengthened? How can people connect? "The arts give us those tools to discover and celebrate our assets and transform our challenges into advantages. The arts can connect us with our neighbors, and they give us an opportunity to celebrate our differences rather than automatically view them as a sign of division." People nodded. "The arts can level the playing field. They are a source of enrichment." People nodded some more.

When Eric and I came out, we tried to keep the conversation light. We talked about people I had worked with. We talked about keeping our chins up. But there was the sense that art needed to engage with the world, and that the world was crystallizing in a way that was hostile to the aims of art. This is a line of thought that connects a number of other things in this book. It's about stilling the voice inside you so you can locate the proper destination. It's about finding like-minded creators—and sometimes about resisting the need to affiliate with them too closely at the expense of your original vision. A few days before I was at the Kennedy Center, the author Jacqueline Woodson presented an award to younger writers as part of the ceremonies surrounding the National Book Awards. She spoke about how she had been marching all week, how she was tired of marching. But she urged writers to write toward the revolution no matter how tired they became. In the Roots, we have always tried to do that. But there was a countermovement, too. At that same ceremony, the comedian B. J. Novak, who was hosting, wondered if he would now be drafted into a political discussion. It struck him as complicated. He knew that the administration's ideas were dangerous. He didn't agree with many of them. But if he started making himself a more overtly political artist, what would happen to his ability to just play around with ideas, to write things in air, to experiment, to wonder?

Back to Black Cool

I am deeply sympathetic to both sides of that argument. There's an idea that circulates through the culture, Black Cool, that identifies the ways in which African American artists occupy (or at least used to occupy) a spot in the culture where they serve as trailblazers in terms of fashionable affect and cutting-edge ideas. These days, that's shifted somewhat. African American culture may no longer be the principal site where conventional culture is resisted and rejuvenated. The bloom may have come off the rose to some degree. But the change in status is also an opportunity. It's an opportunity to stop addressing the politics of black creativity and talk about the trickier hope that black creativity might become, in some sense, productively apolitical.

I'm very much aware that the role of black people in entertainment has been limited to four microcategories. They blur somewhat between personas and actual personalities, but they work as containers for the way that black artists are perceived. Number one is the vicarious bad-guy fantasy. Everybody loves the bad guy. Number two is the Mandingo, the oversexualized image. Number three is the ambiguous, diluted, apolitical safe route: no opinion, no rocking the boat, an artist who doesn't really have a personality. And fourth is the hardest to shake off, and that's the idea that black creatives are somehow out of this world—that they're operating with a level of talent or genius that can't be rationally understood. That's flattering, on the face of it, but it's part of a larger mechanism that is anything but flattering. Dave Chappelle once told me that the best thing that President Barack Obama could ever hope for is to be seen as just a mediocre dude. What happens instead is that there's a narrative of superhuman ability that dogs black creatives. Think of it for athletes. You see a LeBron James: he's out of this world. Michael Jordan's not human. But on the other side of it, O. J. Simpson is an animal. Every plus-two in genius points creates a deficit somewhere else that lets too many people in the world think of too many black people as subhuman. We're

never level. Last year, Donald Glover created a show on FX called *Atlanta* that was the first time I've seen surrealist comedy done in that particular way. The characters are three-dimensional people, not caricatures. They break category. They relate to others because they are fully human. At the end of the day I want to be seen as three-dimensional and relatable, more than anything else.

Once again, this puts me in a conflicted place, a place of tension, and—by extension—of creativity. At the same time that I feel sad that Black Cool has faded, I feel hopeful that its fading will give me (and all of us) a new way to be visible. And at the same time that I feel hopeful about the fading, it makes me sad in specific ways. The saddest and most specific is that it forces me to consider the unraveling of one of my most closely held secrets. For years, people have been asking me what creative projects I want to do but fear I'll never be able to do. Sometimes I say I don't have an answer, but I have an answer. I want to bring back *Soul Train*. It's the show—the cultural moment—that meant the most to me in my youth, and I want to try to bring it back into the spotlight. But even as I say that, I realize that the moment of *Soul Train* may no longer exist. *Soul Train* sprung up in a moment of Afrocentric identity, when there was Black Cool, and when expressing it could speak directly to an audience. In an increasingly multicultural audience, where there's less black and less white and more of whatever we're becoming—rainbow? gray?—I can no longer clearly grasp the role of that old model of cultural expression. I'm not saying that it isn't there. I'm just saying that I'm not sure. Again: tension. Again: creativity.

↓

Expand Experience

If you're a musician, go to an art show; if you're a painter, study dance.

Hello, Art Lovers

I'm a commercial artist. I make work that goes out into the public. And yet, I have to use it to communicate a private world. The best metaphor I have for it is a strange one. When I was a kid, I remember seeing *Mary Poppins*. I'm talking about the only version I consider to be legit, the original Julie Andrews movie, rather than the stage musical or any or other adaptations.

I liked the whole thing, but one of my favorite parts is when Bert, played by Dick Van Dyke, chalks drawings on the sidewalk and then goes into them. Well, he's singing "Chim Chim Cher-ee" as he makes his drawings on the sidewalk. At some point, he notices Mary Poppins. She introduces the kids to him, and the kids tell Bert that they're off to the park. He scoffs. He tells them that ordinary nannies take their kids to the park. Mary Poppins will give them something more special than that. Maybe the river? Maybe a circus? He mimes each of them. Finally, the kids fix on one of the drawings, a typical English countryside. They want to go inside the drawing. Mary Poppins doesn't want any part of it. Bert says he's ready for magic. "You think, you wink, you do a double blink. You close your eyes and jump."

That doesn't work. She's exasperated. "Why do you always complicate things that are really quite simple?" She holds their hands and they all jump. Everyone goes miniature, and just like that they're inside the drawing. While they're in there, there's singing and dancing. A cane and an umbrella do a pas de deux with each other.

When I was a kid, it was an amazing idea. Now that I'm older, I see it as a big metaphor for commercial art.

The first thing Bert says is "Hello, art lovers." He's proud of what he's made. His appraisal of his own work? "Not Royal Academy, but they're better than a finger in your eye."

But it's not art for art's sake. "No remuneration do I ask of you," he sings. "But me cap would be glad of a copper or two." Bert may not be doing it for the money, but the money would be welcome. It would

let him do more of what he wants. It's also an experience that he's trying to promote as superior to other experiences. Normal nannies would take their kids to the park, for free. Nannies with taste and a sense of adventure, like Mary Poppins, go into drawings.

It's not just that. When Bert, Mary, and the kids disappear inside the drawing, they have a magical experience. Bert and Mary consort with cartoon animals. The kids run off to the fair. Bert gets to see how his work is experienced both from the inside and from the outside. He gets to look at it as a creator and he gets to watch others immerse themselves in it. That's the tension that needs to be preserved for good creative art. Never forget that you are working for your own satisfaction, but also never forget that others will occupy the creative work that you have made. Both perspectives need to exist in your mind all the time.

Commercial art has another great component, which is the deadline. When you're making something for yourself, how do you know when it's done? Sometimes you don't. And some of those times you don't even want to know. The process is what is nourishing you, and to bring it to a close would defeat the point.

Commercial art is different. Someone's waiting for you to be finished, so that they can pay you, try to recoup their investment, and then move on to wait for more creative work to be finished, whether it's yours or someone else's. You can't let it drag on forever. That serves no one. You have to get done while the getting is good. And while it's true that this deadline-oriented, investment-recouping-minded process can be crass and corrupt, certainly—I've seen record labels do some of the most crooked things known to man, things that would make a real estate billionaire's head spin—I've also seen the commercial process work wonderfully, and work wonders.

I'll start with a recent example, which is how the Roots work at *The Tonight Show.* We play music when musical guests come on, but we also have, on a nightly basis, some creative participation in the show. For starters, we pick walk-on music: when guests come across the stage to Jimmy's couch, we play songs that reflect some aspect of

their life or career. Sometimes our choice is funny. Sometimes our choice is poignant. Sometimes our choice is a deep inside joke. But we're always making creative calculations. The selection of the walk-on song is a creative collaboration in the finest sense. There's even a walk-on cabinet of band members and writers involved in the process (roll call: Handle Johnbook, Seandamnit, Undeadsinatra, CaptNish, gusto, Spookyelectric, Spread, Lonesome D, Dgnosh).

We're also in skits. We do "Freestylin' with the Roots," where we accompany audience members, but we also act in comedy sketches. That means that the process of putting the show together has very few passive spots. It's active. We get there at noon, and by seven we've made the show for that day. It wouldn't happen without a crack staff around us. The people who make things go, like people on most TV shows, are some of the most intense and focused people I've ever met. But we also need ideas. In the end, the show is a daily reminder of the best-case scenario for commercial art. There's not less creativity than in a free-form Roots recording session. There's the same amount. But in a TV studio, with a clock hanging over our head, we are forced to distill and discipline our creative impulses. There are many questions that arise during the making of an artwork: Should x be added? Should y be subtracted? What if z ends up being different than we thought it would be? They're present in every *Tonight Show* workday, too, but they have to be dealt with quickly, efficiently, and decisively. At the time of this writing, we've participated in thousands of hours of late-night television, and being consistent and disciplined hasn't made us stale or predictable but rather wiser in how to think fast. Jimmy is the captain of the whole ship, of course, and he sets the tone for the rest of the crew: for the monologue writers who sometimes have to add an eleventh-hour political joke just a few minutes before taping; for the segment producers who have to trim skits so that the extra monologue joke will fit; for the Roots, who often have what seems like no time at all to learn a new song's arrangement. Without all the hours of preparation, without the full

workdays for years, we wouldn't be able to know how to react: quick, fast, and in a hurry, but still wearing our most creative hats.

Move the Crowd

Commercial art is largely about audience, of course. The creative process doesn't happen in a vacuum, unless you're James Dyson. (That is a joke about the vacuum magnate.) What I mean to say is that people make things and then they have to release those things into the world. That is a difficult process.

Part of what is difficult is knowing what you mean by "the world." Who are you releasing your work to? How will it be received? We all have audiences. They can be small audiences that keep a creative person going by how passionate or connected they are. For a young artist, it can be a parent or a friend who responds to work and encourages it. In the creative world, artists have to be aware that different kinds of work move through the world differently. This is distinct from the idea of critics. I've handled that before, and I'll handle it a little here, but this is more about distribution (though not in the corporate sense, like how movies get into theaters and how long they stay, and what theater chains do when box office starts to fall off). It's about the process that lets work get to audiences.

One main division at the largest level is between creative work meant to connect with the masses and creative work that cannot connect with the masses but that still tells them something about their lives. There's only really one anecdote needed to prove this point. You know who went to a movie premiere together in 1931? Charlie Chaplin and Albert Einstein. That's not a setup to a joke. It's true. The two of them were friends. Supposedly, as the car approached the premiere and Einstein saw the crowds, he said something to Chaplin about how amazing it was that he had such a huge following. "You do, too," Chaplin said. But then he said something else. "They ad-

mire me because everyone understands me," he said. "And they admire you because no one understands you."

Apart from the weirdness of Chaplin and Einstein hanging out, that's one of my favorite stories about how audiences respond to creativity. And I don't want to hear arguments that Einstein wasn't a creative artist. Scientists can be creative. I've said it before—all that guy did was think of ideas and bring them into the world. There are people who want to draw a distinction between the practices of art and science, and there are definitely some. I remember listening to a conversation between Neil deGrasse Tyson and David Byrne about the differences between the two, and the point was raised that the goal of science is to create the same effects over and over again, to reproduce results, while the goal of art is to do the opposite. Maybe that's a little bit true for the average scientist, but then there are the visionaries, like Einstein, or Leonardo, or Edison, who make leaps into areas that haven't been explored before. Is what they do science or art? Whatever it is, it's definitely creative.

Another example, more recent, more directly to the point, came from the event I did this spring with the director Ava DuVernay at Pratt. She and I were talking about creativity, and creative limits, and how we organize our lives to make work. Ava's job history came up. She had worked as a publicist before she created her own work, and her first couple of films were made completely outside the studio system—her first documentary feature and her first narrative feature were both independent and both self-financed. When Ava was asked what she had learned from this process, her answer focused on audience. She said that she loved working as a publicist, because it taught her that every work has a potential audience, and that the biggest job of a publicist—or, by extension, an artist—is to be honest about what that audience is, how large it is, who's in it, and so forth. Over the course of her career, she said, she's worked on projects intended for smaller audiences and projects intended for larger audiences. The size of the project affected the kind of actors she worked with and the

budgets available to her. (In the months before the Pratt event, she was filming *A Wrinkle in Time*, the first movie with a $100 million budget to be helmed by a woman of color.) But the size of the audience didn't, she said, affect her satisfaction when she saw any audience connecting to her work. "I could go into a theater and see a few dozen people sitting there or I could see in the paper that a movie is opening at thousands of theaters," she said, "and both are rewarding. Sometimes you hear from a company that a certain work doesn't have an audience. That's not true. It has an audience. I've seen those audiences. It's a matter of finding them."

I like that idea so much that I'm going to repeat it, outside of quotes, inside my own head. Sometimes you hear from a company that a certain work doesn't have an audience. That's not true. It has an audience. It's a matter of finding them. When Ava said it at the Pratt event, people applauded. Some people stood up and applauded. She had reached the right audience with her remarks.

A Million Points of Light

Ava's comments, wise and affirming, help to explain the way that audiences reach (or are reached by) artworks. But these days, "audience" means something different than it ever has before. Why? Because we live, for better or worse, in the age of the Internet. Maybe it's more accurate to say that we live in the Internet for better *and* worse. The Internet is many good things, but it is also many bad things. It gives us the ability to know nearly anything nearly instantaneously, but it also undermines and in some cases destroys our idea of our own identity independent from that sprawling network of information. It gives us lots of ways to spend our time, but also it gives us too many ways to spend our time. But one of the most striking ways in which the Internet is both good and the opposite of good is the way in which it provides a platform to humans of all (or at least

most) stripes. This can be amazing at helping to illuminate and give voice to underserved communities. If you are a student in a repressive country, or a poor person in America, the Internet can be a two-way lifeline: it shows you the rest of the world, providing content and context, and shows the rest of the world parts of your life, giving them (hopefully) a sense of connection and compassion.

But the same things that work wonderfully to bring different segments of humanity to light work somewhat less well when the subject at hand is artwork. Again, this requires a clarification. The Internet can be amazing when it comes to disseminating artwork. If you draw a picture or make a song or a video, you no longer have to have the full faith and credit of Major Label or Major Gallery to get your work out there. You can be in your shed in the suburbs of Baltimore and still potentially reach an audience. You won't have an easy time of it. There's no guarantee. But the infrastructure of wires (and wirelessness) has been established to at least permit you to get to the eyes and ears of interested parties. (This is changing. It's getting harder. Four or five years ago, when I first started getting links to bands who were putting their songs on SoundCloud or their performances on YouTube, it was an exciting Wild West moment in the technology's history. "Check it out," someone would write: "It's amazing." And often it was, and more amazing for the fact that it was connecting an obscure group with an—ahem—prominent cultural consumer. If you'll pardon the expression, the mountains were coming to Mohammed all the time. These days, that's changed, obviously. A viral video is as likely to be from the NBA or a high-budget late-night comedy show as from one of those spirited independent artists.)

And the Internet also channels and charges enthusiasms about different kinds of artwork like never before. When I first went to Sukiyabashi Jiro in Tokyo, I documented my experience on Instagram, and when I came home I started to notice how many other people were speaking out about food on the service. They posted photos. They wrote impassioned captions. They successfully illustrated the

Sometimes you hear that a certain work doesn't have an audience. It's just a matter of finding that audience.

way that artwork reached people and encouraged them to create their own artworks in return.

But enthusiasm isn't the same as organized and productive critical feedback. For years, Roots albums were reviewed only by people who wanted them. Some of them were critics with expectations for us, but if they had expectations, they also had experience with our music. They knew that *Phrenology*, say, was a departure from *Things Fall Apart* in certain ways, or that a certain song was an attempt to recapture the energy of an earlier project. At some point, albums could be downloaded for free if you were a gray-market thief. Then they could be streamed if you were anyone. That was a good thing. It gave people access to our work. It was also a bad thing because it gave access to our work to people who were not capable of saying anything critical in the traditional sense. They thumbed up or thumbed down. They threw stars at us like ninjas: three for this one, four for that one. It's not that their response to it is invalid. I'm not suggesting that. But their response may be irrelevant. If you're a color field painter and your work is hanging in a gallery and a guy walks by on the street, looks inside, and says, "I don't like or understand that work," that's nothing that you need to hear. But the Internet preserves it. It puts a bold header, **Not for me**, and then a brief blurb ("I don't like or understand that work") and then a star rating (two and a half). It's even a bit more nefarious than that. It demands that people react to a work. It's not just that people can vote or rate or like without much investment. It's that they often feel as though they have to vote or rate, even when they aren't of the mind to do so. They are coming in resentful,

not just of you, but of the process that puts them on the spot and asks them to have a fully formed (or even hastily assembled) reaction to a piece of work.

My first piece of advice here is to keep your head on the proverbial swivel. Be aware that when you are dealing with works of criticism, you are dealing with creative products—or at least with created products—and that they are subject to the same strains and stresses as any other created product. Reviews have to be written, just like any other piece of prose. People have to take the time to compose them, even when conditions are not ideal. When you are first encountering those reviews, be aware of the conditions under which they were made: the effort, the energy, the experience of the reviewer, the context, the contribution. Scale your feelings about them accordingly.

This is easier said than done. It's very easily said, in fact. I just said it. When I was doing my food book, the chef Dave Beran talked to me about this in detail. Dave was interested in the way that technology has given people too many easy ways to deliver feedback without similarly equipping artists to resist it. In the old days, a consumer of creative work could seek out the producer of that creative work and give an opinion, but it was difficult. You could wait outside the stage door of a Broadway show. You could try to get on the Roots bus after a show. But it took effort. And when you finally got there and it was time to deliver your opinion, there were all kinds of social pressures and contexts. If you wanted to tell me that my show that night sucked, you could, but you'd have to soft-sell it at first so I didn't get irritated with you, and you'd have to give reasons so I didn't dismiss your opinion out of hand, and you'd have to be patient and civil and listen to my rebuttal. Dave said that in the restaurant business, there used to be a very well-understood process. You would voice your displeasure to your server, who would in turn tell the chef or the owner. Sometimes the chef or owner would come out and address the diner's concern, or at least assess it. Sometimes there would be an apology. Sometimes the meal would be comped. "No one likes a

bad review," Dave said, "but that kind of dialogue is something that everyone got used to." Online commentary doesn't require any of that. An unhappy customer can pay his bill, leave, and then rant and rave about the restaurant hours later, from his home. The restaurateur has no way of hearing the complaint in a way that allows him to do anything about it—at least for that customer.

When Dave was talking, I was thinking about how technology has changed feedback for me. There was never a case when I could adjust my performance on the fly, not really—when we released records, those records were locked down and done, and when we performed shows, we weren't likely to go back and play a song again if the audience was dissatisfied. We had good nights and bad nights, and all of them fed into a larger idea of the creative work we were doing.

That's how it works for audience reactions. A real review is a different matter entirely. If a writer takes the time to watch a performance or listen to a record or have a meal, then it's easier to accept criticism, at least for me. No creative person expects to do only good work, not if they're sane. All they can hope for is that their work continues to retain a certain amount of energy.

Evaluation Versus Creation

This is one of my favorite subtitles because it makes me laugh. Why does it make me laugh? Because if you read it really quickly, it makes it look like I'm about to debate evolution versus creationism. I don't know if any of you think it's as funny as I think it is. And I don't really care. Or do I? That's the point of this section.

Does art need an audience? This is really two questions in one. The more conventional way of thinking about this is whether or not art has a destination. Will the book you're writing be read by people eventually? Will the song you're singing be heard by people eventually? Will the comedy sketch that I had to get to work early to run

through be seen by people? The last of these is the easiest. Yes. It will. It's on *The Tonight Show*. Millions of people will see it and then circulate it around the Internet. These questions are important ones, but they have to do with how art is commercialized and consumed.

There's also a less obvious version of the question: How does art anticipate and prepare for its audience as it emerges from the artist? That's something that I have thought about from the very beginning. Some of my best ideas have been the ones closest to the inside of my brain, ones that weren't subjected to dialogue or even my internal ideas of what dialogue might be. But some of my worst ideas have come from that same process. I went looking online, and I found a publication called *Creativity Research Journal*. Who knew there was such a thing? I guess I would have predicted there was, but it also sounds like something that a guy who's working on a book about creativity invents to justify some of his ideas. "Oh, of course—that reminds me of an article I read in the, uh, *Creativity Research Journal*." This particular journal is real and includes input from academics all over the country and even all over the world: France and China and even Norway. I did find an article called "Social Influences on Creativity," which was pretty general, but it had a subtitle that was much more badass: "Evaluation, coaction, and surveillance." The badass subtitle came from the main experiment that the article was dealing with, in which a group of creative people was divided into two subgroups, three separate times. In each of the three sections, half the group was told one thing and half another, and the difference had to do with their expectations regarding the presence or absence of certain kinds of audiences or evaluators. In the first part of the experiment, half of the creative people were told to expect evaluation of their work and half of them were told that their work would not be evaluated. The second and third parts of the experiment put the creative groups in contact with people in different ways. Part two was about coaction, which meant that they were placed in a room with other people who were doing the same tasks that they were. (I had

Be aware that when you are dealing with works of criticism, you are dealing with creative products.

never seen the word "coaction" before. I immediately thought of a sequel, *Coaction Jackson*. I'm writing it as we speak. It's not *Dangerous Passion*, Weathers's next movie, which was called *Action Jackson 2* in Germany. This is a real one, with new Jesse Johnson songs. I'm not really writing it, but someone should.) And part three was about surveillance, where people were placed in a room with other people who were watching them. (For this one, I'm thinking of planning a sequel to the Rockwell video for "Somebody's Watching Me.") Coaction and surveillance had no strong effect on the creative people—coaction had no effect at all, and surveillance had a slight weak effect, probably because people were creeped out slightly by the idea that other people were watching them (while others may have been slightly excited by it—exhibitionists). But evaluation made a big difference. Creativity, however it was defined for the experiment, was "significantly lower" for the groups expecting evaluation.

The Internet, and particularly social media, provides one gigantic version of this experience. You see coaction. You see surveillance. But more than anything else you see (and hear and feel) evaluation.

There's one final, fascinating counterexample here, and that's the way technology ideas move into the world. I am increasingly collaborating with technologists and tech entrepreneurs, whether Kevin Systrom (of Instagram), Tim Westergren (of Pandora), or Andy Rubin (of Android), and I'm always amazed to look at how the tech model for creation stacks up against the artistic model. In many ways, they're the same. Creators have flashes of inspiration. They have to take those flashes and attach them to existing ideas, which they can then extend.

Every once in a while, they find something that's in completely un-charted territory, where they have to invent a new material to build the boat to sail to that corner of the map. But technology has some key differences when it comes to putting ideas in front of people. The main one, of course, is the idea of the beta, where the idea—already sparked, already started—is released into the world before it's fin-ished. The audience then helps to refine the work, to resolve the ques-tions that the creator could not on his or her own. There are versions of this in other fields. This is a largely commercial process, but it's in-teresting to think about in relation to art. There's no beta for a song or a book or a painting, not in the traditional sense. (Sometimes artists will leak a song to see if their fans are comfortable with a new direc-tion, or a politician will use a surrogate to float a new message, trial-balloon style.) But even if the creative world doesn't have betas, you can internally imagine a beta. Think of your work making its way out to people. What will they say? Will they think it's too long? Too short? Too confusing? Too straightforward? Too difficult to operate? Too de-manding on the surface and then too unrewarding at the core? Serv-ing as your own beta tester, at least in a conceptual sense, is yet another example of the principle I've outlined several times: be both present and absent, both in the work making it and outside the work assessing it. Occupy both positions. Play both roles. Push that thing past beta, further along in its own alphabet, further along toward existence.

↓

What's in Store

Even if you're a noncommercial artist, think about how your work may reach others, and the ways in which that process is similar to or different from commercial distribution.

The Failure of Bad Reviews

If you make things long enough, you will fail. That's important enough that I'm going to say it again, with emphasis. *If you make things long enough, you will fail.* The same thing that put you in the elevated place of being a creative artist in the first place will curdle or invert or fall on its face or on your face and you will be a person who made something that they should not have made. You will fail to connect with your existing audience but also, sadly, fail to connect with a new audience. When this happens, you'll feel terrible. You'll feel gutted. You won't know why you started making things in the first place. People will call you or text you and try to draw you out of your cave. They will say that you should be more philosophical about these issues of success or failure, that you should worry only about connecting with your true inner self. You will stare at those people and think they are idiots.

There are a thousand of these stories about failure—at least one for every single creative artist. Chris Rock has made movies that didn't achieve what he wanted. People were more mixed on Dave Chappelle's comeback specials in 2017 than I thought they would be. Even Eddie Murphy had a period where he couldn't buy a good review. There's one that has stuck with me, because I heard it discussed in such detail. I remember listening to the comedian John Mulaney, in an interview on Pete Holmes's podcast *You Made It Weird*. *You Made It Weird* is a weird podcast, as you might expect. While other podcasts chronologically recap the careers of guests (Marc Maron's *WTF*) or discuss specific topics (*How Did This Get Made*, which reviews bad movies), the Holmes show offers a wide-ranging conversation about spirituality, identity, and consciousness. It can be exhausting—there are episodes that run for as long as three hours. He can come off like Sherlock Holmes in that he investigates things that you wouldn't have thought about. He can come off like Eldridge Holmes in that there's a kind of music to his proj-

ect. And he can come off like John Holmes in that it can be a little naked and gross. The Mulaney episode was an exception, and an interesting one, in that it focused largely on one aspect of his career—his self-titled sitcom, which had run on the Fox network.

For many years Mulaney was a golden boy. His bit about trolling patrons at the Salt & Pepper Diner in Chicago with Tom Jones's "What's New Pussycat?" on the jukebox is the kind of #CareeerGoal I could only dream of if I ever found the nerve to make stand-up comedy job number twenty-one. I recite it to other people by heart, the same way frat boys yell DMX's "Ruff Ryders Anthem" loud in the car on a Saturday night.

He cared tremendously about succeeding, and partly because of that, he made the right choices to ensure that he did. He was an assistant at Comedy Central. When he was twenty-six, he auditioned for *Saturday Night Live* and was hired as a writer, where he stayed for six seasons. He wrote a bunch of sketches that were among the highlights of that era's shows, including the Stefon sketches that he created with Bill Hader. During that time, he also started to create a sitcom. Lots of *SNL* writers do that. It's a natural evolution, and no one would have doubted that it was Mulaney's evolution. He developed an idea for a semiautobiographical show that would deal with his own life as a wunderkind, as well as touching on some of the darker aspects of his own story—specifically, the drinking and substance-abuse issues he faced while in college. The show was called *Mulaney*, and it was originally in development at NBC, the same network that employed him as an *SNL* writer (and, full disclosure, the same network that employs me as the bandleader for *The Tonight Show Starring Jimmy Fallon*). NBC took a look at the pilot that Mulaney had filmed and passed on it. That's not tremendously uncommon. Lots of pilots get made, and not very many of those end up getting full series orders. Mulaney had a second life, though—Fox picked it up and ordered six episodes, which they later expanded to sixteen and then reduced to thirteen. It premiered on Fox in October

2014. At that point, the show had a slightly different plot than Mulaney had originally imagined.

So far, that seems like a familiar story. Young comedy star continues to be young comedy star. And on the face of it, the show had lots going for it. It was a *Seinfeld*-like blurring of real life and character. Mulaney's character, John Mulaney, was a young comedy writer living in New York with two roommates, Jane, played by the Iranian American comedian Nasim Pedrad, and Motif, played by the African American actor and comedian Seaton Smith (side note: Tariq auditioned for this role). John's life takes a sharp upward turn when he is hired as a writer by a legendary sitcom star named Lou Cannon, played by the legendary Martin Short. The equally legendary Elliott Gould played Mulaney's elderly gay neighbor, Oscar. The show had a *Saturday Night Live* foundation—Pedrad had been a cast member during Mulaney's time there, and it was executive produced by Lorne Michaels—but there were also some *Seinfeld* veterans attached to it. The show's main director was Andy Ackerman, who had worked on both *Seinfeld* and *Curb Your Enthusiasm* with Larry David.

Before the season, everyone thought the show would be a hit. How could it fail? But from the very beginning, there were bad signs. Critics just weren't getting on board. They thought it was too similar to *Seinfeld*, or too traditional, or too cluttered with quirky secondary characters, or too labored in its joke setups. They thought that Short's comic tone, flamboyant and knowing, might not be a good match for Mulaney's regular-guy humor. But TV comedy isn't about the critics, right? Take it to the people. They took it to the people and the people took it right back to them. The premiere drew 2.3 million viewers, low for a network show, and the audience shrank steadily after that. Apart from an uptick in January that happened primarily—well, maybe only—because the lead-in was the NFC Championship Game between the Packers and the Seahawks (and an overtime game at that!), the show hovered slightly north of a million viewers until the network put it out of its misery.

One thing should be clear to every creative person. If you make things long enough, you will fail.

Mulaney went through much of that on *You Made It Weird*. But he approached it more intimately. What he did, for much of the show, was try to explain to Pete Holmes—and, probably, to himself—how he had coped with failure. The first thing he did was accept the word. His show had failed. There was no way around that fact. It was not liked by critics and it was not liked by audiences. Mulaney had spent two years developing something that had vanished from the air quickly and unceremoniously. He felt the pain of it acutely. In the weeks after its premiere, he would run into friends on the street— either comedians or friends from his normal life—and what he found most disconcerting was their refusal to mention the show at all. In the interview, he remembered asking the comedian Neal Brennan (who cocreated *Chappelle*'s Show) if when Mulaney entered a room, everyone was thinking that he was the guy with the failed show. Yes, Brennan said: that was likely. What made it worse, Mulaney said, is that by designing his sitcom the way he had, he had fused people's ideas of the show with their ideas of him. It wasn't *The Larry Sanders Show*, where Garry Shandling played a similarly named approxima-tion of himself, or even *The Mary Tyler Moore* Show, where the title identified the star but not the main character. This was *Seinfeld*: the name of the show was the name of the man who starred in it and the name of the character he played. As a result, when viewers criticized it, there was no reference but the direct personal one. Mulaney wasn't funny. Mulaney was a waste of time. It was hard to hear whether or not the word was in italics.

It had been a year since the show had been canceled. But Mu-

laney was obviously still struggling with its failure to some degree. He laid out some rules for creative survival, which were interesting to me, because I was starting to work on this book. Really, they were something more specific: rules for dealing with a collaborative process in a way that didn't risk your sanity if the process failed. One of them stood out, so I decided it was okay to borrow it if I credited him. (It wasn't even his originally. It was something that an older comedian, maybe even Seinfeld or Larry David, had told Mulaney.) The idea was that there are a staggering number of decisions that have to be made in the course of a sitcom's life, and Mulaney had to bow out of many of them, had to cede control by simply not showing up, because that way his presence in other meetings would be considered more consequential. Mulaney said that initially that was a hard lesson for him to learn. He liked the idea of being a good manager, of working with everyone, whether it was wardrobe or the network's marketers. But he learned that he didn't need to be everywhere.

He said there were certain risks he wanted to take that he never got to take. He wanted to shake up the format to subvert the traditional sitcom. That sounded like a good idea. He wanted to introduce a subplot about actual ghosts. That sounded like a bad idea. But he let certain aspects of the show get away from him as the process took hold. Still, he said, the full credit (or blame) for the show should fall on his shoulders.

Pete Holmes, both as the host of the podcast and as a friend of Mulaney's, didn't rush to his defense. Far from it: he admitted that he hadn't cared for the show. Even this admission, even a year later, seemed to hurt Mulaney's feelings a bit. In the end, Mulaney admitted that the show had done him in for a little while. It had made him briefly manic and then, for a longer stretch, slightly depressed. He had gotten married the same month the show premiered, and as the show had slid toward its demise, he had focused more on understanding his new relationship. He had found his way back to creative challenges. In the year since the show, he had taped a stand-up spe-

cial and costarred with Nick Kroll in an Off-Broadway play, *Oh, Hello*, that was heading to Broadway. Everyone seemed to agree that the play was good.

Don't Be Afraid of the Dark

There are at least two lessons to take away from stories of failure. The first, of course, is not to be afraid of it. Any career, if it is to be a long career, includes a mix of successes and failures, and it should. That mix is oxygen-rich. It keeps you breathing.

For many years the Roots were critics' darlings and then some, and it was a little bit of a prison. When I was a kid, music artists looking to see what critics were thinking about them mostly had to content themselves with the *Rolling Stone* review. A four-star review was impressive. A five-star review was almost unthinkable. We've discussed the rare albums that achieved that milestone. A little later, the measurement became *Source* microphones. If you got five, the world was acknowledging your genius. Nas got five for *Illmatic*. Outkast got five for *Aquemini*. De La Soul got five for *De La Soul Is Dead*. Again, this is only one measure of success, critical success by an authorized publication, but it mattered. In our era, the critical brands all shifted around thanks to the Internet. It wasn't *Rolling Stone* so much anymore or even *The Source*. It was Pitchfork scores. That was the metric that told you whether or not your shit was hitting ears correctly. Pitchfork rates albums on a 0.0 to 10.0 scale. Only a handful of albums have ever gotten a 10.0 at the time of their initial release—Radiohead's *Kid A*, the Flaming Lips' *The Soft Bulletin*, Kanye West's *My Beautiful Dark Twisted Fantasy* among them. (Lots of albums get that score on reissue, but that's different—that's art plus hindsight. The real trick is to hit the mark the first time out.)

I didn't expect a 10.0. I knew better. But I also knew that we were a critically acclaimed band, and that we were making some of

our best music in the late nineties—the songs were some of our most powerful and also our most accessible. When we released *Things Fall Apart* in 1999, I crossed my fingers for the highest possible rating, and we got close: we got a 9.4. That record wasn't just a well-conceived and well-executed record that landed with critics. It also sold well and kept us in the public eye for a while. If there was such a thing as across-the-board success, that was it. *Phrenology*, the next album, came out in 2002 and continued on in that vein. Pitchfork gave us an 8.1: it wasn't quite as high, but it was still way up there. But *The Tipping Point*, the album that followed that one, was a big come-down. I remember Rich Nichols, our manager, calling me. "You're not going to like what Pitchfork has to say," he said. I got stopped at the top: 5.4. It wasn't even what they had to say. It was just a number. And it wasn't the number I wanted to see. Eventually I read the review. The reviewer said a number of negative things about the record, most of which I disagreed with, some of which made sense to me—I had been there when we made it, of course, and I knew a little bit about why some songs may have sounded lyrically loose or musically inconsistent. It wasn't that I could learn much from the review. I was aware of the limits of the thing we had made. But I kept coming back to that number.

What does failure do to an artist? It can mess with your head. That's primarily because it's only ever in your head. The things that are hailed today may be forgotten tomorrow. The reverse can happen, too. A work stamped one way doesn't stay that way. Some works are deemed masterpieces and exist in that rare air forever, but usually this designation passing down through time unchallenged, unrevised, and unrevisited is the result of a shortage of thinking on the part of audiences, the result of a preference for received wisdom.

Failure is not fatal. For starters, it can be a motivator. Smooth sailing isn't always the best way to convince yourself to put your nose back to the grindstone. Struggle and frustration and fear (I think I've referred to that same exact combination before, in *Mo' Meta Blues*,

Smooth sailing isn't always the best way to convince yourself to put your nose back to the grindstone.

which I remember because it sounded like *The Wizard of Oz*, lions and tigers and bears) can be great tools for learning to focus and recharge yourself. But that's true of any kind of failure: a girl won't go out on a date with you, or your boss doesn't want to give you that promotion. But failure in creative pursuits is a special occurrence of the same principle. In an interview (I think it's with German TV), David Bowie said something I really liked. I don't know if he said it often, but it's the kind of thing that you should get tattooed on your leg. He said that creativity is "one of the few human endeavors where you can crash your airplane and walk away from it." Your mistakes don't have to bring you down, not by any means. But Bowie's observation has an even deeper level. Creative failures can feel like near-death experiences, and surviving them can create a sense of liberation. There's that movie *Fearless*, starring Jeff Bridges, where he is in a plane crash and survives. It's not exactly Bowie's metaphor. It's not his airplane. He's just a passenger. But he lives through a crash. In the weeks and months following the accident, he finds that he is seized by a kind of mania. He takes risks that he wouldn't have taken before. He bonds with Rosie Perez, who plays another survivor who lost her child in the crash. (Rosie Perez got an Oscar nomination for that movie, which was the right move and then some: *Fearless* is when I realized that *Do the Right Thing* wasn't a fluke. Quiet as it's kept, Perez might be the spark to my *Soul Train* obsession. No human—no singer, no dancer, not even Don himself—matters more to me than Rosie Perez dancing on that show.)

Creative failure leads to a similar liberation. When you walk

away from your crashed airplane, you're playing with house money. You can do anything—and hopefully you will. Failure is sometimes in your mind. Sometimes it's in the eye of the . . . well, not the beholder, exactly, but the afflicted. Even when it's not, even when it's indisputable, it's never the end. Think of James Brown, who had so many high points, undeniable peaks, but then other moments where he made work that wasn't well received or was out of step with the time. Sometimes it's because his audience wasn't ready for what he was doing. Other times it was because he was too eager to get outside his own head and catch up with trends rather than stay in his own head and set trends. But so what? There's no law that says that every time has to be "Cold Sweat." Even when you don't feel like a Sex Machine, you get on up. The only correction I'd make to this formula is that true creative people don't walk away from it, not exactly. They walk toward the next thing.

Rising From the Ashes

I have a great example of this principle. I heard a story from a film-maker. I won't identify him, because he might not want me to. Years before, someone had made a movie based on a book he had written. It was a science fiction story, and I hadn't heard of the movie, which maybe isn't that surprising, because there are lots of science fiction movies I don't know. Anyway, it was a book he was proud of, and he was happy when it was optioned as a film, and he was excited when the director and actor met with him and promised that they would keep his original vision intact, and he was heartened when he visited the set . . . and then that was the end of his optimism. As the movie went on, it became clear that the director and the lead actor had no intention of preserving his original vision. They were going to tear the book up and remake it in their own image.

The film, when it finally appeared, was even worse than he had

imagined. It had nothing to do with his book. They had changed the main character. The actor had gone for vanity. The director had simplified the structure to the point where the book's main point, something about how time folded on itself, was completely lost. Even worse, the movie got destroyed by critics and was a failure at the box office. The reviews pointed out what he already knew, but they did it in a way that made it look like the flaws had been in his original book. The guy was devastated. For six months, he could barely get out of bed. But then he started to get angry, and not in a way that was familiar to him. He started to get angry and motivated. I have described the guy as a filmmaker, but said that this movie was based on a book he wrote. That might sound like a mistake on my part. It's not. It's an explanation of exactly what happened. Originally, the guy had been an author. He had written six or seven books, some of which sold very well, others of which didn't. Critics seemed to like his work. But when he recovered from his months of depression, when he started to feel his anger at the movie as something that he couldn't hold back any longer, he began to think of himself less as an author and more as a filmmaker. For starters, he was a little gun shy when it came to writing again. He was still flinching from the pain of the movie. On top of that, he wanted to understand how the film was made, how it had so badly mishandled the book he had written. He started making his own movie about the process of having a movie made of his book. He was honest with himself that he didn't have any idea what he was doing. He didn't know how to get professional actors. He didn't know how to light a scene or mic for sound correctly or clear music rights. It was obvious to him that whatever he was making wasn't a movie he could screen for audiences in the traditional sense. But he learned as he went. And what was important wasn't just that he was learning, but that he was creating. He was excited about it and engaged in the process and determined to do his best, and most of those things hadn't happened in years. As an author, he had become a professional, a successful one who had lost

Your ego is one of the things that needs to be managed rather than indulged or ignored.

contact with the basic spark of making things. As a filmmaker, he had reconnected with it. At the time he was speaking, he was start-ing a second film, one that he hoped that maybe he could release.

In light of his experience, he began to have a different under-standing of failure. For him, at least, at that time, failure was a form of nourishment. He realized that if it was digested correctly, it could produce a tremendous amount of energy in an artist. That's the real question about how your work as a creative professional is received. For other people, it's whether or not they like it. For you, it's not about whether or not they like your work so much as whether or not the way they feel about it motivates you to make more work. Creativity fails when it stops. It can pause, but it then has to go on and take on other forms. "Here, the author paused, thought about a film that had been made from one of his works, and came back as a filmmaker."

If at first you succeed, that's not necessarily so great either, ex-cept for your ego, and your ego is one of the things that needs to be managed rather than indulged or ignored.

This same principle applies in situations where artists don't fail. More to the point, it applies in cases of success. When you start out as an artist, you only think about success. You want it. You'd do any-thing to get it. And if you have a sense of the history of your art form and the important role that art in general plays in society, you don't want that success to be solely financial. You want people you respect to look at your work and acknowledge its quality. They don't have to love it, but they have to respect its goals and the way in which you have chosen to pursue them.

This can be its own kind of trap. That 9.4 from Pitchfork for *Things Fall Apart* is a number that I'll never forget, because it got us so tantalizingly close to 10.0, which is perfection. Then we were down, and then we came back up. The *Game Theory* album, which came out in 2006, got a 7.7 on Pitchfork. A success. *Rising Down* was a 7.8. Success. *How I Got Over*, in 2010, got us back to *Phrenology* levels, with an 8.1. I know that these are just numbers, and that they're every bit as reductive as lower numbers. I'm using them to make a point. (I don't completely know if I know that these are just numbers. But that makes a point, too.) As we were moving up the ladder, it didn't always have quick or happy financial consequences. I like to tell people that the Roots were the longest overnight success in the history of the record industry. I remember being at the Grammy Awards when my electricity back home was being turned off. We kept going because we wanted to be going, and because we imagined a certain destination, even if that shifted around a little bit. After we got back on track after *The Tipping Point*, people seemed to agree that that destination was the right one.

But success, if misunderstood, can be just as dangerous as failure. I'm especially proud of *How I Got Over*, not because of its Pitchfork rating, but because of all the things it isn't. It's not a carbon copy of *Rising Down*. It's not even an attempt to be that. We had recently been hired by *Late Night with Jimmy Fallon*, and that put us in contact with lots of new music. That made us aware that we had to learn to play with any kind of band. You could argue that it was the opposite of creativity. But *How I Got Over* was the record where we were determined to connect our TV job to our overall creative project. We had lots of guests on that record. Joanna Newsom was on it. Dirty Projectors were on it. Jim James was on it. There was also an idea, which was signaled by the title. What were we getting over? We were getting over anxiety. We were getting over stress. We were getting over the difficult middle of our career. But in a strange way, we were getting over success.

But don't let success knock you down, either. It can put you in a narrow lane and make you afraid of experimentation. Think of all the famous actors who are forced to make the same kinds of movies over and over again because studios are eager to re-create successes. I'm not saying that we should feel sorry for them. We should most certainly not feel sorry for them. They're famous actors. But on a purely creative basis, their lateral movement is being restricted.

Insecurity Force

There's a racial component to the issue of success. There's no two ways about it. There's one way about it.

In my theory, especially with those successes that we cherish in black music, I feel like the common denominator as of late is that a lot of black artists take between three and eighteen years to put out a new record. Why does it take that long when Stevie Wonder or Smokey Robinson needed eight months, and James Brown needed less than that, and the two years it used to take Sly Stone was considered an eternity? I don't think it's an accident. Making things is a psychological process, and delay is a common form of self-sabotage. Why would you sabotage yourself as a black artist? I can't speak for everyone, but I think there's a strong strain of survivor's guilt if you come from a place of poverty or cultural inequity, from a place where you're disadvantaged when you're growing up. Suddenly, in the blink of an eye, your life changes—and not because you were forced to fit into a system, necessarily, but because you were being yourself. Why did that happen? What made you so lucky? When this happens, there's lots of guilt. A good example would be Allen Iverson. How do you emerge from poverty and obscurity into prominence? How do you squander so much money at such a young age? And how do you think of yourself as you're going through that entire process? I used to think about how black artists treated their audiences and to see it as

cool when they seemed not to respect the process. When Miles Davis used to perform, he would turn his back on the audience. His whole persona was a constant middle finger at society. But when I started digging deeper, I found that people—even Miles, a genius several times over—wanted to reject the public before the public rejected them. I can name seven or eight artists who overthink and talk themselves out of the situation. In Mike Birbiglia's *Don't Think Twice*, one of seven creatives in a comedy troupe, played by Keegan-Michael Key, is offered the chance to appear on a *Saturday Night Live*-esque show. The movie doesn't show him struggling with race, exactly—he's a fairly white black guy within the comedy world—but he definitely struggles with survivor's guilt, partly because his girlfriend (played by Gillian Jacobs) is one of the members of the troupe that he's leaving behind. And remember, these things are subjective. What makes one person better than their community? When you elevate one above the group, what are the results? Do you grasp that once-in-a-lifetime opportunity or do you throw it away out of guilt?

In creative circles, sometimes a kind of survivor's guilt makes people turn on their own best ideas. The chef Dominique Ansel, during cronut fever, had an issue with his own success. He had lots of money offered to him to continue to focus exclusively on that one idea, or to think of another idea with the same mainstream success. Partly, he didn't do it because he insisted on always being new, but I think he was also worried about the perception of other chefs, about the respect of their inner circle. There are two related issues here, so let me separate them for a second: there's fear of being held above the community that has supported you, and then there's fear of losing the context of those similar artists. For me, those two things combine to create a specific insecurity. I think of how I act during DJ gigs, or rather right after them—the second the last song ends, I want to get out of there. I bolt for the door. I have friends who have, over the years, encouraged me to stay. They think I should have conversations with the other creative people who have come to see my set. If it's

during a period when I've been single, my friends have encouraged me to stay to speak to women. But I don't do it. As I say, door, bolt.

It's shyness, of course, but it's not a simple form of shyness. It's also a form of arrogance. I think of the people I respect, the people I revere, like Prince and Michael Jackson, and I can't imagine them waiting behind after a show to grab a drink at the bar and speak to fans. Social media has already made me more available than might be healthy. I can fire off a random idea in the middle of the night via Twitter, or show people a weird mushroom growing on a pipe in the basement of a venue via Instagram. But I believe in perpetuating a certain amount of mystery. Deep down, even though I participate in social media as much as, if not more than, any other celebrity, I don't necessarily believe in what it does to my presence in the culture. Or rather, it extends and amplifies my presence in ways that might have a negative effect on my creativity.

On the other hand, I'm getting better at realizing that some of these new social media platforms are themselves inherently creative. Late last year, I did my first Instagram live chat. The idea of it was that I would appear on camera, play a record, maybe talk about it. I did a little spoken prelude that was very apologetic and self-deprecating. I warned people that they might be disappointed. I explained that I'm not as engaging as the Kardashians, or at least not as engaging in the language of the medium. I wasn't going to pout for the camera or do cutesy photo setups. Instead, I was just going to go through some music, and a specific kind of music—marching band covers of soul records. I think maybe in the back of my mind I was announcing this as a disclaimer so that I could be proven wrong by the crowd. If I told people there was nothing that would hold them in, no real centrifugal force, and the numbers went from five hundred to a thousand to ten thousand, I'd be proven wrong—and in the course of that, be proven right. But that's not what happened. Instead, what happened is what I said would happen. The number of viewers following the live chat started at around a thousand, and then ticked down to nine hundred,

Remember: Success, if misunderstood, can be just as dangerous as failure.

and then to eight hundred, and then to seven hundred. People were dropping off quick. The number was like an altimeter in the cockpit in a plane-crash movie. But of the people who remained, most of them got what was happening. They understood it. They were deeply connected, wired in like people were wired in to the Matrix, with that plug that went straight to the brain. You'd think I would have liked that, at some level. But it was also a little disruptive to the creative ego. I have a friend who is a writer who says that when he used to do readings and the crowd was especially small, he would get angry. "Why did you get angry at the people who were there?" I asked him. He shrugged. "If I'd had a good understanding of it, it wouldn't have happened," he said.

After that event, I thought about the whole process—why I had agreed to do it, why I had picked a subject that I knew wouldn't have the broadest possible appeal, why I had issued a disclaimer, why I had harbored hope that my disclaimer would prove unfounded, and why I couldn't quite see clear to appreciate the people who stayed behind. I came to at least one conclusion, which was that my fear of rejection was so strong that it caused everything to short-circuit. This is central to the idea of failure. It's not just making something and having it not work on its own terms. It's making something and then, whether or not it works on its own terms, feeling a break between you and the audience you imagined. You are thrown from that fantasy like a driver from a car crash who wasn't wearing a seat belt. Wow: that's two crash metaphors in two paragraphs. But no apologies. I guess that's the way it feels. If you watch the post-*Big Fun* Miles Da-

vis, where he's just walking around, back toward the audience, you get another sense of it. We used to think it was such a cool pose. Miles is the best. He's so pure. He cares only about his art. But the more I watched him, and the more I experienced a career that was, if not exactly his career, some version of it—things made and extended into crowd space—the less I believed in the idea of a pure art, and the more I believed in the very complex process of artists acting in ways to avoid rejection. Why wouldn't they? Rejection is a sting. It's a fist in the face. It's a bad feeling in your romantic or professional life, and maybe even more devastating creatively, when what's being rejected is some fundamental piece of your being, something personal and spiritual, the grain of your own unique ideas. Artists incorporate the feeling of rejection into their personality. You can come and go with success or failure, but the more fundamental dynamo of fear of failure will always be there.

I forgot who first told me the balloon story, but it's extremely relevant here. It's a hypothetical scenario that tells you about a person's outlook on the world. Here's the story: You're standing in a field. A guy drives up in a truck and hops out. He has a giant bunch of helium balloons, easily enough balloons to lift you off the ground. The guy doesn't get lifted himself because he's wearing heavy boots. "Take this," the guy with the boots says, holding them out to you. You grab them. You begin to rise. What do you do? Most people say they would let go immediately, fall three or four feet to the field, and watch the balloons shrink into the sky. But then I met a young black guy after a show. We were talking about music and creative work and his aspirations, and I presented him with the balloon scenario. "What would you do?" I said.

"I'd brace myself for the ride," he said.

I couldn't believe it. "So you're telling me that you have a thousand helium balloons, and you're slowly rising from the earth. You're five inches in the air, six inches. And you can't wait to go higher?"

"Of course," he said.

"No, no," I said. I had to explain to him all the dangers involved. "Anybody else I've given this example to knows to let them go."

But as it turned out, he was explaining it to me. "I wouldn't let them go because then the balloons would be in the air and I'd still be on the ground. And I've always dreamed of flying."

I had to ask, "Where did you grow up? What was your life like?" He was born in 1993. His parents were still married. Both sets of grandparents were alive and still married. He grew up lucky, and then some: part of the generation of black folks who grew up in a stable, encouraging, nurturing environment. He escaped the entire process of self-doubt and self-hate. "What happens when you get too high?" I said. "With the balloons, I mean."

He shrugged. "I figure maybe people will come to rescue me."

It was an amazing insight, and one that had never occurred to me, partly because it's not true. People won't come to rescue you. Ultimately, you'll have to do it yourself. But maybe there's something to the belief in being rescued. Maybe there's something to the bravery of holding on to the balloons. Maybe there's wisdom (even a callow wisdom) in the brain that keeps the hand from letting go.

Setting Your Mind

Failure and success are just states of mind. And because they are states of mind, you can restate them inside your own mind.

First, there's the question of where to draw the line around a particular creative work or experience. One of the major things about a creative life is to realize that you get to manage time and even, to some degree, control it. I don't mean that you get to pick how long you live, though that would be an amazing perk. (I don't think I would choose immortality, partly because I don't see how I'd be motivated to do anything if I knew that I had endless time to do it, but that's a discussion for another day.) What I mean is that you get to decide, to

some degree, what the unit of your creative life is. Think of a football game. You might have a terrible first half and then a great second half that lets you come from behind and win the game. That's what happened in 2017's Super Bowl between the Falcons and the Patriots. The first half was a failure for the Patriots, but they went into the locker room at halftime and adjusted. Then they came out and dominated their opponent. Because it's a game with set rules, there are a number of different layers of success and failure, but the end result is that the Patriots prevailed. Creativity is even more nuanced. It factors in the possibility that you may want to focus only on the first half, because you're creating a first half, in which case you can admire the way that Atlanta performed. Or maybe what interests you isn't just the game but the game plus the way the players treated their families when they went home that night, in which case (and this is pure speculation) you admire the Falcons players who didn't take out their frustration on others and the Patriots players who weren't high and mighty (those are forms of success), and you have issues with the Falcons players who let their sadness and frustration affect how they treated others and the Patriots players who partied all night while their wives or girlfriends were back at the hotel (those are forms of failure). Or maybe you want to look only at a specific aspect of the game, such as the precise moment of executing a handoff. In creative work, this is the equivalent of noticing that your technique is improving even if the work that it's serving isn't up to snuff. The point is that as a creative person, you are in charge of the size of the work being judged. If the critics don't like this album, but they like the next one, and you want to feel that as an overall positive, that's up to you. If they like neither, but the reasons have to do with their trust in your talent and their belief that you have a great album in you waiting to come out, you may choose not to feel that as a failure, either. People may say that these are mind games, that you're shifting reality around to make yourself feel better. My answer to that? Of course they are! Of course you are! That's the point.

Much of what you do creatively will not land in the middle of a receptive audience.

The second issue has to do with individual responsibility, and how much you personally have to bear the brunt of any critical assessment of your work. Again, let's go back to football. In a team game, there are always people to share in the outcome and the consequences of that outcome. A receiver can go out onto the field and do everything he's asked, but if his defense doesn't stop the other team, if his coach doesn't make the right calls, his performance might be in vain. (This also happened in the Super Bowl. Sorry, Julio Jones.) The same is true of a band, to some degree. When I go out with the Roots, we're all in it together; a good night is both a victory for the whole group and not a pure measure of my own worth, and a bad night is a sobering experience for all and not a pure measure of my own worth. Other kinds of artists all have their own version of this. Some of my comedian friends like working as MCs. Some of my writer friends like working as moderators in panel discussions. Those are ways of being part of the team without being right out in front, in the spotlight.

But there are times when performers are very much up in front, when the team concept or the band concept recedes and they are standing alone, exposed, with their work. In those cases, you need to return to all the other strategies I outlined previously. You need to be aware of the nutritional benefits of failure and the empty calories of certain kinds of success. But I want to end with one more point, and it's also a philosophical one. One of the best ways that you can cope with the feelings of failure (or the stresses of success) is to embrace a simple fact: the world mostly doesn't care about you. When you are a young creative person, whether a musician or

a writer or an artist, you work on your craft with no good sense of who your audience is. If you do a show at lunchtime and ten people show up at the courtyard to watch you sing, or dance, or tell jokes, that can give you a huge feeling of satisfaction. Later on, as you achieve more fame, your sense of audience shifts. You expect more people to care about what you're doing. If you put out a record and fewer people buy it than projected, if you write a book and it sells worse than you had hoped, even if you tweet out something funny and it doesn't get the likes and retweets that you've grown accustomed to, you might have the tendency to panic or feel especially bad about yourself. Don't. Feel good about it. You're getting back the gift of freedom. People's silence, or an audience's distance from you, isn't necessarily a negative review. The world is extremely cluttered. It's filled with everything. Much of what you do creatively will not land in the middle of a receptive audience. It will just fall into the world, to be ignored by most people and found by a few who react strongly to it, either positively or negatively. This may not speak to your ideas of fame or celebrity, but it does speak to your ideas of creativity, whether you know it or not. Creativity needs a certain amount of isolation to improve your ability to understand connection. Creativity needs a certain amount of indifference to improve your ability to make a difference. Creativity needs a certain amount of void so that you can be (and create) content.

Healthy Competition

How do you keep a balance? How do you keep swimming despite those two riptides? Part of the secret here is to always stay within sight of healthy competition.

The first story that springs to mind is from the late nineties. I wasn't a new artist anymore. I was a kind of veteran. I had been in the hip-hop game for almost a decade, which was about as long as any-

one ever thought that a hip-hop career would last. I was still working with the Roots, but I was starting to branch out and do recording and production work with other artists as well. This was during the period when D'Angelo was recording *Voodoo*. That wasn't as long as the period that produced *Black Messiah*—that was a decade-plus—but it was still a few years. I have talked about the way he suffered from writer's block and how he overcame it. By this point, it was entirely overcome. He was humming with new material. Lots of us were contributing to his record, one way or another—as musicians, as producers, as sounding boards—and we used to hang out in the studio. Hours were long but morale was high. All of us sensed that the album we were helping bring into existence would be something major.

I remember one afternoon when we were working on "Devil's Pie," and DJ Premier was adding his scratches to the mix. Q-Tip was there with us in the room, and then he was gone—he had to make a phone call—and that left just four of us: D'Angelo, me, J Dilla, and Premier. We worked for twenty minutes, and then twenty minutes more, and then we took a break. Premier said, "Hey, anyone got anything new to play for the group?" He was a little older than the rest of us, but more important, a little more veteran. Gang Starr had numerous classics and their new single from *Moment of Truth*, "You Know My Steez," had just come out and swiftly propelled the group to their first gold album. If he was throwing down the gauntlet, that meant we had to come up to it. D'Angelo went first. He rummaged around for a cassette, found it, and played us maybe thirty seconds of a new song. Thirty seconds was all he needed. I'm not sure what song it was, maybe "Left & Right," but it was electric. The room erupted. Everyone was hooting and hollering like they had been stung, and in a way they were. Dilla went next. He played us "Fall in Love" and a sketch of what was forming into "Once upon a Time," with Pete Rock. Again, there was a huge outpouring of pleasure and excitement and more than a little envy. Premier went third. He had staged the whole thing, so he knew what he had in his pocket: he played

"Downtown Swinga '98," by M.O.P., and a rough of Group Home's "The Legacy."

Then it was my turn. That was a problem. That was more than one problem. For starters, I didn't have lots of material. I had a work tape for the song that would become "Double Trouble" on *Things Fall Apart*. There were no finished vocals: not Tariq's full performance, nothing at all from Mos Def. It was only a skeleton. But it's what I had in my bag, and it's what I went with when the arrow swung around and pointed at me.

I will never forget that room. The walls were gray. And so was the feeling that came over the place when I played "Double Trouble." If you had been a new arrival, you might not have noticed. You would have seen the same drill that followed D'Angelo or Dilla or Premier: laughing, heads thrown back, legs slapped. But you wouldn't have seen the slight undercurrent of insincerity. It wasn't anything especially egregious. It was just something in the posture of the other guys. It seemed studied. They kept a straight stare on their eyes, looking out into the middle distance, and bobbed their heads a bit. They didn't make eye contact with me or with each other.

It was the sign of death. I took the cassette out and put it back into my bag. I might as well have not even been there anymore. I was as gray as the gray feeling in the gray room.

That night, I went into the studio with a vengeance. I reworked the song completely. Whatever wasn't working, I took it out. Whatever was working, I made better. I have said that I was like Glenn Close in *Fatal Attraction* in the sense that I would not be ignored, but it's a little misleading. I would not ignore myself. I wanted to be the equal of the others. I wanted to be able to go into my bag and pull out a song that would light up the room. Again, I want to distinguish between process and results. Did I do that? It's hard to say. You could argue that still, to this day, "Double Trouble" isn't the equal of "Left & Right," at least on a first-listen basis. Tariq's verse is great. Mos Def adds a huge amount of wisdom and power. It's not a grab-you-by-

the-lapels pop song, but that's not the issue, so much. What sent me back into the studio to work on it was the creative motivation. In this case, the motivation was competition, plain and simple. I didn't care if that song sold fifty million copies or topped the chart. I wanted to impress the room, or at least make something that I could imagine might impress the room.

This connects to other principles that I've sketched out. This is the place where the network sustains you. It's a way of shrinking the world down so that you are contending not with the million other things that are being made all the time around the clock by everyone in every time zone. You don't even want to yardstick yourself with your own long history of making things. You want to win the room. That's where your creativity has to keep humming along. It's the best form of peer pressure, the only valid way to use like minds.

Staying on (the) Track

There's another way to think of competition, and it has to do with trains. Let me explain.

In late 2016, Childish Gambino released an album called "Awaken, My Love!" Childish Gambino, of course, is Donald Glover, the actor and rapper. He first became known for starring in the NBC show Community and then created and starred in another TV show, Atlanta, which won him two well-deserved Golden Globes and an Emmy. He also recorded and released a series of hip-hop records. For a little while, he occupied a strange position in the music world. Some people were amazed at his versatility: How could a comic actor make these legit records? Other people dismissed him as a dilettante, or assumed that "hip-hop performer" was just another role he was playing. (Camp, the album he put out in 2011, got a brutal beatdown from Pitchfork, a 1.6. It gave me nightmares, and I wasn't even the one being reviewed.) I won't wade into that dispute, except to say

that I didn't think it was a very important one. There were cuts I liked on his first couple of albums and cuts I didn't, cuts I responded to at some basic level and cuts that left me cold.

Then came *"Awaken, My Love!"* I knew that Donald was taking a left turn in his music. He had talked about it in interviews. He was listening more and more to late-sixties and early-seventies funk records, particularly albums by George Clinton's P-Funk empire and by Sly and the Family Stone. I'm talking about landmarks like *Maggot Brain* and *America Eats Its Young* and *There's a Riot Goin' On* and *Fresh*. I was prepared for a shift in sound. But I wasn't prepared for the completeness of the transformation. From the second I put the new Childish Gambino record on, I was shocked. It was late at night, or what other people call early in the morning. I immediately called D'Angelo. "D," I said. "You have to hear this. It's the train."

He knew what I meant. Only a few other people would have. But now everyone can know. When I was young and I was taking the train around Philadelphia, I would have strange thoughts about the trains arriving at the platform. If a train left and I hopped down onto the tracks and started walking, how far could I get before another train came along and ran me over. It wasn't a healthy thought, maybe, but it wasn't a thought about self-destruction or anything, either. I just wondered how long it would be before something else came along. As I got older, I started to turn that into a metaphor for art. If the Roots put out an album right on the cutting edge of jazz and hip-hop, we could enjoy it for a moment. We were the only kid on the platform. But there was always another train about fifty yards behind us. We couldn't turn to make sure, because it could be the last thing we'd ever see. We had to keep going, keep making things, stay creative, stay challenged.

The reason I called D'Angelo was because of his own music. His own great music, I should say—*Voodoo* was a genuine masterpiece, and then he took some time (this is called artful understatement) to deliver *Black Messiah*, his follow-up. When it finally appeared at the

end of 2014, it was everything everyone thought it would be. It did amazing things bringing old funk and soul into a new age, keeping the spirit of that music alive but also keeping it pointing forward. There was nothing like it. Or was there? D'Angelo thought he was the only one on the train track, and I was right there with him. In our heads, we were the only ones on that track. But when I heard the Childish Gambino record two years later, I knew we were wrong. We had been camping on the track so long, operating under that false belief, and suddenly I realized there was a twenty-ton locomotive coming at us. Donald had a certain power, due to his TV platform, but also because of the distance that had passed since the works that had inspired him. No artist of his size, of his prominence, was working with the same ingredients in the same way. Half the people who bought his record had never heard of *Maggot Brain* or *Fresh*. This was their way in, and it brought that music to life for them, and that was an unqualified good. But it was also a lesson in competition.

I had lots of arguments about that record, that night and in the days to come, with D'Angelo. One interesting one, at least for the purposes of that discussion, originated with the idea of influence, and it returns to some of the concepts I discussed at the beginning of this chapter. D'Angelo asked me if I thought the record was derivative. Of course it was, and I said so. But I also asked him why he thought he had the right to soak everything up, from Smokey Robinson to Marvin Gaye to Curtis Mayfield to Prince, and remake it in his own image, while Childish Gambino didn't. It all came down to time frame. In D'Angelo's mind, he was drawing on oldies, but oldies that were acquired legitimately, on the radio, in his own record collection, whereas Childish Gambino was wearing them like fashion. In my mind, that's not a good argument. You don't pick where your inspiration comes from, or where your competition comes from. You are inspired by and compete with things that matter to you. Sometimes they come to you across the decades. And then there's the funny second implication in what D'Angelo was saying. He was suggesting that

Childish Gambino was also, in some sense, copying him, that he was using the same set of moves to reach his audience. I told D'Angelo that I agreed with him—but that he had to realize that he was an oldies act, too. That was something he didn't like to hear. But I asked him to look at the calendar. His debut album was more than twenty years old. His hugely influential second album was more than fifteen years old. His innovations—the way he understood hip-hop, the way he arranged vocals, the way he moved through a melody—had been in place for a long time. If a new artist was imitating Smokey Robinson, they were also almost certainly imitating D'Angelo. It's even more specific than that. In Richmond, Virginia, where D'Angelo's from, there's a whole micro-generation of young musicians whose parents met and dated in the period around *Brown Sugar*. Now those guys are in their early twenties, and many of them are musicians. They are advancing the D'Angelo sound just like Childish Gambino is advancing the P-Funk sound. They are imitating, but not just imitating—they're absorbing, digesting, and remaking, both representing and re-presenting. And, because D'Angelo is still active, all this imitation is also a form of competition. To me, that's a good thing, and possibly a great one. It reminds us that we're all on the same track, and that what goes around always comes around. Think about the trains. Never forget that they're on their way.

Rewrite Reviews
Find a review of your work and rewrite it to say the exact opposite of what it says.

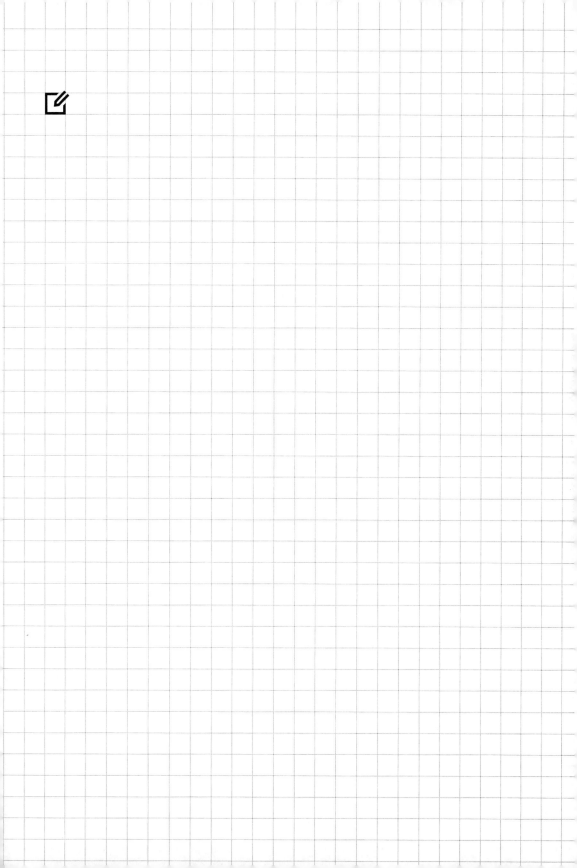